BECOMING MICHELANGELO

Apprenticing to the Master and Discovering the Artist through His Drawings

ALAN PASCUZZI

With a Foreword by William E. Wallace

ARCADE PUBLISHING · NEW YORK

First Paperback Edition 2022

Passages from *The Craftsman's Handbook* by Cennino Cennini, translated by D. V. Thompson are reprinted by permission of Dover Publications.

Arcade Publishing books may be purchased in bulk at special discounts for sales promotion, corporate gifts, fund-raising, or educational purposes. Special editions can also be created to specifications. For details, contact the Special Sales Department, Arcade Publishing, 307 West 36th Street, 11th Floor, New York, NY 10018 or arcade@skyhorsepublishing.com.

Arcade Publishing® is a registered trademark of Skyhorse Publishing, Inc.®, a Delaware corporation.

Visit our website at www.arcadepub.com.
Visit the author's site at www.alanpascuzzi.com.

10 9 8 7 6 5 4 3 2 1

Library of Congress Cataloging-in-Publication Data

Names: Pascuzzi, Alan, author.
Title: Becoming Michelangelo : apprenticing to the master and discovering the artist through his drawings / Alan Pascuzzi.
Description: First edition. | New York : Arcade Publishing, 2019.
Identifiers: LCCN 2018055735 | ISBN 978-1-62872-915-3 (hardback) | ISBN 978-1-950994-37-3 (paperback) | ISBN 978-1-62872-916-0 (ebook)
Subjects: LCSH: Michelangelo Buonarroti, 1475-1564—Knowledge and learning. | Art—Study and teaching. | Drawing, Italian—Copying. | CYAC: Artists—Training of. | BISAC: ART / History / Renaissance. | ART / European. | BIOGRAPHY & AUTOBIOGRAPHY / Artists, Architects, Photographers.
Classification: LCC N6923.B9 P376 2019 | DDC 709.2—dc23 LC record available at https://lccn.loc.gov/2018055735

Cover design by Erin Seaward-Hiatt
Front cover artwork: © Alan Pascuzzi (figure drawing); © janeb13/Pixabay (Creation of Adam detail); © iStockphoto (paper and fabric textures)

Printed in China

This work is dedicated to my parents,
Louis and Yolanda,
whose love and gentleness are with me always;

to all of those who offered support and encouragement in my endeavors;

to my wife, Loredana; and to my children, Gioele, Elia,
and little Amelia, who was born when I was finishing this book.

Contents

Foreword

Thousands of artists have learned by copying Michelangelo, but none have come as close to going to jail as Alan Pascuzzi. In the riveting opening vignette of his book, Pascuzzi describes the moment he realized he could make a simple exchange, leaving his perfect copy of a Michelangelo drawing on the British Museum study table while slipping the original sheet into his portfolio. The two were identical. Fortunately, he did not succumb to the momentary temptation.

Michelangelo's biographer Giorgio Vasari tells us that Michelangelo was hugely successful in imitating other people's drawings: "He also counterfeited [*contrafare*] sheets by the hands of various old masters, making them so similar that they could not be detected." Alan Pascuzzi may be absolved of the crime of counterfeiting; he set out to remake, not to fake, the drawings of Michelangelo, with the noble, upright purpose of becoming a better artist. And he is. He never "became Michelangelo," but he did become Alan Pascuzzi, a largely self-taught artist, author, teacher, and professional cicerone of his adopted Florence.

Pascuzzi mastered his craft by devoting thousands, if not hundreds of thousands of hours, to patiently copying the drawings of Michelangelo Buonarroti—a lifetime master class from one of the greatest draftsmen of all time. He learned his craft well, as this book, and its many illuminating

illustrations, amply attest. Yet, even as he became a master himself, Pascuzzi remained a humble and respectful apprentice.

Renaissance apprenticeships were long and arduous, often lasting seven to ten years. Pascuzzi's self-apprenticeship to Michelangelo has lasted much longer and has been equally arduous, especially when he was nearly derailed by the arcane methods, expectations, and multiyear demands of completing a PhD in art history. An artist in his heart and soul, Pascuzzi weathered the stunting environment of the university and succeeded in writing what he calls a "dense, cold, note-ridden academic brick." That brick wasn't so bad, which I know since I was his doctoral adviser. To this day, I feel some guilt, yet I like to think that Alan's years spent in the academy were also a sort of apprenticeship—a preparation for writing this marvelous book. And this book is no cold, unreadable brick!

Alan claims that his book is an artist's study of an artist . . . for anyone who loves Michelangelo. Since there are many who love, or at least admire and are familiar with Michelangelo, Alan should have a very large audience indeed. And what does he have to say to us? We learn much from being granted the privilege of looking over the accomplished draftsman's shoulder as he copies drawing after drawing in the world's most important drawing collections. "As an artist myself," Pascuzzi writes, "I approach my study of Michelangelo as a practitioner of the same craft." He learns and teaches us by doing, with the same materials and techniques employed by the Renaissance masters he so admires.

Many years ago, an editor of a prestigious magazine asked, "Hasn't the bull been milked?" which expressed his exasperation with the ever-growing avalanche of Michelangelo publications. There is so much written about Michelangelo that it is impossible, even for an interested scholar or layperson, to "keep up," much less to know what to read among a Sargasso Sea of writing. It would be a serious shame, however, for this book to get lost amidst the flotsam. Alan Pascuzzi's book is better and different; it stands out from the crowd.

This wonderfully readable and personal account of Michelangelo's early years reminds us that becoming a genius requires work and unwavering dedication. Alan Pascuzzi, an accomplished historian and a highly successful, sensitive, and insightful artist, combines a rare set of skills that permits him to tell the story of how an unlikely Florentine aristocrat became the greatest artist of all time. After reading this book, you may well feel the inspiration "to create masters out of mere mortals like us."

WILLIAM E. WALLACE

Author's Note

A DANGEROUS DIMENSION OF MASTERY

There I sat, staring at what I had done. It was February 1996, and I was alone in the drawing room of the British Museum in London, surrounded by boxes of some the most important drawings by Michelangelo. Before me was an original Michelangelo drawing in red chalk, perhaps one of his finest, a study of Adam for the Sistine Chapel ceiling (Figure 1). Beside it, a copy I had just finished was, if I may say so, perfect. I had tinted the paper to make it look old, cut the sheet to the same size as the original, and used the same type of natural red chalk, from Florence, Italy, that Michelangelo had used (Figure 2). I had spent hours that morning drawing it while carefully studying the original. There wasn't a single mark, stroke of shading, muscle, or stray line that I did not reproduce. It was a cloned Michelangelo original. And I sat and looked, feeling radiant and glorious. I had spent the last five years copying Michelangelo drawings, and this was the finest I had executed yet. Then, suddenly, an uncharacteristically sinister thought popped into my head. I looked around; no one was watching. I could return my copy with the originals and place

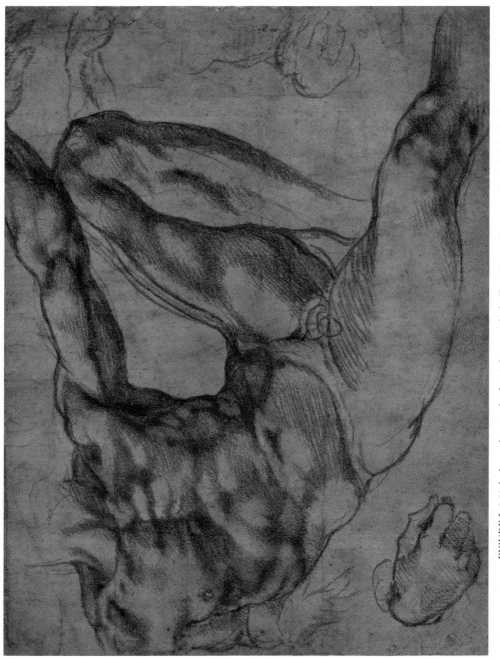

FIGURE I: Michelangelo, study for Adam, red chalk, 190 x 237 mm (7.7 x 9.3 inches).

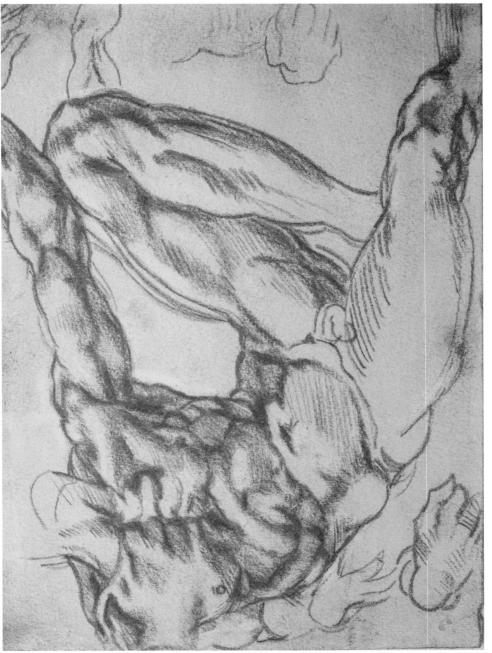

FIGURE 2: Alan Pascuzzi, copy after Michelangelo, study for Adam, red chalk, 190 x 237 mm (7.7 x 9.3 inches).

the original in my portfolio and simply walk out. *My God*, I thought, *I could take this!*

I could already see the headline in the *International Herald Tribune*: Fulbright Scholar Steals Michelangelo Drawing and Replaces It with Exact Copy. How many years could I get for it? Would it be worth it for the glory and fame? *Wait*, I thought, *isn't this what Michelangelo did to Ghirlandaio? Didn't he copy his master's drawings so well that he put his copies back into the master's portfolio and passed them off as originals?* I sat there, reflecting on whether I should begin a life of crime right there in the British drawing cabinet. An attendant passing by interrupted my imagined brush with crime and infamy and brought me down to earth. I placed the Michelangelo original back in its box—not without some faint regret, I admit.

While collecting my drawing tools and slipping my copy into my portfolio, I began to think of what this meant. I had arrived, finally. After years of libraries and travels and fighting against the yin and yang of my academic and artistic schizophrenia, with this copy, this perfect copy, perhaps I had finally entered into that long-desired realm: a dimension of mastery.

PREFACE
What This Book Is

I OWE THE READER AN explanation of the nature of this book. In 1999, I submitted my PhD dissertation, *Michelangelo's Early Drawings: The Formation of the Artist*, to my committee at Washington University in St. Louis, Missouri. In it, I presented a scholarly and artistic study of all of Michelangelo's early drawings in a dense, cold, note-ridden academic brick of four hundred pages. Only the professors on my committee read my dissertation, I suspect—seven in all. This book, however, is not for an academic committee of seven. Instead, *Becoming Michelangelo* is an artist's study of an artist—the way I had always desired to study him. It is for anyone who loves Michelangelo's art and is moved by his genius.

In writing this book, I returned to the Kunsthistorisches Library in Florence where I had done all of my dissertation research. The "Kunst," as it is affectionately called by art historians, contains one of the most complete collections of art history publications on Earth. As I looked up at the section where the books on Michelangelo are kept, I was confronted with several huge wooden shelves filled from floor to ceiling with literally hundreds of tomes on Michelangelo—on his art, poetry, everything down to his bank records. There are four volumes of just the lists of books and articles written about him alone. Five hundred forty-odd years after Michelangelo's death, art historians are still writing about him—and

give no signs of stopping. There are dozens of biographies, from Condivi and Vasari to Hibbard and even my own professor, William Wallace, that contain a comprehensive view of his life and works. The best of all wasn't written by an art historian and isn't even an academic biography. It is Irving Stone's *The Agony and the Ecstasy*, a brilliantly written novel about Michelangelo that weaves historical fact and fiction to provide an insightful view of the artist's life and work. I suggest all of these works for the reader interested in the life of Michelangelo.

With so much already written about him, why would I bother writing another book on Michelangelo? *Becoming Michelangelo* is not another biography in the conventional sense. Instead, I am writing about Michelangelo from the standpoint of both an art historian and an artist. Through the study of the most practical side of his art—his drawings—I offer a way for the nonacademic reader to get inside his artistry and his life.

Before Michelangelo was a field of academic study, he was an artist. He was a master practitioner of his craft. As an artist myself, I approach my study of Michelangelo as a practitioner of the same craft. I rely on that part of my experience as well as my training as an art historian to excavate new ideas about Michelangelo the draftsman, insights that are not just for scholars, but for everyone.

This book offers a concentrated examination of Michelangelo's gradual development into a master, roughly from 1485 to his completion of the Sistine Chapel ceiling in 1512—from when he was a teenager until he was thirty-seven. This period of the artist's life was perhaps his most important: it is when Michelangelo learned to become Michelangelo. It was the basis for his entire career and subsequently his eternal fame.

I have always been drawn to Michelangelo's style and force. When I began studying art in high school, I became even more attracted to his mastery of anatomy. In graduate school, I began to study him seriously. I was particularly fascinated by his achievements during his youth. He became a painter's apprentice at just thirteen. I wanted to find a way to

"relive" his artistic development from his point of view and, by doing so, learn to draw like him. And that is what I did: to understand Michelangelo and his masterpieces, I copied every single one of his extant drawings from this period at least two times over. I sought to enter into his mastery, discover how he became a master and perhaps even be like him. Rare is the art historian who does not secretly wish to be like the artists they study. For me, I had a double envy, as I was both an art historian and an artist.

To understand this period of Michelangelo's life, I have drawn on the art historical record of events and dates, but I have relied equally upon my own art experience, specifically through copying his drawings. In addition, I bring to this study twenty years of living and working as an artist in Florence and experiencing the city's unique creative ambiance, just as Michelangelo did in his time. The sixty-two drawings that I have analyzed and pieced together chronologically combine like tesserae to create a mosaic of Michelangelo's artistic development. There are missing sections, but combining the artistic and historic approaches will help us to fill in the gaps.

My endeavor is to relate something that is extremely difficult to verbalize: a quasi-mystical, private artistic quest that Michelangelo experienced as a youth studying drawing in Florence. I want to offer a sense of being in a city where some of the greatest artists walked and of what it's like being surrounded by Giotto and Brunelleschi and Masaccio, seeing beautiful things every day and trying to realize that same facility, that same beauty—and same mastery. In my own quest, I tried to understand and experience the artistic thirst that Michelangelo had when he drew from Giotto and Masaccio. I worked to channel his intense need to understand anatomy by drawing from the human figure. Following Michelangelo, I have attempted to master drawing—the basis of all the arts—in the centuries-old Florentine tradition. To do this I used the same materials, tools, and techniques as apprentices used in Michelangelo's day.

Michelangelo drew to get closer to the masters and become a master himself. Pushed ever onward by a passion to learn, he undoubtedly felt elation with each good drawing but also frustration and a need to know more. A true artist never ceases to learn. Having tucked the good drawing safely in the portfolio stowed under his arm, he must have walked home through the narrow streets of Florence feeling one step closer to his goal. This feeling of growing mastery is what I want to convey in the most historical and visual way possible, and that's why I've included so many of his drawings and my copies. Through the copies, we can identify the materials Michelangelo used and understand better how and why he drew using these materials and methods.

Although relying on my own artistic experience may seem subjective to art historians, it still has a methodology—one I made use of as a Fulbright scholar in Florence completing my dissertation. But ultimately the making of art is not a science to be objectively studied and analyzed; it is a passion that, to be understood, must be felt and experienced from the inside. I have tried to master the same drawing, painting, and sculpting techniques as Michelangelo, copying his works on paper (and in painting and sculpture) in the same city he learned to use them. I learned to make works of art like him as if he were my master and I his student. Have I discovered something new about Michelangelo? Perhaps I have only revealed facts that were already known, but my lens is a new, revolutionary way of looking at him and his artistic formation from the inside. Through this lens, Michelangelo is more human, more mortal like us, and perhaps even more incredible.

BECOMING
MICHELANGELO

1

Did Michelangelo Have to Learn How to Draw?

MICHELANGELO: ONLY HUMAN?

One of my favorite quotes about Michelangelo comes from Mark Twain in *The Innocents Abroad*: "Enough, enough, enough! Say no more! . . . say that the Creator made Italy from the designs by Michael Angelo!" Nearly a century and a half after Twain's comic protest, that is where we still are—we see Michelangelo as the artist who was so talented he couldn't possibly have been human.

That perception is obviously not true, of course. Michelangelo was born in 1475 in Caprese, a small town near Arezzo, Italy, and he went on to become one of the greatest of the High Renaissance masters, along with Leonardo da Vinci, Raphael, and Titian. We picture him as a boy genius or child prodigy like Mozart, but he had to learn to be an artist. He was not born a genius; he followed the traditional apprenticeship method common in the Renaissance—incredible as it may seem. When I looked deeply into Michelangelo's youth and closely at his drawings, it became evident that he was in fact no different than any other young boy in the late 1400s whose attraction to art led to an apprenticeship.

The apprenticeship method of the 1400s was based on a traditional didactic structure whose main purpose was to train young boys the rudiments of drawing and painting as part of an artisanal craft, passed down from master to student in the context of a workshop. In some cases, this training included sculpture as well. The scope enabled the students to learn enough artistic skill to assist the master on large commissions before eventually breaking away to open up their own workshops. Initially, apprentices started with simple art exercises such as copying from the master's drawings to learn contour and shading. After a period of copying, the apprentices began to draw from sculptures to understand three-dimensional form and volume. After several years of drawing, apprentices would start drawing from a live model and also began to learn to paint and help the master on large commissions.

As a student, I set out to explore the apprenticeship method in order to fully grasp how the divine Michelangelo began to learn to draw. Treatises from Theophilus Presbyter (ca. 1070–1125), Cennino Cennini (1370–ca. 1440), Leon Battista Alberti (1404–1472), and Leonardo da Vinci (1452–1519) all served as textbooks of the time and described the didactic method of an apprenticeship, and they became my textbooks as well. It was all there, plain as day—just follow this method, and you will become a master. The idea fascinated me and fired my passion to find out more about Michelangelo but also, egoistically, to become a master myself. So that is what I did. I dedicated myself to following the same method as Michelangelo in order to fully understand how he became a master.

Soon my life and career would revolve around this process, and eventually I would not only teach it to student apprentices, but also use it to produce my own works in painting and sculpture. This book tells the story of both Michelangelo's apprenticeship and my own. What I hope to accomplish in it is to share a new way of looking at Michelangelo—and, more important, to reveal the potential of the apprenticeship method, even centuries later, to create masters out of mere mortals like all of us.

MICHELANGELO'S APPRENTICESHIP: CONDIVI VS. VASARI

Where does one begin to understand Michelangelo's apprenticeship? Of all the biographies of Michelangelo, the most trustworthy, and most entertaining, are by Giorgio Vasari and Ascanio Condivi. Both were contemporaries of his and wrote their biographies in the 1550s. It seems like a simple task: just read the biographies and you'll get a clear picture of how Michelangelo began to study art. Unfortunately, this is not the case. From the primary-source biographies of both Vasari and Condivi, the subject of Michelangelo's apprenticeship reveals itself to be hotly contested.

Giorgio Vasari and Ascanio Condivi had a difficult time retelling Michelangelo's early years. Both tended to portray Michelangelo as superhuman and even divine, but neither could not completely ignore his ordinary artistic beginnings. The first biography of Michelangelo was contained in Giorgio Vasari's *Lives of the Artists* of 1550. For art historians seeking primary source information on Renaissance artists, Giorgio Vasari, the first art historian in all respects, presents a unique problem. While Vasari sought to provide much factual information in his biographies, he also tended to shape and manipulate historical facts in order to convey his personal view of the artists or tell a good story. His account of Michelangelo's early years sometimes evinces hero worship. According to Vasari, Michelangelo's natural enthusiasm for art caused him to use every scrap of paper and every whitewashed wall to draw his figures. At thirteen, Michelangelo was sent to study as an apprentice under Domenico Ghirlandaio, one of the most successful artists of late Quattrocento Florence. While in Ghirlandaio's workshop, he showed such great skill in drafting that he was openly envied by his older master. Vasari notes that Michelangelo left the workshop two or three years later to study sculpture under Bertoldo di Giovanni in the Medici sculpture garden founded by Lorenzo the Magnificent at San Marco. There he impressed Lorenzo so much that the powerful patron and virtual ruler of Florence took him into

his own home and gave him the Neoplatonic education that formed the basis for the rest of his brilliant artistic career.

Michelangelo had his own idea of how his past should be portrayed and didn't care for Vasari's version. In response, he dictated his biography to one of his followers, Ascanio Condivi. Condivi's *Life of Michelangelo*, published in 1553, is an attempt to "correct" Vasari's version, in which Michelangelo is portrayed as having begun a formal apprenticeship like any other youth. Instead, Condivi commences his story with a romanticized description of "nature's constant stimulus" acting on Michelangelo to become an artist. He also relates Michelangelo's struggles against his father and uncles, who beat him when he abandoned letters for art. Although Condivi must have known of the apprenticeship, he chose to obscure that part of the history. Instead, he presents Michelangelo as wandering independently around Florence, "drawing one thing and then another at random, having no fixed place or course of study." Rather than any mention of formal study, he emphasized Michelangelo's friendship with another boy, named Francesco Granacci, who lived just around the corner from Michelangelo's house in Via dei Bentaccordi near Santa Croce. According to Condivi, it was Michelangelo's dear boyhood friend Granacci, not Ghirlandaio, who had some influence on his early training. The boy Michelangelo was self-driven in his independent artistic studies and learned "nothing from Ghirlandaio," he asserts.

In the 1568 version of the *Lives*, Vasari responded to the Condivi biography, including an expanded version of the life of Michelangelo that appropriated material from Condivi's biography but also added new information. Countering Condivi's denial of Ghirlandaio's influence on Michelangelo, Vasari cited verbatim the written agreement that he had only mentioned in his 1550 biography. Although a devout follower and admirer of Michelangelo, Vasari must have relished publishing the contract, which was between Michelangelo's father, Lodovico Buonarroti, and Ghirlandaio. The document records:

I acknowledge and record, this first day of April, that I Lodovico di Leonardo di Buonarroti have engaged Michelangelo my son to Domenico and David di Tommaso di Currado for three years next to come, under the following conditions; that the said Michelangelo shall remain with the above named during all the said time, to the end that they may teach him to paint and to exercise their vocation, and that the above named shall have full command over him, paying him in the course of these three years twenty-four florins, as wages, in the first six, in the second eight, and in the third ten, being in all ninety-six lira. ★

With the publication of the contract, the question of Michelangelo's apprenticeship was finally answered—or so it would seem. Michelangelo didn't respond to Vasari's declaration, but he probably didn't have to. He knew he had the means to leave an even more persuasive record of his early artistic beginnings for future generations, one that would reinforce the legend of his "divine" genius for art, no matter what any published contract might imply. The truth of his early artistic career would be revealed through the most powerful documents he had—his drawings.

Very few drawings from Michelangelo's apprenticeship—roughly from 1485 to 1488—survive. It seems likely that Michelangelo destroyed anything that would have revealed the "human" struggle throughout his career—in other words, his "worst" boyhood drawings or drawings that showed his craftsman-like approach to commissions. He may even have destroyed drawings or sketches that showed just how hard he had to work, while carefully preserving for posterity his best drawings, the ones that testified to a natural, "divine" talent. This scenario seems credible, since, according to the chronicle of his last days (as I will discuss more in chapter nine), Michelangelo burned heaps of his drawings at the very end of his life.

★ Giorgio Vasari, *Lives of the Artists*, ed. E. H. and E. W. Blashfield, and A. A. Hopkins, 4 vols. (London: G. Bell, 1897 [ca. 1896]), 40.

THE "MICHELANGELO CODE"

The question of Michelangelo's apprenticeship is not easily determined through traditional art historical study. The primary sources contradicted each other, and all the literature since then simply repeats the same information. The drawings themselves do provide insight through close art historical analysis and observation, but important clues are sometimes hidden in the most insignificant sketches and are missed completely. The true story of Michelangelo's apprenticeship can be discovered with a less traditional method, an artistic/analytical approach that gathers information from reproducing every single line and hatch-mark on every drawing. It is by reliving and reproducing Michelangelo's artistic efforts that we can decipher what could be called the "Michelangelo code"—the secrets to his mastery.

2

Wanting to Become a Master

A FAMILY OF ARTISTS

The questions surrounding Michelangelo's apprenticeship and innate, God-given genius touched an artistic nerve deep inside of me. Although I dedicated myself to art history as a student and scholar, becoming a master—in the traditional Renaissance art sense of the word—had always been my goal. I grew up in a family of traditional artists. Wanting to paint and sculpt and achieve a true sense of mastery in art felt natural to me. My uncles were figurative sculptors who worked with Gutzon Borglum on Mount Rushmore in the 1930s. My mother was a painter in a classical, traditional style. All six of my brothers and sisters studied studio art and later pursued artistic, creative professions. As children, we were surrounded by paintings, sculptures, and art books. Art was in our blood.

When I was a small child, my mother would sit at her easel in our living room and paint as she watched over me. With seven children running around the house, she had to paint to keep her sanity as well as exercise her amazing creative spirit. While she was working at her easel, I would sometimes pull out her large art books on Rembrandt or Norman Rockwell and look at the pictures. The one I remember looking at the most was

her huge Harry Abrams coffee-table book on Michelangelo. The powerful figures in his paintings and sculptures fascinated me, and I would just stare at them in silence. One day, while scrutinizing the figures of the fresco of *The Last Judgment*, I remember asking my mother as she painted at her easel why Michelangelo's figures were so big and bulky. She simply replied, "That was his style."

From junior high school through college, I studied art with no idea of how important Michelangelo and Renaissance style would become for me. I benefited from many good teachers, but as I studied art in school, I had the growing sensation that I was not learning what I should. The profession of art instruction was still recovering from the 1960s. Postmodernism emphasized still life and abstract projects and no classical art training. We never considered the old masters, and Michelangelo was just a long-dead Italian one. Art class was always a problem for me because I didn't understand the value of knowing how to draw rusty teapots or fruit anatomy. Abstract art simply was not in my DNA. During my senior year of high school, one teacher looked in disgust at my pitiful attempt at an abstract assignment and said, "You think too straight." Confused, I stared back and wondered if he was complimenting me or indirectly calling me a nerd. What I did understand was that my fellow art students were excelling in abstraction and I was being left behind. They had found their own artistic path, while I was still searching for mine. I wanted to learn something real but didn't know where to go to find it. In my final senior art class, I pulled away from the abstraction gang and instead began drawing figures from photographs.

COLLEGE, SISTER MAGDALEN, AND THE CALL OF THE MASTERS

Despite being on the fringes of artistic fashion in my interests, I decided to study art at Nazareth College in Rochester, New York. I had no idea what future I had in art, but painting and drawing were all I wanted to do.

Everything changed, however, when I met my adviser, Sister Magdalen LaRow. A nun from the order of Saint Joseph, she was a brilliant art history professor and artist in her own right who was trained in the "old school" mentality of art instruction. Sister Magdalen understood my problem—I was a natural-born classical artist with innate traditional tendencies in a field where traditional art was no longer taught. She knew who I was before I did. Perceiving my need for old art, she steered me to changing my major to art history, wisely advising me to discover the masters while continuing to take classes for a minor in studio art. Art history as a major sounded more academic and valid to me, and I followed her advice. Sitting in her art history lectures, I studied Greek sculptures and Roman frescoes on the large lecture-room screen while Sister Magdalen provided factual explanations woven with amusing anecdotes. With each lecture, I became more enthralled by and enamored of the world of classical art and the old masters. Greek *technites*, Roman fresco painters, medieval architects, and Renaissance artists—I was drawn to them all and began to feel the urge to do what they did. When Sister Magdalen began the section on Renaissance art with Leonardo da Vinci, Raphael, and Michelangelo, I knew I had found my path. They inspired my artistic aspirations. I could almost hear them calling me to follow them, but it was as if they were behind a closed door. I became obsessed with emulating the masters and becoming one in my own right.

My obsession was further fueled when I read Irving Stone's biographical novel about Michelangelo, *The Agony and the Ecstasy*. Stone masterfully wove historical research with narrative to create a complete story of the life and struggles of Michelangelo. Reading his book cemented my desire to not just study the Renaissance masters but learn to draw, paint, and sculpt like them. But I didn't know yet how to begin. In the summers throughout college, I made an effort to explore the techniques of the old masters on my own. I tried painting with egg tempera, carving marble, and even painting frescos, but I didn't yet understand how to do any of them correctly.

WHEN AND NOT IF: IN FLORENCE FOR THE FIRST TIME

The summer before my senior year, I was able to immerse myself in the old masters when I studied in Florence. Sister Magdalen had always said to me, "Someday you will go to Florence and see these masterpieces and truly be inspired—it is not a question of if, but when." Sadly, she passed away in my junior year. After she died, I discovered she had left me a box of guidebooks that she had accumulated throughout her years of travel. I later understood that this bequest was her eternal gentle encouragement to go seek the masters. When I arrived in Florence in 1990, with Sister Magdalen's precious guidebooks in my suitcase, everything that she said would happen did. I immersed myself in the city, its art, language, and history. I attended classes in the morning and went to the museums in the afternoons to draw. While drawing from the sculptures of Michelangelo, I felt I was getting closer to the artistic truth I longed for. In fact, when I copied from the *David* in the Accademia one day in July 1990, something strange happened: I had spent three hours drawing, when an Italian man with his young daughter came up and asked to see what I was doing. I was happy to show them. Considering my drawing, the daughter said to her father, "Look, he is the new Michelangelo." Flattered and embarrassed, I tried to thank them in my halting Italian. It was only when I walked out of the Accademia that the little girl's words began to sink in. I was particularly drawn to Michelangelo, and that little girl had seen it. Becoming a "new Michelangelo" was highly ambitious, to say the least, but I would remember her casual comment later on.

CENNINI AND THE KEY

After college, I received a Florentine Renaissance art history fellowship at Syracuse University, where I pursued a master's degree. When I started the program, however, I found myself slipping into a kind of agony. I was buried in art historical research and ignoring my true desire for formal

classical art training. I began to feel trapped in lonely libraries and weighed down by research and writing papers. It felt as if I was destined to become the typical frustrated artist as art historian. It was a cruel twist of fate.

Then, something happened. During my first hellish semester of grad school, I came across a footnote referencing an art treatise written in 1399 by Cennino Cennini called *The Craftsman's Handbook*. I checked the handbook out from the library and read it in one night. For many art historians, Cennini's book is simply an art manual for apprentices that contains instructions on how to fashion drawing instruments, prepare panels for painting, and make and use pigments. But the treatise also speaks directly to the artistic longings of those young boys who want to become artists. Cennini starts his narrative with the words, "[I]t is not without the impulse of a lofty spirit that some are moved to enter this profession." Although Cennini wrote this in the late 1300s for boys of the same century, I understood it perfectly. The treatise contained what I had always been seeking: not just recipes and instructions but also, in clear terms, the steps one had to take in order to become a master artist. Finally, in Cennini, I had everything I needed to know, from what materials to use to what path to take to achieve my own artistic style and mastery. For the first time, I saw a small ray of hope. Mastery was a distant dream, but with Cennini, I had the key to unlock the door to get there.

3

A Lofty Spirit:
My Apprenticeship to Michelangelo

CENNINI AND WANTING TO FIND A MASTER

In one of the first sections of his art treatise, Cennini uses an effective euphemism for those who were in artistic agony like me—the "impulse of a lofty spirit."

> *It is not without the impulse of a lofty spirit that some are moved to enter this profession, attractive to them through natural enthusiasm. Their intellect will take delight in drawing, provided their nature attracts them to it of themselves, without any master's guidance, out of loftiness of spirit. And then, through this delight, they come to want to find a master; and they bind themselves to him with respect for authority, undergoing an apprenticeship in order to achieve perfection in all this. There are those who pursue it, because of poverty and domestic need, for profit and enthusiasm for the profession too; but above all are to be extolled the ones who enter the profession through a sense of enthusiasm and exaltation.*

Some might misunderstand what Cennini is referring to and question whether this "loftiness" means being on a "higher intellectual plane" or

simply a way of avoiding reality or being a dreamer. I know, however, what he was getting at. I am not always sure if being an artist is a blessing or a curse. For the monetarily successful artist, it is a blessing; for others, it amounts to suffering. In any case, for artists, there is always that urge to make something, to leave a part of you on paper or in paint or in stone.

Even in 1399, Cennini refers to this "desire" and describes how those who want to become artists are drawn to creating. He asserts that the trueborn artist will "want to find a master" and "bind themselves to him." Once he finds the master, the apprentice will "take great pains and pleasure in constantly copying" the best things from the master. Lastly, Cennini gives advice about what type of master to choose, "the one who has the greatest reputation," and how if you copy from him every day, "it will be against nature if you do not get some grasp of his style and of his spirit."

Cennini spelled it all out clearly. Artist, lofty spirit, drawing, copying from the best master. This was the game plan. But which master to choose? It was obvious. Cennini did not say the master had to be alive, only that he had to have the greatest reputation. I had been fascinated by Michelangelo's style since I was a child, and I decided that it was his style and spirit I wanted to grasp. I wanted Michelangelo as my master.

Sitting at my desk in my one-room apartment at Syracuse University, I formally became an apprentice to Michelangelo. There was no contract or oath; all I knew was that I wanted to dedicate myself to my master and hopefully become like him. I decided to follow Cennini's advice to the word and copy something by Michelangelo every single day. And that is what I did. I took out every book in the Syracuse art library on Michelangelo's drawings and began to copy them—one every evening after class. My days were filled art history and seminars and books and articles, but at night I became an apprentice and lost myself in Michelangelo's drawings. I spent many hours alone that semester on dozens of Michelangelo's drawings, trying to learn anatomy, volume, and gesture from them just as Renaissance apprentices did. The materials alone were a challenge. In art

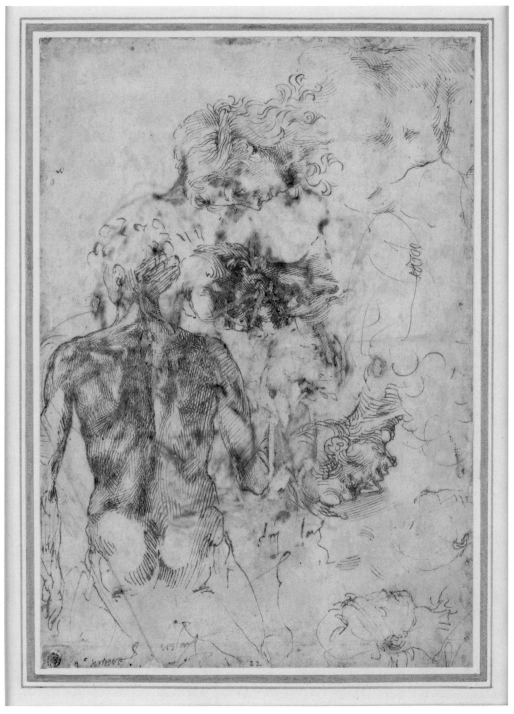

FIGURE 3: Michelangelo, nude studies, pen and ink,
256 x 173 mm (10 x 6.8 inches).

FIGURE 4: Alan Pascuzzi, copy after Michelangelo, pen and ink,
262 x 185 mm (10.3 x 7.2 inches).

classes in high school and college, I was required to use hard graphite pencils and conté crayons, which I never liked. But to learn the lessons of my master's drawings as faithfully as possible, it was absolutely necessary to use the same materials he had—with no exception. I began to draw with natural charcoal; I searched for a decent substitute for his red chalk and made a pen from a goose quill. The materials were not modern but ancient, and handling them led me step-by-step back in time as I drew. I had never formally worked with these materials before, but slowly, with each copy, my hand began to adapt to the natural and organic quality of the chalks, charcoal, and feather pen. This challenge thrust me into the world of anatomy, and I struggled to duplicate the complex poses of Michelangelo's figures. But, voraciously, I copied every drawing—from the seemingly insignificant pen sketches like his nude studies for the *David* (Figures 3 and 4) to his finest red chalk studies for one of the nudes on the Sistine Chapel (Figures 5 and 6).

As I worked on those first copies, it was obvious how much I didn't know and how hopeless and crazy it was to try to reproduce Michelangelo's drawings. Yet with each new copy, my grasp of how far I had to go increased—as Einstein observed, "as our circle of knowledge expands, so does the circumference of darkness surrounding it." There was so much I didn't understand: true anatomy, effective shading, composition, originality. My friends thought it was strange how I closed myself off to the world and began to draw every evening. They were alarmed when they entered my apartment, which was covered in sketches of arms, legs, torsos, and heads. My peers were all studying subjects that would propel them into future professions, but I had begun a fifteenth-century apprenticeship to learn to become a master. They were moving forward into the future; I was going back in time. Yet, although I struggled with each copy, with every one I finished, I felt I was slowly making progress, moving forward—or was it backward?—and finally learning something real. It was difficult and frustrating, but thanks to Michelangelo and Cennini,

I had opened the door and taken my first steps into the realm of mastery. I was content.

"SOME GRASP OF HIS STYLE AND OF HIS SPIRIT"

As I drew to learn as an artist, the art historian in me began to see various patterns and aspects of Michelangelo's drawings that became visible only through reproducing them. This called to mind what Cennini had written: "it will be against nature if you do not get some grasp of his style and of his spirit." I began copying not only to train myself but also to learn more about Michelangelo. The various idiosyncrasies of his style I observed in studying every line in order to copy it perfectly began to fit together like pieces of a puzzle, giving glimpses of his own artistic development. Every drawing, from the quickest pen sketches to the finished chalk studies, presented priceless clues to understanding Michelangelo.

As I developed artistically while copying his drawings, I realized that in my own limited way, my development paralleled his. Just as the apprentice Michelangelo had copied his master's drawings before becoming a master himself, I was now copying his as his apprentice. At first, I couldn't believe there was something new to discover: *This is Michelangelo*, I thought, *everything that can be known or discovered about him already has been*. With each study I copied, however, I began to see new links to his other studies, and even changes in the way he drew. It slowly became evident that I was not just observing his drawings externally as an art historian but internalizing them as an artist. It was as an artist that I was finding there was something fresh to discover. Based on what I was seeing, I slowly arrived at a conclusion: impossible as it seemed, I was looking at Michelangelo from the inside and perhaps had uncovered a new way to understand him. I couldn't tell anyone or even make it known in any way—no one would believe me. But I knew there was something real there.

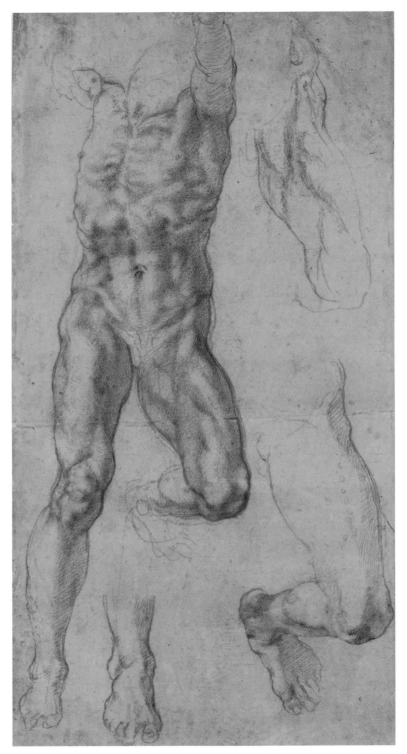

FIGURE 5: Michelangelo, study for Haman, red chalk,
406 x 207 mm, (15.9 x 8.1 inches).

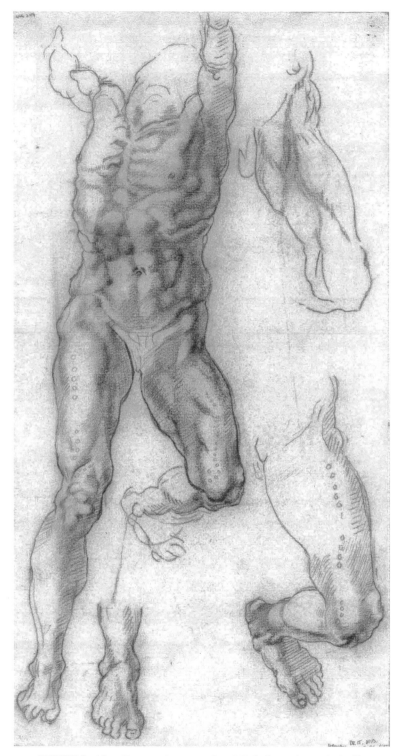

FIGURE 6: Alan Pascuzzi, copy after Michelangelo, red chalk,
406 x 207 mm (15.9 x 8.1 inches).

IN FLORENCE

In January 1992, I moved to Florence for one year to complete my master's degree. Living in the city where the Renaissance began was beyond a dream come true for many reasons. For one, I could now literally retrace Michelangelo's footsteps, drawing from the same things he had as a boy and then from the sculptures he made as a true master.

For the entire year, I became a "museum rat," drawing from his works in the Bargello, Accademia, Palazzo Vecchio, and Medici Chapels in San Lorenzo. I produced about two hundred drawings that consisted of copies and studies from Michelangelo's sculptures. At the end of my master's year, I organized an exhibition of my copies at the Villa Rossa, the site of Syracuse University in Florence. It was my first solo show ever and was called "An Artistic Study of Michelangelo's Drawings." I had spent more time copying the master's drawings than on my studies for my master's degree.

A PHD, AND ART VS. ART HISTORY

Upon finishing the degree, I realized I had to pursue this study on the doctoral level. I was accepted at Washington University in St. Louis, Missouri, and went on to study with an internationally known Michelangelo expert. I combined my artistic study with serious research on Michelangelo, delving thoroughly into his artistic formation. My professors were intrigued by my approach, but I could feel their suspicion that I was constructing a dangerous bridge between art history and art—two academic disciplines that were traditionally antithetical. I couldn't understand why here, like at so many other universities, there was such mutual distrust and aversion between art historians and artists. One without the other could never exist. At Washington University, the art and art history departments were in the same building, but the only time the art historians had any sustained contact with the art professors was when they got into arguments about who got the closest parking spots.

My fellow grad students researched from books and articles and used mainly art historical means to write their papers. I did the same for my own papers and presentations but also used artistic means such as copying and reconstructing artworks and wrote about how pieces were made and how the masters worked. Theory is important, but I was more interested in the practice and felt sure that art was part of art history. To some of my professors and fellow grad students, the way I used my copies to study Michelangelo made me seem like a frustrated artist falling back on art history as a profession. This bothered me, but I knew that an artistic means of study was unthinkable for many art historians because, in many cases, they simply do not draw, paint, or sculpt.

While finishing up my research and chasing grants to finance my writing, I took a chance and submitted my approach to Michelangelo drawings as a proposal for a Fulbright scholarship to Florence. A Fulbright to Italy, and especially to Florence, was one of the most prestigious grants an art historian could hope to receive, and thus extremely difficult to win; I remember that no one thought I would get it. Several months later I received a confirmation letter informing me that I had been awarded the Fulbright for the year 1995–1996. I waited one month before telling my professors.

FULBRIGHT SCHOLAR AND MICHELANGELO'S NEIGHBOR

Back in Florence in 1995 as a Fulbright scholar, I looked for an apartment and, after a few days, found a small place in Via dell'Anguillara, right by the basilica of Santa Croce. Via dell'Anguillara—"street of the eel"—is a curving street in one of the old medieval sections of the city. It winds from Piazza San Firenze to the Piazza Santa Croce, crossing over Via dei Bentaccordi. I loved the area and signed the contract quickly. The owner, Dr. Tendi, a refined, white-haired, old-school Florentine gentleman, asked me why I was in Florence. I told him I was researching Michelangelo's drawings. "You know that this apartment is right next door to where Michelangelo lived," he told me.

I had no idea. I needed to see for myself and quickly descended the ninety-four steps (my apartment was on the top floor) to the street and turned the corner onto Via dei Bentaccordi. Sure enough, fifty yards from the door of my apartment building, there was a plaque high on the wall that said, "*CASA dove MICHELANGIOLO BUONARROTI, Nato a Caprese nel Casentino Visse gli anni della sua giovinezza*" ("THE HOUSE where MICHELAN-GELO BUONARROTI, Born in the town of Caprese in the Casentino, Lived the years of his youth") (Figure 7).

This was where Michelangelo grew up, where he began learning to draw with Ghirlandaio, and where he drew, perhaps by candlelight, desiring to improve with every stroke. I would be living right next door! This could have been merely some amusing coincidence, but, being the romantic young man that I was, I took it to be a cosmic, auspicious sign about the prospects of my dissertation on his drawings. My attic apartment had a huge window that overlooked the roof of the house where he had lived. Through it, I had a clear view of the facade of the basilica of Santa Croce, where Michelangelo is buried. From my desk, I could see the basilica and the roof of his house at every hour of the day.

It was at that desk looking out at Santa Croce that I recopied many of his drawings. This time around, I was able to make even better copies, more authentically than before. I had searched and found the real, locally sourced materials used by Michelangelo—real goose-quill pens, iron-gall ink, natural black chalk, and natural *sanguigna*, or red chalk. I found all of these materials at the best art store on the face of the planet, Zecchi Colori in Via dello Studio, which is a stone's throw away from the Duomo of Florence. The Zecchi brothers had opened their store soon after the 1966 flood in Florence. Since restorers needed authentic materials to restore the thousands of paintings damaged by the flood, the Zecchi brothers, using Cennini's manual as their guide, recreated all the traditional materials, from rabbit ear glue to silverpoints, and provided them for restorers and

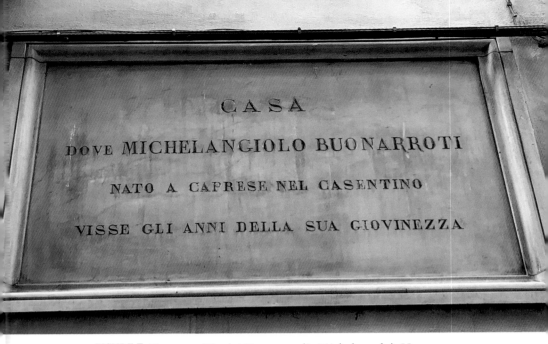

eventually artists. It is thanks to Zecchi's that I was able to find the authentic materials to make even more authentic copies.

Not only did I begin using the same materials as Michelangelo, but during the coming months I would also observe and draw from the originals and exact photographic facsimiles at the Gabinetto Disegni e Stampe degli Uffizi (room of prints and drawings) and Casa Buonarroti. After years of waiting, I had the opportunity to copy from and handle the actual drawings that Michelangelo himself had touched. During the last phase of my drawing research, I traveled to other European museums as well. I viewed and copied Michelangelo drawings in the Louvre in France and the Oxford Museum in England. The culmination of my travels to copy from original drawings was the British Museum in London, which houses the finest of Michelangelo's drawings, such as the studies he did in red chalk for the Sistine Chapel ceiling. It was there that my apprenticeship to Michelangelo took a dangerous turn—my Adam copy in the drawing

cabinet of British Museum (Figure 2). After years of copying, I understood anatomy and how Michelangelo manipulated it. I had gained a proficiency in his use of line and shading techniques. Most importantly, I had reconstructed his method of composition—and understood how to recreate it.

4

The World of Renaissance Drawings

RENAISSANCE DRAWINGS

I traveled to various museums in the United States and Europe to copy original Michelangelo drawings. This was not just research for my dissertation but also a type of artistic, almost archaeological hunt for pieces of a large puzzle that made me feel like an art historical Indiana Jones. Each of the museums I visited had separate "drawing rooms" that were not open to the public and were accessible only to scholars doing research on works of art on paper. In the drawing rooms of the Uffizi or the Louvre or British Museum, there was always a hushed, reverent, and scholarly silence. To enter a place like the Uffizi *gabinetto* (which literally means "cabinet" but here refers to a drawing room), where there are over a hundred thousand sheets from the greatest masters in the world, makes you feel special. The rooms are carefully designed to protect the drawings from termites, who like to munch on the paper, and from fires, which would be disastrous. They are also carefully guarded—they have to be. One of the few Michelangelo drawings still available—a study for a Risen Christ—came up for auction at Christie's in 2000 and sold for $12,378,500. Think of the Uffizi or British Museum, where there are dozens of them, and imagine

the value. To see the drawings and copy from them, I had to present a letter of reference from my professors attesting to my doctoral research, which necessitated that I view Michelangelo's drawings firsthand. I had no problems in the Louvre, the British Museum, or museums in the United States, where the staff was always polite and respectful. But I almost didn't get admitted to the Uffizi, where many of Michelangelo's most important drawings are held. When I presented my project, I was told flat out that I couldn't see the drawings. When I asked why, they replied, with typically baroque Italian bureaucratic logic, that I could only see the drawings if I had already published some sort of book or article on them. The problem with that, I explained, is that you cannot publish on the drawings if you haven't seen them! It was a perfect art historical catch-22. Luckily, at the time my professor, William Wallace, was in Florence for research, and I was able to have him come in and confirm that I was indeed legitimate and my copying was part of my research. Wallace is a well-known scholar with multiple publications on Michelangelo, so the director of the gabinetto took his word and reluctantly agreed to let me view the drawings. Though the director let me into the drawing room, at the beginning she didn't trust me. For the first few days, she sat in front of me and watched my every movement as I worked. You can imagine her concern over my handling millions of dollars' worth of drawings. Over the months that I was in the Uffizi, however, I earned her trust and respect. She soon saw that I was legitimate and eventually became a good friend.

There were always scholars with ties and white cotton gloves in these drawing rooms, carefully measuring master drawings with rulers. They would examine them through a jeweler's lens, which made me wonder what they were looking for that was so small. Every morning when I entered, everyone thought I must be a typical art historian ready to pull out my lens and ruler and begin measuring. When I started to take out my papers and chalks and set up a mini art studio and began to copy from the

drawings, I could feel their disdain and almost intellectual disgust. Heads would turn, and I knew that they were thinking: *What is that artist doing in this room?* I began to truly understand, while copying in the Uffizi, that I was working in a no-man's-land where artists and art historians feared to tread.

This became especially clear one day while I was copying a Filippino Lippi silverpoint drawing using a real silverpoint stylus. In the midst of my research on Michelangelo, I had decided that I needed to understand the technique of silverpoint drawings and to learn the drawing styles and methods of the period. Since I had already been granted permission to view Michelangelo's drawings, the director let me view and copy from the vast collection of silverpoint drawings from the late 1400s. I concentrated on those of Filippino Lippi, son of the painter Filippo Lippi. I tried to do everything according to the traditional technique as explained in Cennino Cennini's treatise. Using paper prepared with crushed bird bone, I drew with a stylus made of real silver. One day as I was copying a small drapery study by Lippi, I was asked by an art historian, who was writing on Lippi's silverpoint drawings, what I was using to copy. "It's a silverpoint. I am copying Lippi's drawing in the same material." She replied, "Oh, I have never seen one before. May I hold it?" "Of course," I told her. She then made a little stroke on my gray prepared paper and handed back my silverpoint. That brief incident was one small proof of the value of my approach, suggesting that there might be a way to bridge a gap between the two fields and offer a new way of researching all types of art.

"HE HAS THE BOOK": HEBBORN AND FORGERIES

Another curious incident happened not long after I began to copy Michelangelo's drawings in the Uffizi. I had purchased a new book by Eric Hebborn, an English artist who had had a fairly troubled childhood but was fortunate enough to able to develop his classic artistic skills in painting

and drawing to an extremely high level. Reaching his artistic maturity in the period of abstract expressionism, he was unable to make a mark for himself and instead turned to the "dark side" of art production—making and selling forgeries. His book, *The Art Forger's Handbook*, sold out in Florence in a matter of days. It was an incredible recipe book for how to forge paintings and, most importantly for me, how to forge drawings. Everyone was talking about it in Florentine art circles—he was fast becoming an artistic, albeit quasi-criminal, celebrity. For my part, I devoured the book in no time flat and started to experiment with the techniques, methods, and tricks Hebborn revealed there. They worked extremely well, and, following his instructions, I was able to produce drawings that simply looked old. Just months after he published the book and was still rocking the art historical world, Hebborn was found dead in the street in Rome under mysterious circumstances. To this day, no one is sure if the publication of the book is related to his death. Hebborn's forgeries had ruined many reputations in the art world, and perhaps *The Art Forger's Handbook* was the ultimate motivation for revenge.

One day after Hebborn's death, I decided to bring the book into the drawing cabinet of the Uffizi to use as a guide in executing some of the drawing techniques. As soon as I took it out and put it on the table next to me, an attendant named Massimo (who later would become a good friend) picked it up—his eyes wide open as if to say, *He has the book!*—and quickly ran with it to the director, who was still in her office. After a few minutes of sitting there wondering what this all meant, I watched as the director came out with the book in her hand. In a gentle and calm voice, she said, "We are not sure what you are doing with this book in here, but please be aware that this is fairly dangerous material. Please do not bring it back in here." She handed it back to me, then turned and left. *What's this all about?* I thought, perhaps naively. *It's only a book.* It may have been just a book, but it was a book on how to make forgeries, which I was in essence doing in sight of everyone. I realized I had entered into a

fascinating and mysterious realm of art forgery, which, in Florence, is a topic that many people are privy to but no one admits to knowing about.

Hebborn was an extremely sensitive topic in drawing rooms all over the world. He had sold hundreds of his works on paper to auction houses and museums—some of which were probably in the Uffizi as well. He had specialized in Rembrandt's bistre drawings but also must have forged numerous other Renaissance drawings that museums everywhere had acquired. This incident opened my eyes to the semi-risky nature of my enterprise and how I was unknowingly walking a fine line between research and forgery. I also began to understand a different aspect of the strange looks I received and everyone's mistrust and even fear of me copying old drawings so scrupulously. I have to admit, I secretly reveled in this newly acquired "dark" art historical aura. Years later when I was teaching in various American universities in Florence, I came in contact with someone who knew Hebborn personally. This person told me that Hebborn had a secret contact who was an expert on drawings and authenticated his works to get them sold to museums. I was shocked to learn that Hebborn's secret contact was the very professor who helped me get a permanent entrance card to the Uffizi drawing cabinet when I was in Florence studying for the first time in 1990. I had been in direct contact with Hebborn's main partner in crime and never knew it.

A PIECE OF HISTORY IN YOUR HANDS: PAPER AND DRAWINGS

Aside from my brush with the criminal art world, I was completely taken with my study of Michelangelo's drawings. When working from originals in various museums, I often stopped and said to myself, *Mamma mia, I'm copying from a drawing that's five hundred years old!* I also sometimes just stared at the drawings, admiring them for what they were—rare works of art—totally in awe. Unlike paintings and sculptures, which are finished works, Renaissance drawings offer a much more intimate view of an artist. You

can look at paintings and sculptures and appreciate them, but the master's hand is many times hidden by the finish of the work. By contrast, Renaissance drawings reveal the artist's hand in all of its immediacy. Drawings disclose more about the inner workings of the artist's mind than anything else. You can see the initial ideas for figures or compositions or appreciate the exquisite, surgeon-precise handling of the drawing tool.

Drawings have an almost mystical energy to them; the artist had to concentrate all of his passion and talent to create the marks on the paper, which in a sense retains the imprint of his or her soul. To view up close a drawing that was held by the master himself puts you in almost direct contact with him—you can imagine him making the marks on the paper with the pen or the chalk. On drawings, you can also see scribbles, writings, and even mistakes that make a person from centuries past come alive right in front of you. Handling old master drawings is also an experience—to hold and view a sheet of paper centuries old is magical—like holding a piece of history in your hand—and you have to be extremely careful at all times. You must always wear cotton gloves and never touch them with your bare hands so as not to damage or mark them.

Some sheets are so well preserved, the paper still so white, that they look as if they were just taken from the master's portfolio. This is because the paper of Renaissance drawings is amazingly resistant. In the Renaissance, the highest quality paper was made from linen and the lower quality paper from cotton or rags. The cloth-like paper is naturally acid-free and does not turn brown and brittle like some modern papers do.

Paper in the 1300s and early 1400s was produced in just a few cities in Italy, like Fabriano, and was fairly expensive. By the mid-1400s, however, paper began to be produced on a larger, more industrial scale in many cities, which dropped the price and made it more available. It is no coincidence that there is an abundance of drawings that survive from the mid-1400s on. The increased availability of paper had a real impact on artists and art production. I believe that one of the true reasons for the

Renaissance and general development of naturalistic art was that artists could draw and sketch freely from nature as much as they wanted, without having to worry about wasting valuable paper. Artists before the 1300s did not have this luxury. In many cases, all they had was parchment—animal skin—which was way too expensive to use for quick studies or experimental drawings.

Perhaps this is why art—that is, painting—had remained fairly static before then. Artists did not have the freedom to make preparatory or exploratory studies. Madonnas and other figures never really moved far beyond the Byzantine idiom, since artists were limited not only by tradition but also because they couldn't freely invent and refine new ideas. With the advent of cheap and available paper, they could make multiple drawings to figure out new solutions, which also allowed them to invent or modify their own style. This new freedom translated directly in their painting and thus manifested itself in a general artistic development—in other words, the Renaissance. It is no coincidence that the most significant developments in Renaissance art, such as the portrayal of anatomy, shadow, and composition, took place right after the industrialization of papermaking. The availability of paper also influenced the training of apprentices as it allowed them more opportunity to learn by making numerous drawings.

For new apprentices, paper was available only after they had learned the basics of drawing using other materials. Cennino Cennini mentions this in his treatise: since beginners weren't yet able to draw, they would only waste paper, so they weren't provided with it. Instead, they were given pieces of boxwood prepared with a crushed-bone powder emulsion (sometimes mixed with gum arabic or saliva), a piece of charcoal, and a feather. They were to draw with the friable charcoal on the white surface of the boxwood and then simply brush it off with the feather, since their first drawings were not good enough to keep, and repeat. It was the act of drawing that was important—not the final result. Michelangelo may have

done this when he entered Ghirlandaio's workshop. After the apprentices had learned the rudiments of line and shadow, they were finally given a sheet of paper, a pen, and ink with which to draw. By the time Michelangelo began to study to become an artist, he and all the other intermediate apprentices had the opportunity to use paper for their drawing exercises and the freedom to pursue, without major economic concerns, their own personal style.

Michelangelo's Early Apprenticeship

"I RECORD ON THIS DAY 6 MARCH 1474 WAS BORN A MALE CHILD GIVEN THE NAME MICHELAGNOLO."

Michelangelo was born on a Monday morning on March 6, 1475 (or 1474 according to the Florentine calendar, in which the new year began on March 25), in the small town of Caprese near Arezzo. His father, Lodovico, recorded the place and even the time of his birth (around 4 a.m.) in a handwritten document in the archives of the Casa Buonarroti in Florence. Soon after Michelangelo was born, his family—which consisted of his father, Lodovico, his mother, Francesca, and a brother sixteen months older than he—moved to Via dei Bentaccordi in Florence. The Buonarrotis had three more sons. But Francesca died suddenly in 1481, leaving Lodovico to raise five sons—a tremendous task for anyone. The death of his mother must have been traumatic for the six-year-old Michelangelo and his younger brothers, influencing them in ways only those who have suffered a loss of a parent at an early age can fathom.

Lodovico, like any father, was concerned about the well-being of his five sons and intent on having them choose secure professions where they could earn a decent living. On a more selfish level, he also had plans for

the reputation of the family as a whole. Michelangelo's grandfather had had a successful small-scale money-changing business that made the Buonarroti Simoni wealthy and fairly prominent. By the time Michelangelo was born, however, the family had lost its money and its social standing. This must have forced Michelangelo's father, who was too proud to do manual work, to maintain his family—and perhaps prop up his social status—by becoming a traveling administrator who served short terms in various town governments. While in Florence, Lodovico looked for professions for his sons that would regain some of the family wealth and status.

To understand what Lodovico faced in choosing a profession for his sons, it's worthwhile considering what Florentine society was like in the 1480s. When Michelangelo's family moved to Florence, they encountered a distinct class structure that had been in place even before Dante roamed the city in the 1300s. Florentine society consisted of four major levels: the aristocracy; the wealthy middle-class (known as the *popolo grasso*); the working class (*popolo*); and finally, the lowest rungs of society, beggars, thieves, and prostitutes. The understructure for this hierarchy were the guilds, or *arti*. The *arti* were associations of professions or trades. They had tremendous influence on all aspects of Florentine society, politically, socially, and culturally. There were seven major and fourteen minor guilds. The major guilds comprised the most prestigious, lucrative, and intellectual (i.e. white-collar) professions and were the economic powerhouses of the city. These included, for example, the wood merchants, bankers, doctors and apothecaries, and judges and notaries. The minor guilds consisted of more manual professions (like blue-collar professions today), such as the butchers, shoemakers, and blacksmiths, to name a few. The guilds were in essence the "work world" of the Florentines. Young boys coming of age could enter into these professions based on their wealth and social status or through a family connection with a guild. Not all professions were represented by a guild. Artists were associated with

two separate guilds: sculptors were connected with the stonecutters' guild, while painters were part of the apothecaries' guild, since they ground their pigments as the pharmacists did with their medicines.

When Michelangelo reached the age of around ten or eleven, according to Condivi's biography, his father, being the absolute ruler over his sons as was custom in this time, sent him to school to learn to read, write, and become familiar with math and calculations in order to become a notary in the judges' and notaries' guild. Lodovico seemed to have chosen this guild because it was the most prestigious and "white-collar" of all the guilds. It promised certain employment; since Dante's time in the 1300s in Florence there were upwards of six hundred notaries in the city. Lodovico clearly wanted his son to become an intellectual, with money and a high social position—everything the Buonarroti Simoni family had lost in the last century. Michelangelo dutifully followed his father's wishes, at least at first.

FATHER, I WANT TO BECOME . . . AN ARTIST

Both Condivi and Vasari agree that Michelangelo had the "impulse of a lofty spirit," a spirit that compelled him to study art. I can imagine the young student, bored and restless, doodling during his lessons, as we all have done. He was most likely unhappy. This changed through his friendship with Francesco Granacci, who lived next door. Granacci was several years older and already a student of the artist Domenico Ghirlandaio. Michelangelo must have been enthralled by and was perhaps envious of Granacci's freedom to become what he himself secretly desired to be. Condivi records that Michelangelo would skip his lessons and go with Granacci to Domenico's workshop. The *bottega*, or workshop, must have been filled with other boys of the same age drawing and painting and learning what he could not. Nothing is more frustrating for an artistically minded individual, and Michelangelo's desire to study art was so great

that, according to Condivi, Granacci provided him with drawings to copy. This would have been his first instruction in drafting. The day came when Michelangelo mustered the courage to tell his father he didn't wish to become a notary and preferred to study art. The fact that Michelangelo confronted his father on this matter signifies how strongly he felt in following his heart and his passions—it was a courageous declaration of identity. But for Ludovico, choosing the life of an artist was no better than becoming a craftsman or common laborer.

According to Vasari, the young Michelangelo was "beaten" by his uncles to try to force him to forget his "natural impulses" and continue his study of letters. Yet Michelangelo resisted the pressure and the beating, and somehow convinced his father to accept his choice.

What may have convinced Lodovico was Michelangelo's choice of the prestigious Ghirlandaio workshop, which promised some financial return for his father. The Renaissance workshop was a thriving painting firm, which provided for all aspects of an apprentice's education and well-being. Usually, a young art apprentice who went to study in a bottega was sent to live with the master. In addition to being given a place to stay, the apprentice would be fed and clothed by the master while learning the craft of art. Apprentices could be unpaid or paid depending on their ability. A typical apprenticeship lasted five or six years, but for more experienced or talented apprentices the duration may have been shorter and the apprentice may have been paid. This was probably the case for Michelangelo. He was older than most of the boys in the workshop and may have already demonstrated some artistic skill, with the help of his friend Granacci. Nevertheless, Michelangelo had to begin his apprenticeship at the same level as the other, younger apprentices and follow his master Ghirlandaio's training as they did.

Lodovico drafted the contract between his son and Ghirlandaio, making sure, in particular, that he—Michelangelo and therefore Lodovico—was to be paid for his time in the workshop. Besides this contract, there is

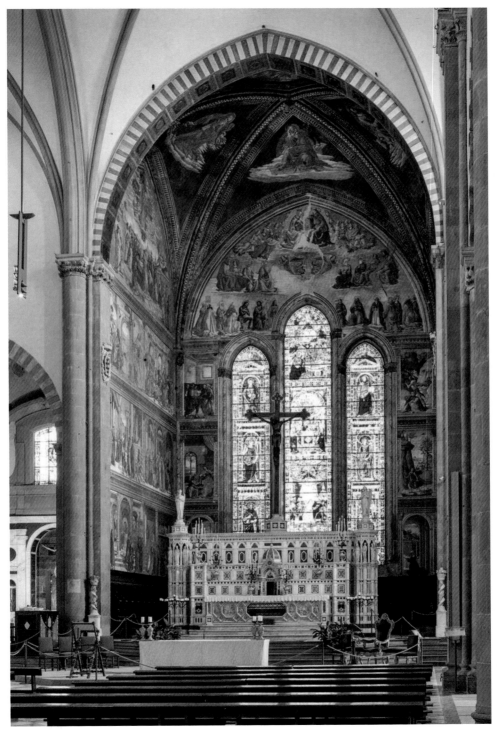

FIGURE 8: View of Tornabuoni Chapel, Church of Santa Maria Novella, Florence.

one other piece of evidence supporting Michelangelo's apprenticeship. Discovered by chance, a document from 1487 mentions Michelangelo as having been sent to pick up a payment to Ghirlandaio for an altarpiece for the chapel of the Ospedale degli Innocenti (Hospital of the Innocents) in Florence. The payment of June 28, 1487, written in Ghirlandaio's hand reads:

> *Domenico di Tomaso del Ghirlandaio is debited on this day the 28th of June 1487 three large florins, taken by Michelangelo di Lodovico, in 17 lire, 8 soldi piccioli di quattrini.*

From an art historical standpoint, this is extremely important, for it supports the account given by Vasari. Based on this evidence, we can now attempt to reconstruct Michelangelo's initial art instruction under Ghirlandaio.

GHIRLANDAIO'S WORKSHOP

The Ghirlandaio workshop was one of the most prestigious in all of Florence, and Michelangelo was extremely fortunate to have entered it. It was run by the master, Domenico, and his business associate and brother, David. Domenico Ghirlandaio was a brilliant draftsman and an accomplished fresco artist. His skill and his well-organized workshop produced the most complex and beautiful frescoes in the city, such as the Tornabuoni Chapel in Santa Maria Novella (Figure 8). Domenico was a master of creating complex scenes in perfect linear perspective with numerous figures and portraits. He was so confident of his abilities that he often put his own likeness in his paintings as his proud signature, as seen, for example, at far right in the fresco of the *Expulsion of Joachim* in the Tornabuoni Chapel in Santa Maria Novella (Figure 9). The Ghirlandaios were extremely well connected with the Florentine elite and worked for many

of the most important families in the city, including the Tornabuoni, Sassetti, and Medici. In the early 1480s, it was Lorenzo de' Medici himself who sent Ghirlandaio, along with other artists, to Rome to help decorate the Sistine Chapel.

Ghirlandaio the artist was organized, disciplined, and firmly established in the traditional methods of art practice. He was a traditionalist in the way he taught his apprentices too. It is important to remember that studying to be a painter in the 1400s was totally different than our modern concept of art school. For young apprentices, the workshop was a vocational school. They were there to learn a valid profession that they would carry on for the rest of their lives. The master was their professor and mentor. He would guide them like a father figure until they were ready to leave, start their own workshop, get commissions, and take on apprentices of their own, thus repeating the cycle. Unlike being an art major today, a Renaissance apprenticeship prepared you for future work earning your livelihood as an artist. Artists had a role in society, and people paid them for doing art—incredible as it may seem.

What did the average apprentice learn in the workshops like Ghirlandaio's? Cennini gives us a quick rundown of what Michelangelo was supposed to learn in his studies. He writes that the apprentice has to learn the "basis of the profession," that is, to draw and paint. But apprentices must also know the craft of art and must learn "how to apply size to grind [pigments] . . . to put on cloth, to gesso . . . to gild . . . to plaster . . . to draw and [how] to paint in fresco."

In essence, young boys were instructed on how to grind pigments and make brushes, ink, and paint. They also must have been instructed on how to prepare glue, decorate frames, prepare panels with rabbit ear glue and gesso for painting, tint papers for drawings, make silverpoints, prepare charcoal sticks, make pens from feathers, and use transfer drawings. This was the craft side of art production, which was almost as important as the artistic aspects of learning to draw and paint. Unlike today, when

artists buy all of their materials, Renaissance apprentices became invested in their works from the very beginning by making their own brushes, tinting paper, and grinding their own pigments.

When I taught traditional art courses at the university level, I too would have my students make their own tools like silverpoints and feather pens, and even prepare their own papers with colored tints. Since many of my students were non–art majors who had no experience with art materials and felt uncertain using them (which was understandable), this craft approach served to familiarize them with the tools, which then felt less "threatening." Once familiar with their tools, they didn't hesitate to use them, for they were "in control" over what they had themselves made. Making your tools or working with the materials before actually jumping in to make art—just as was done in the Renaissance workshop—is a rational and natural way of easing into the profession of making art.

In addition to familiarizing themselves with art tools and techniques, apprentices were assigned simple but vital jobs around the workshop, like cleaning up after a day's work or becoming the servant of others. The document of 1487 provides one example of this, for it records the young Michelangelo being sent on an errand to pick up the payment for his master.

The apprentices who endured the initial period of manual labor and servitude and were still eager to learn were given the opportunity to begin formally learning how to draw. While still performing menial tasks—grinding and such—the apprentices spent their free time observing and drawing on their own. In the general hierarchy of the workshop, the young apprentices were probably not directly instructed by the master, who was occupied with the creative tasks of designing and executing commissions. The actual art instruction was done by the older, more experienced apprentices, who were expected to supervise the younger *allievi* (students) in their formal drawing exercises. The master probably occasionally visited the young apprentices to fulfill his responsibility as

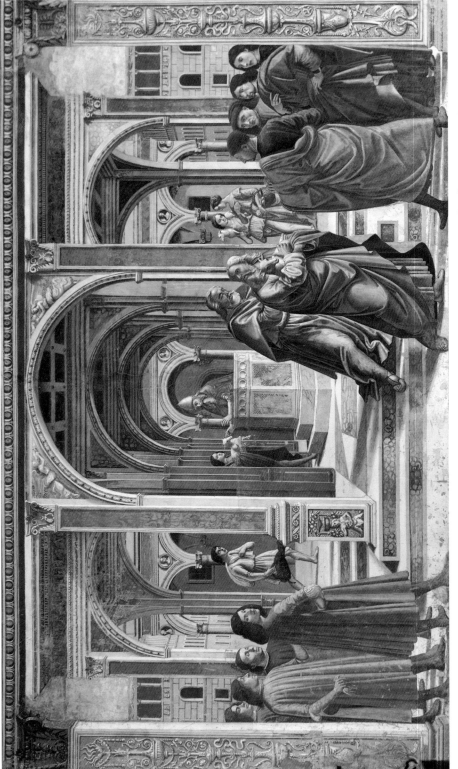

FIGURE 9: Ghirlandaio, *Expulsion of Joachim*, Tornabuoni Chapel, Santa Maria Novella, fresco, 1485–90. Domenico Ghirlandaio, Michelangelo's master, is figure at far right with red cloak pointing to himself.

the overseer of their professional training and to determine who was particularly skilled and might become a future valued assistant.

MICHELANGELO LEARNING TO DRAW: CENNINI AND THE THREE STAGES

The treatises by Cennino Cennini and Leon Battista Alberti outline a didactic method of instructing young apprentices that was standard in all Renaissance workshops, and together they give us clear examples of how apprentices like Michelangelo learned to draw. The traditional sequence consisted of three basic stages. In the first stage, the young boys began by copying drawings, and then drawing from paintings to acquire the initial facility in drawing two-dimensional forms through simple lines. The second stage involved copying from sculptures to learn how to draw volume and shade three-dimensional objects. Finally, the more experienced and older apprentices moved to the third stage, which was drawing directly from the live nude model to study anatomy and the clothed model to study drapery. Once drawing had been mastered in these first three stages, the boy who was by now an intermediate/advanced apprentice, was skilled enough technically and manually to graduate to learning how to paint in fresco and egg tempera.

Based on standard Renaissance practice, Michelangelo's first drawing exercises were probably simple charcoal sketches on prepared boxwood and brushed off with a feather. Beginning apprentices were not good enough to use paper, as explained in chapter three. After this trial period of getting used to drawing, apprentices began their first formal drawing exercises, copying from simple shapes and recognizable forms with pen and ink on paper. These initial drawing exercises were based on the practice of copying or simply reproducing a given subject as accurately as possible. Copying was the fundamental exercise in Renaissance art education, and all had to apply themselves in first learning how to copy

everything the master gave them. Apprentices had to learn the basics before they undertook something original.

Among the first things beginning apprentices were given to copy were images from the pages of model books and pattern books. Model books were an essential tool in most Renaissance workshops and used by apprentices and masters alike. They were usually bound volumes of parchment sheets with highly finished drawings, often in color, of animals, figures, plants, ancient architecture and sculpture, and ancient decorative motifs. Pattern books were collections of drawings by the master and his advanced apprentices of figures and drapery studies. Beginning apprentices utilized model books in the first stages of their artistic education. Animal studies in model books were normally drawn two or three to a sheet, isolated and not overlapped, and seen in strict profile or directly head on. The forms of the individual figures were distinct and emphasized by precise and easily comprehended contour lines. They were largely a carry-over from the early Renaissance, when artists who had to fill up space in large paintings used the model books as a source for ideas. Any image of an animal in early Renaissance paintings, like the dog found in Gentile Fabriano's *Adoration of the Magi* in the Uffizi in Florence, was most likely copied from a model book.

When I first started copying Michelangelo's drawings to learn how to draw, in essence I used his studies as my model book. I let my eye and hand be guided by the master to familiarize myself with the mechanics of line and form and understand how to render anatomy and shadow. With each drawing I copied, my hand became more accustomed to making the correct movements and reproducing what I was seeing. This has to be experienced to understand it. It is a passive type of learning in which you leave your own personal (and sometimes inaccurate or untrained) artistic impulses behind and concentrate on developing the mechanical connection between analyzing the form, understanding it completely, and then drawing what you see accurately. I would sometimes tell my students to

look at "what" (i.e., the object) they were drawing more than their own drawing itself to gain as much visual information in their heads. In doing this, they would be more able to reproduce the object accurately. If you look more at your own drawing (i.e., the piece of paper) than what you're drawing, then you begin to draw what you "think" you see, which is going to be was distorted by your artistic impulses and your received notions about how the object should look. In many cases, this will be inaccurate. The skill of looking and recording accurately what you see was the very basis of Renaissance art and masters. Ghirlandaio understood that the initial hurdle for beginning apprentices was to acquire the simple skill of looking, seeing, and drawing accurately. Copying simple forms from model books that were easily understood by young boys was the way to achieve this. Once an apprentice had mastered this basic skill, he could build on it. He would advance to copying more complex forms, usually drawings by the master himself.

THE EARLY DRAWINGS AND THE "MICHELANGELO FACTOR"

Do any early drawings by Michelangelo survive to show this first stage in his traditional artistic training? The most important goal of my study was to locate and determine the earliest drawings Michelangelo executed in order to establish his starting point as an apprentice. This would provide some sense of his initial ability and eventual progression. The first drawings of any artist done as a child are a good indicator of just how much natural talent he or she has. In Michelangelo's case, I had to determine his earliest drawings stylistically by copying them. Once identified, they could be compared to the standard artistic practice of the time and reconciled with his contemporaneous biographers' conflicting accounts of his artistic beginnings. I realized, too, that I would have to account for one final factor: Michelangelo's desire to control his legacy and construct our perceived image of his early beginnings, which I call the "Michelangelo

factor." As is demonstrated by Condivi's biography, Michelangelo was determined to leave a record of himself as a precocious boy genius with no formal training. The story about Michelangelo as an old man purposely burning piles of his drawings and saving only those he wanted to leave for posterity also suggested how difficult it would be to find drawings surviving from his time as a novice apprentice.

COPYING FROM MODEL BOOKS: LIONS AND DOGS AND AN EAGLE

Amazingly, there is such a drawing in the Albertina Museum in Vienna (Figure 10). It is generally accepted to be one of Michelangelo's earliest works on paper. The fact that we have such a sheet is truly remarkable, for it had to survive his many travels, and be kept by the master until he died at age eighty-nine. That he saved it for so long probably signifies that it held some special significance to him.

The Albertina sheet would have been executed when Michelangelo was just beginning to learn how to draw—when he was approximately thirteen years of age. The sheet of paper is large, about 12 x 16 inches (30 x 40 centimeters). Based on the style of the drawings, it was probably one of the first times the boy Michelangelo was deemed good enough by his master to be given a sheet of paper to make studies to keep. This makes the sheet a remarkable piece of evidence of his early studies.

The contents of the sheet are also telling: in the center, a lion that stares out directly at us; on either side are lionesses, one seen full face, the other in profile attacking another animal. Above these three main studies are three other lion heads, the head of a dog, and the head of an eagle. In the lower half of the sheet are sketches of two torsos; one seen from behind, showing the lower back and gluteals, while the other is of the front view of the upper chest with the head looking up, which may be somehow interacting with the figure above. In the upper right are various writings: the top one added by Michelangelo and the smaller script below by an

FIGURE 10: Michelangelo, animal copy drawing, pen and ink, 273 x 378 mm (10.7 x 14.8 inches).

unknown hand. Strangely, there is a small, perfectly complete drawing of the *Bacchus* sculpture that Michelangelo executed in 1496–1497 in Rome, and in the lower right corner a sketch for Pope Julius's tomb, a commission he began in 1505 but wouldn't finish until 1545.

The Albertina sheet reveals much about Michelangelo's initial training. The way the animals are drawn resembles the standard format and characteristics of Renaissance model books (Figure 11). All of the animals are shown in individual studies, as they were depicted in model books like this one, in profile (the lion head at top-center, the attacking lioness at right, and the eagle head at top) or frontally (the lion in the middle and lioness at left that stare out at us). One can imagine the thirteen-year-old boy carefully copying these images as part of his first exercises.

Yes, Michelangelo began his apprenticeship as anyone else would have in his day—by copying animals. When I studied this drawing and then copied it using a feather pen—as Michelangelo did—I noticed that the shapes were simple and direct and that they allowed me to concentrate on the contours. There is hardly any shading or volume, just shapes. Copying the sheet took me back to the basics of concentrating on the lines. In reproducing the placement of the animals, I noticed how the sheet was composed, which allowed me to reconstruct the sequence of execution. It is usually natural to begin in the center of a sheet, as Michelangelo probably did, with the lion that stares out directly at us. The boy then most likely began drawing around this first copy in the open areas in the sheet. The attacking lioness at right was next and is fairly complete. The lion at left was drawn at a larger scale but still was done carefully, so as not to overlap with the other drawings. After a substantial amount of time making these meticulous copies, Michelangelo used the upper section to do smaller drawings of the eagle, dog, and other lions—always taking care not to overlap.

Perhaps the most interesting sketches on the sheet are the two torsos at the bottom of Figure 10, which were drawn by turning the sheet vertically.

FIGURE II: Anonymous Florentine, model book drawing of animals, pen, and bistre wash, 182 x 155 mm (7.1 x 6.1 inches).

When we think of the perfect anatomy of the *David* or other muscular figures Michelangelo created throughout his career, we don't often wonder how he began learning to execute realistic human anatomy—but these two little torsos are probably some of the first he did. The figures show an unsure, even naive, rendering of anatomy—fitting for a thirteen-year-old boy, however gifted. The forms are less distinct than the lions', and several contours are heavy and thick, as if gone over several times to correct them. Through copying, I noticed that the manner in which Michelangelo placed the pen lines on the torsos is much more haphazard than for those of the lions. This was due to his closely following the model book image. The semi-correct arrangement of the muscles suggests that they were perhaps drawn from memory based on his passion for, and desire to learn to draw, the human figure. The desire to draw the human figure is evident; the precision is lacking. What is most intriguing is the almost humorous vulgarity of the placement of the upturned head close to the genitals of the other figure seen from the back. The proximity of these two figures might fuel some art historical psychosexual, homoerotic interpretation, but I believe it simply demonstrates a typically scatological sense of humor among the Florentine youths in the workshop and nothing else.

The small drawings of the *Bacchus* (top left) and the tomb of Pope Julius II (bottom right) have caused the most trouble for art historians in their desire to date the sheet. Both of these small sketches were done well after the animal drawings. They were probably made when Michelangelo was in Rome on two separate occasions, working on the two different commissions mentioned above. The small but complete sketch of his sculpture of the *Bacchus* probably dates to 1496—the same year he executed that work. The small drawing of the Julius tomb is dated to around 1505, when Michelangelo was in Rome working for Pope Julius II. Some art historians have dated the entire sheet to 1496 based on the *Bacchus* drawing. I find this difficult to accept, since these two small drawings show a

more skilled handling of the pen, with secure, perfect contour lines and an articulation of anatomy and composition that is in direct contrast to the more basic torsos and animals on the rest of the sheet.

The only plausible explanation for both the sheet's survival of Michelangelo's purging of his earlier works and the differing levels of artistic skill is that it was of particular value to Michelangelo. He kept it with him, and, when he needed, used it to make impromptu small drawings for his later works during his travels, which he did in the only open areas, the corners.

MICHELANGELO'S GROWING ABILITIES AND DOMENICO'S ENVY

The Albertina sheet is the only surviving example of Michelangelo copying from model books. It demonstrates that, as part of his earliest studies, Michelangelo copied from these books like any other apprentice to learn line and form. In the workshop sequence of art training, after the apprentices learned basic drawing skills, they were given more challenging things to copy. The more complex subjects could have been pattern books. These were books of drawings of figures done by the master and more experienced apprentices. Other subjects were sketchbooks with drawings done only by the master himself, or from prints from other artists from northern countries. Florentine artists, Ghirlandaio included, were astounded at the realism and detail of northern painting when the first examples arrived in the city, such as the Hugo van der Goes *Portinari Altarpiece*, which is in the Uffizi gallery. In addition to paintings, prints from northern artists like Martin Schongauer were also circulating in the workshops and were collected and shown as examples of "good" or masterful drawing.

There is no paper trail of Michelangelo copying from pattern books, Ghirlandaio's sketchbooks, or such exemplars from northern Europe. However, we do have literary evidence of him advancing in his early

studies. It can be found in Condivi's and Vasari's biographies and the stories of Michelangelo's artistic beginnings. Although neither Condivi nor Vasari provide details of Michelangelo's apprenticeship or, in the case of Condivi, even formally acknowledges it, both biographers claim that Ghirlandaio was constantly amazed at the young boy's skill.

Condivi recounts the story of Michelangelo copying a print of *The Temptation of Saint Anthony* by the German artist Martin Schongauer, which was given to him by his friend Granacci. According to Condivi, Michelangelo "composed [rendered] it in such a way . . . that it aroused wonder in anyone who saw it." Michelangelo's copy of Schongauer's print also "aroused jealousy in Domenico [Ghirlandaio], the most esteemed painter of that time."

Vasari also relates Ghirlandaio's envy in his biography of Michelangelo, writing that Michelangelo showed so much skill that "Domenico was amazed" and that Michelangelo not only surpassed his other disciples "but also equaled himself, who was the master."

Condivi says that Ghirlandaio's envy grew when one day Michelangelo asked him for a sketchbook of his in which there were "shepherds with their sheep and dogs, landscapes, buildings, ruins, and such things." Ghirlandaio, already feeling threatened by the prodigy, refused and "was not willing to lend it to him."

The "sketchbook" that Condivi mentions (in other words, which Michelangelo recalled for Condivi's biography) is most likely a model book. Some art historians think it was the *Codex Escurialensis* that Ghirlandaio had in his workshop. Ghirlandaio is known to have put together numerous studies of various ruins and things in Rome while painting in the Sistine Chapel in the 1480s. Since photography didn't exist for recording imagery, the codex provided priceless documentation in drawings of Roman decorative motifs and also figures from sarcophagi. Roman motifs were precisely what Ghirlandaio's clients in Florence wanted in the works

they commissioned from him. As in the workshops of other Quattrocento Florentine masters, Ghirlandaio used the codex, along with other model books, his own drawings, and other artists' sketches as a ready collection of stock motifs available for paintings and for teaching young apprentices, but these sources were extremely valuable and undoubtedly handled with care. Condivi's story of Ghirlandaio's refusal to lend the precocious Michelangelo the book of drawings out of envy may simply be invented or exaggerated. If true, and the sketchbook was the codex, it seems probable that Ghirlandaio didn't want to lend it to the boy simply because it was far too valuable for a young apprentice's fumbling hands, or again, possibly because Michelangelo was not yet his contracted apprentice when he asked for it.

DOMENICO'S ENVY: SILVERPOINT, AND MICHELANGELO DRAWING FROM (AND FORGING!) GHIRLANDAIO'S OWN DRAWINGS

Like other apprentices who had made progress in drawing, the young Michelangelo was probably given Ghirlandaio's studies in silverpoint, pen and ink, and black chalk for his own artworks to copy in order to learn the fundamentals of representing the human figure and faces. Being the traditional artist, Ghirlandaio had a set approach to executing studies for his paintings. This consisted of first doing quick idea sketches for large compositions. After finalizing the placement of the figures, he would study each element with care. This consisted of executing detailed drapery studies from dressed mannequins and portrait studies from life in silverpoint, pen and ink, or black chalk (Figures 12 and 13). He would have had hundreds of his own studies in the workshop, which were available for worthy apprentices to copy from. Cennini states that the first drawing tool that apprentices were allowed to use was silverpoint and the first drawings of the master the young boys were allowed to copy from were studies in silverpoint.

DRAWING IN SILVERPOINT

Silverpoint is what it sounds like—a stylus or drawing instrument with a point of silver. The paper for silverpoint is prepared with crushed bone meal (usually chicken bones) and a binder (gum arabic, spittle, or the white of an egg). The bone meal emulsion was usually colored by adding various pigments (gray, pink, or yellow were the colors most used in the Renaissance) and brushed onto a piece of paper and left to dry. The emulsion creates a microfine sandpaper-like surface. When a silverpoint is dragged across this surface, it leaves a mark that cannot be erased (Figure 14). The point of a silverpoint is fairly sharp and allows for thin, precise lines but can also be used for delicate shading. Silverpoint was the most precise drawing technique available to artists for their studies for paintings, and from the advent of paper in the 1430s, they used it primarily to execute portrait and drapery studies.

Beginning apprentices were given silverpoint early in their studies to make copies of their master's drawings. Later, they would use silverpoint to execute figure studies or drapery studies from a model in the studio. They would likely struggle at first with the sharpness of the tool and with putting on highlights, as described below. Cennini gives precise advice on how to execute a silverpoint drawing, which is usually done as follows: first the paper must be prepared, which takes a craftsman's knowledge of how to mix the bone meal, binder, and tint and spread it evenly on the paper. Since silverpoint lines cannot be erased, the artist makes the first sketch on the prepared paper with the more forgiving material of charcoal, just as he would when working with pen and ink. Any mistakes are removed with a feather and redrawn until the contours and shadow areas are correctly indicated. After gently brushing the dark charcoal lines away leaving a faint gray line as a guide, the artist draws the contours directly over them with the sharp silverpoint. The faint charcoal lines are then completely brushed away with a feather leaving only the silverpoint lines, which are permanently fixed to the paper. This is the little trick that

FIGURE 12: Domenico Ghirlandaio drapery study, pen and ink,
219 x 168 mm (8.6 x 6.6 inches).

FIGURE 13: Domenico Ghirlandaio, head study, black chalk with white highlights, 345 x 220 mm (13.5 x 8.6 inches).

FIGURE 14: Illustration of drawing in silverpoint. Charcoal, feather to brush away charcoal drawing, silverpoint, drawing with sequence of execution.

Renaissance draftsmen used to hide their preliminary sketch in charcoal—by brushing it away once it was established in silverpoint. After the initial contour lines are drawn in, the shaded areas are rendered by plying lines, or by pressing on the point and moving it in a tight circular motion to build up the dark areas. The cold, hard silver sometimes emits a squeaking noise when it is pressed hard to make the shadows. The final stage to complete the drawing is the application of white highlights, usually done with *biacca*, a mixture of white lead and a binder (gum arabic) that was applied with a fine brush.

Drawing on tinted paper is not easy and requires the sensibility to combine the dark and middle tones with the highlights in such a way that together they create volumetric forms. If done correctly, silverpoint can produce delicate drawings with subtle tones of gray, which are enhanced by the various pigments used to tint the preparation. The technique, however, is extremely meticulous, as all shading has to be built up carefully so as not to make mistakes. The drawings are usually quite small and require hours to produce.

There are thousands of apprentice silverpoint studies on tinted paper in the Uffizi, dating to the exact time Michelangelo was an apprentice. Many of them show an apprentice modeling for the other students (Figure 21). It seems the practice was that each took turns standing in front of the others, either dressed or partially undressed or perhaps with a cloak. While copying Michelangelo's drawings in the Uffizi, I became fascinated by these apprentice studies. I began to do a parallel study of them and copy all the drawings from the various workshops contemporary with Michelangelo's stint with Ghirlandaio. I copied drapery studies from Lorenzo di Credi (which are some of the most beautiful ever done) as well as life drawings and drapery studies from Filippino Lippi (full of nervous energy). I also concentrated on the studies done in the workshop of Ghirlandaio and drawings from the master himself (Figure 22). As I was executing these works, it dawned on me that they are all extremely rigid and stiff,

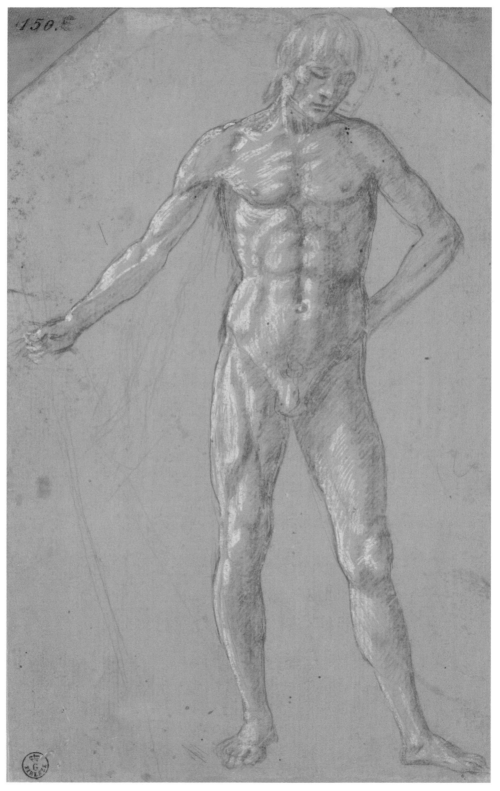

FIGURE 21: Filippino Lippi (Workshop), male nude, silverpoint on blue-gray paper with highlights, 252 x 158 mm (9.9 x 6.2 inches).

even predictable. As I would finish a copy, I was satisfied with its aesthetic beauty—the silver and the tinted paper with the highlights—but they moved no ground and repeated the same forms using standardized methods and techniques. Condivi writes that after being given a Ghirlandaio head study to copy, Michelangelo rendered it—most likely in silverpoint—so precisely that he put it back in his master's portfolio in place of the original. According to the story, "at first the owner [Ghirlandaio] did not detect the deception." Ghirlandaio was said to have discovered the switch only when he overheard Michelangelo telling a friend (which must have been Granacci), and laughing about it. We can imagine the fury of the duped master.

Vasari also mentions this use of model books and other drawings and writes that Michelangelo copied from the hands of many old masters so well that "the copies could not be distinguished from the originals." Vasari also reports Michelangelo's foray into the world of forgeries. He writes that Michelangelo "tinged" his copies to give them "an appearance of age with smoke and other things" to make them look old so that they were indistinguishable from the originals. Yes, Michelangelo forged drawings. He may not have made money from them, but he passed off his copies as originals. From personal experience, I would say this delineates a natural progression in the act of copying as a method of learning. Once you've mastered copying what is on the sheet, you move on to creating a complete reproduction of the object—even to the point of tinting the paper to make it look old. When you get so good at it that you want to fool people—who can resist such a temptation?

These stories from Condivi and Vasari tell us a number of things about Michelangelo in Ghirlandaio's workshop. First, the young Michelangelo copied from drawings by Ghirlandaio himself. Second, Michelangelo's skill was such that his copies were exact enough to be mistaken for the originals. Sharing such anecdotes—assuming the original source was Michelangelo— was a good way for the artist to leave a record of his precocious genius.

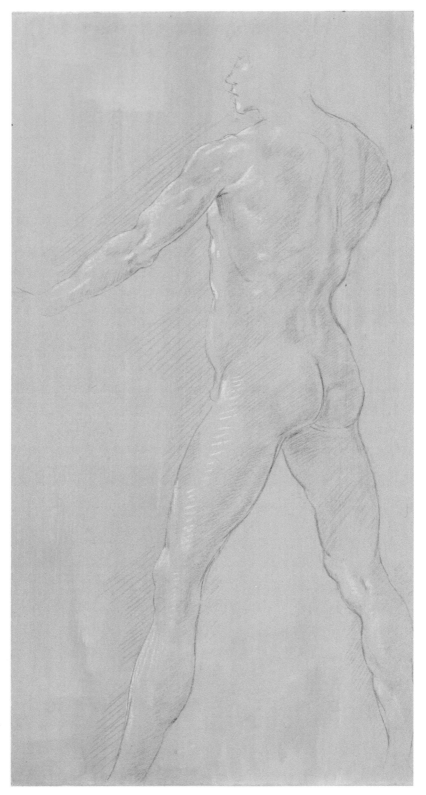

FIGURE 22: Alan Pascuzzi, copy of study of male nude by Francesco Granacci, silverpoint with white highlights on pink prepared paper, 299 x 156 mm (11.7 x 6.1 inches).

Regardless, they also attest that he learned by copying from his master, part of the standard sequence of study in a Renaissance workshop.

Michelangelo's copying of Ghirlandaio's drawings also demonstrates the overall goal of the apprenticeship method of art instruction. Masters like Ghirlandaio took on apprentices to teach them to draw and paint by having them learn the basic characteristics of their own style. This served two purposes: the master fulfilled his duty to teach his students how to draw and paint as stipulated in the apprenticeship contract, but also, as assistants learned the master's style, they could eventually assist him on commissions. With his numerous skilled apprentices helping him, the master could undertake large commissions and maintain a stylistically consistent appearance in his works. This was important not only aesthetically but also economically, for it meant that the master could take on multiple commissions and have skilled apprentices who painted like him work on them. His workshop could finish pieces without his direct intervention, allowing for a greater volume of income-generating work. This practice has caused many problems for today's art dealers and art historians, who sometimes have to determine what is by the master and what is by "his school."

DOMENICO'S ENVY: MICHELANGELO DRAWING FROM LIFE

Vasari gives further evidence of Michelangelo as an apprentice given progressively more challenging things to draw. According to him, when Ghirlandaio was painting the chapel of the high altar in Santa Maria Novella, the young Michelangelo "set himself to draw" the scaffolding, trestles, and various utensils used by Ghirlandaio to fresco the chapel, along with the apprentices who were working with him. When Domenico came down from the scaffolding to check what the boy was doing, he saw the complex and involved drawing and exclaimed, "This boy knows more than I do."

The notion that Michelangelo was lurking in the church by chance with his drawing board and pen and ink and jumped out to draw the scaffolding and Ghirlandaio's apprentices is highly suspect. In reality, like the other apprentices, Michelangelo would have been at the church because he followed Ghirlandaio to the worksite. The Tornabuoni chapel in Santa Maria Novella was one of the largest fresco cycles ever painted in Florence and one of Ghirlandaio's most important commissions. His patron, Giovanni Tornabuoni, was not only a wealthy banker but also the brother of Lucrezia Tornabuoni—who was the wife of Piero de' Medici and mother of Lorenzo the Magnificent himself. Giovanni, therefore, was Lorenzo the Magnificent's uncle. Painting the frescoes for the Tornabuoni chapel was an extremely prestigious commission that required the help of the entire workshop. In the chapel, there are hundreds of square meters of frescoed scenes with architecture, landscapes, and dozens of draped female and male figures. The beginning apprentices would have had to assist the master and his more advanced assistants as they painted. In addition, assisting in such a huge project was a prime opportunity to observe how to fresco, use cartoons, and organize a worksite. Scaffolding had to be built to reach the ceiling—some four stories high—mortar had to be mixed, pigments had to be ground, and all the materials had to be brought into the church. For the apprentices, this was on-the-job training.

Vasari's story illustrates Ghirlandaio's role as a master artist and educator: using his apprentices to execute his works but always making sure that they continued drawing as part of their studies. A break in work probably gave the pupils an opportunity to draw. To keep his boys out of mischief, Ghirlandaio might have given them an involved drawing of the chapel to execute. To draw the entire chapel with the scaffolding and the other, more advanced apprentices on the wall was a true challenge. The composition required drawing some sort of perspective, anatomy, and also details of the various utensils used by artists in painting frescoes such as buckets,

tables, drawings, etc. When Domenico returned, he naturally looked over the students' work. The contention that Domenico exclaimed that Michelangelo knew more than he is also fairly suspect. But, recognizing a good drawing, he may well have complimented the young Michelangelo on his developing skills.

When explaining the frescoes in Santa Maria Novella to tourists, many guides are quick to point out two nude figures in the frescoes and declare, "Do you see that nude figure? See the muscles and the force? It was done by the boy Michelangelo when he was only thirteen years of age—already a master." While teaching art in Florence, I often brought my students to copy from the frescoes in the chapel. After hearing of the "mastery" of the boy Michelangelo countless times, I finally took it upon myself to correct any guide who uttered this bogus claim. At the age he was, Michelangelo wouldn't have been allowed even to pick up a brush. All he was permitted to do was draw the scaffolding as an exercise. My righteous art-historical umbrage aside, I recognize that there's a reason we want to believe Michelangelo painted those figures: it makes him more amazing, and we like to be amazed. However, to this day, if I hear someone point to those figures and say, "Michelangelo painted them," I will interject, "Excuse me, but . . ."

GATHERING FLOWERS: DRAWINGS FROM GIOTTO AND MASACCIO

According to standard workshop practice, once an apprentice acquired the basic skills in drawing by copying from model books and his masters' drawings, he was tasked with making more detailed copies from the paintings and frescoes of previous masters found in the churches of Florence. Copying from painted images was a way for more advanced apprentices to learn to see, determine, and draw the interplay of light and dark on flat objects that appeared three-dimensional. Though more challenging, this was still not as difficult as drawing from a sculpture or live model.

This practice also served to introduce students to the established masters of their craft and have them learn, appreciate, and imitate the style of revered painters from the past. This respect for the artistic styles of past masters and willingness to learn from them is very unlike our modern concept. The modern approach emphasizes subjective, often accidental "originality." In the Quattrocento, it was unthinkable for an apprentice to formulate his own style without having diligently studied and understood the art of the great masters that came before him.

Cennini stresses this concept of "constantly copying from the best things you can find done by the hand of the great masters." He recommends that the beginner should always "take care to select the best one [artist] every time, and the one who has the greatest reputation," and observes that if you continue to copy day to day, it will be "against nature if you do not get some grasp of his [the master's] style and his spirit." Cennini warns, however, not to copy from too many masters so as not to become "capricious" from all the different styles swirling around in your mind. Instead, he counsels that the apprentice study from one artist to form a clear view of a single style. In this way, if nature has given you any ability at all, your imagination "would have to be crude indeed" if you do not manage to acquire an individual style of your own. Cennini adds that if your own style is derived from the study of one artist, it "cannot help being good, because your hand and your mind being always accustomed to gather flowers, would ill know how to pluck thorns."

In the reference to "flowers" and "thorns," Cennini's style takes on a deliberate poetic eloquence. Cennini resorts to this sort of imagery, I believe, in order to emphasize a crucial, intimate element in the master–apprentice relationship: the passage of a sort of "mystical flame" of style from master to apprentice. By copying from a master, you acquired a style individual to yourself. Your style, Cennini states, "cannot help being good," and therefore, after being honed, will be singular and fresh and take art to a new level. In copying Michelangelo's drawings, I realized

that, while his style was made accessible to me through the act of copying, it was as interpreted by my own abilities. It became clear too that this system works only through the "constant practice," though, as Cennini himself states. The constant concentration entailed in looking and copying Michelangelo's drawings slowly began to reshape my mental processes and influence how I drew. It's psychological—like subliminal persuasion or perhaps a sort of "artistic osmosis." If every day you draw and copy and reinforce in yourself the methods of your master, eventually the master's habits will stick. During this process, your brain and hand will alter them and make them your own—hence constructing your own style.

Cennini's advice to young apprentices to study and learn all they could from the great artists of the past is key to understanding the workshop tradition that Michelangelo was a part of. The city of Florence is filled with great art and was used as a classroom by generations of masters teaching their students. Quattrocento Florence was an artistic wonderland that must have inspired thousands of enthusiastic apprentices to learn from and emulate the old masters. In Michelangelo's day, every major church was filled with paintings and frescoes—many of which no longer exist. The most accessible works of painting were frescoed chapels in various churches done by some of the most famous painters in the Italian Renaissance, including Giotto and Masaccio. These chapels were sponsored by wealthy families each trying to outdo the other by getting the most famous artist of the day to paint visually rich scenes. In this way, the families would show off their wealth, importance, and yes, of course, their religious piety.

Cennini, Alberti, and even Leonardo da Vinci comment extensively and specifically on the importance of drawing from paintings in churches. Cennini in the late 1300s advised young apprentices "to go out alone . . . in churches or chapels, and [begin] to draw." He also suggested "to copy a scene of figures" and look at the shadows and highlights—in other words, to concentrate not just on contour and form but on volume. In the 1430s Leon Battista Alberti echoed Cennini's suggestions and advised

apprentices to have "some fine and remarkable model which you observe and copy."

In the early 1500s, Leonardo also had something to say about art training and makes specific suggestions that can be found in his notebooks. Leonardo himself must have had a similar artistic training to Michelangelo, but we almost never think about this. Instead, we have turned him into some kind of cosmic guru who knew the code of the universe. Always considered the most logical and analytical of his contemporaries, Leonardo left this advice for young artists regarding the stimulating artistic environment for apprentices of drawing together in chapels. He writes:

> *I say and insist that drawing in company is much better than alone, for many reasons. The first is that you would be ashamed of being seen among a number of draughtsmen if you are weak, and this feeling of shame will lead you to good study; secondly a wholesome envy will stimulate you to join the number of those who are most praised than you are, for the praise of others will spur you on; yet another is that you can learn from the drawings of those who do better than yourself, and if you are better than the others, you can profit by your contempt for their defeats, and the praise of others will incite you to further efforts.*

Knowing the historic importance that Renaissance art training placed on drawing in chapels, are there any extant Michelangelo drawings that provide evidence of him doing just that? There are two such examples. Two sheets, one in the Louvre (Figure 15) and the other in Munich (Figure 17) demonstrate that Michelangelo was sent to draw from the fresco cycles in city of Florence, one created by Giotto and the other by Masaccio (Figures 16 and 18). Both drawings were executed in a more accomplished pen technique than evident in the Albertina animal drawing. The drawing in the Louvre is of two figures in the scene of the Resurrection of Saint John in the Bardi Chapel by Giotto. The chapel was painted in the early 1300s and was considered one of the most important frescoes of the early Renaissance.

Giotto, who is seen as the father of modern Renaissance painting, revolutionized art by moving away from the flat, iconic Byzantine style to a more naturalistic representation of the world around him. The figures in his frescoes are volumetric with solid shading that gives the forms a depth and weight. Michelangelo's drawing from Giotto's frescoes is perhaps one of the first attempts at the old master's monumentality and force.

The second drawing in Munich is of the figure of Saint Peter from the Tribute Money in the Brancacci Chapel. The Brancacci Chapel was painted around 1427 by Masaccio and Masolino, who collaborated on the frescoes depicting the life of Saint Peter. Masolino's style was daintier and more refined, while the younger Masaccio had a more forceful style that continued Giotto's volumetric rendering of figures with a heavy chiaroscuro shading. Michelangelo's drawing here concentrates specifically on the folds and shading of the drapery of the figure of Saint Peter.

These two drawings show that Michelangelo was indeed following a traditional apprenticeship and learning his craft guided both technically and aesthetically by his master. They also reveal more about the general artistic intent of Ghirlandaio, who had a clear idea of what his apprentices should copy. He consciously chose these two great masters because he relied on their work for his own imagery, but his choice also reflected a general trend at the time. Ghirlandaio was not alone in looking back to the past. Florentine art of the late 1480s and 1490s was experiencing a revival of the traditional, monumental, and forceful style of Giotto and Masaccio, who were both pillars of the early Renaissance. This was in part a response to the rise of refined, personal, and even more idiosyncratic styles as seen in the 1470s and early 1480s in the works of Botticelli and Filippino Lippi. The revival of older styles could have been prompted by the internal turmoil that Florence was undergoing at the time due to the rising power of the puritanical monk Girolamo Savonarola as well as to external threats from the French, which hindered artistic patronage and productivity.

FIGURE 15: Michelangelo, copy after Giotto, pen and ink,
315 x 206 mm (12.4 x 8.1 inches).

FIGURE 16: Giotto, Peruzzi chapel, Detail of *Ascension of Saint John*, Santa Croce, Florence, fresco, early 1300s. Michelangelo drew a copy from three figures at far left of scene.

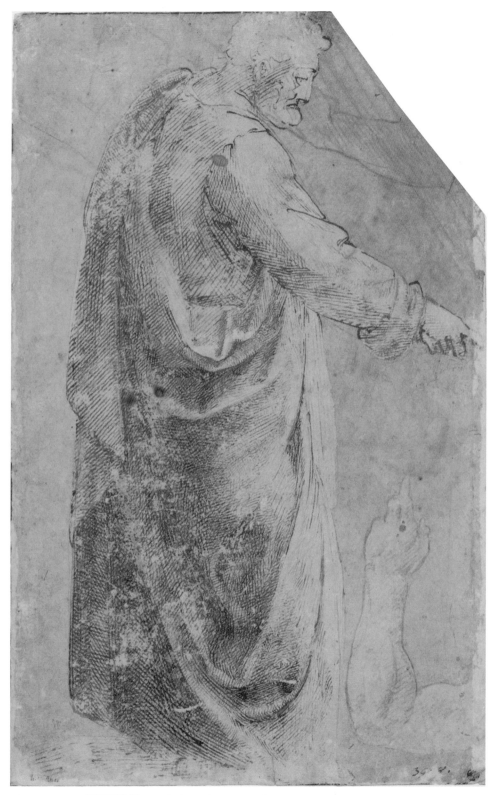

FIGURE 17: Michelangelo, copy after Masaccio, pen and ink,
317 x 197 mm (12.4 x 7.7 inches).

FIGURE 18: Masaccio, Detail of *Tribute Money*, Brancacci Chapel,
Santa Maria del Carmine, Florence, ca. 1427.

The general trend of Florentine art in the last two decades of the Quattrocento reflected a return to the artistic values of simplicity, gravity, and solidity exemplified in the work of Giotto and Masaccio. Ghirlandaio was part of this revivalist movement. As primarily a narrative painter, he was undoubtedly influenced by these two artists, and he made his own apprentices, including Michelangelo, study from their most important works. For his second-stage workshop apprentices during the 1480s and early 1490s, the most significant and accessible examples of Giotto's works were the Peruzzi and Bardi Chapels in Santa Croce and those of Masaccio's in the Brancacci Chapel. It is no coincidence that of the extant early drawings Michelangelo did of the old masters, two of them come from these chapels.

Michelangelo's drawings after Giotto and Masaccio correspond precisely with what his first biographers recount about his early artistic training. Both Condivi and Vasari state that the young Michelangelo copied with other students "for months" in the Brancacci Chapel. The two concur on this, since they both wanted to demonstrate that the young Michelangelo had rejected contemporary artists and independently chosen Giotto and Masaccio: instead of the elegance and mysticism of Botticelli or the expressiveness of Filippino Lippi, he found in Giotto and Masaccio the strong style he was seeking to express his youthful, creative genius. This narrative has been sustained by modern Michelangelo scholars such as the esteemed expert Charles de Tolnay, who commented that already in his choice of models Michelangelo revealed a personal penchant. Instead of copying the works of then fashionable artists (such as Botticelli and Filippino Lippi as well as Ghirlandaio), he imitated the monumental frescoes of Giotto and Masaccio. He turns away, by choice, from the refined and decadent art of his contemporaries in order to embrace the most monumental tradition of Florence.*

* C. De Tolnay, *Michelangelo*, 5 vols. (Princeton University Press, 1945), vol. I, 65.

Although these two drawings can serve to validate Condivi and Vasari's portrayal of Michelangelo—as the independent genius choosing Giotto and Masaccio for their monumental force—in my view, the sheets prove beyond doubt that Michelangelo had progressed to the second stage of his apprenticeship under Ghirlandaio. Juxtaposing the two drawings after Giotto and Masaccio with the Albertina sheet of copies from a model book reveals Michelangelo's artistic development. Whereas the animals and figures of the Albertina sheet were drawn mostly with unsure contours and shaded with unorganized parallel hatching in the shadows, the old master copy drawings show a surer hand, confident lines, and a truly virtuoso use of crosshatched lines.

Tellingly, Michelangelo's crosshatching in these drawings is a clear sign of Ghirlandaio's effective training methods. Ghirlandaio was the first to develop and consistently use crosshatching in his drawings. The crosshatch technique of shading with groups of parallel strokes that overlap at a variety of angles to follow the forms was unique to the Ghirlandaio workshop and a hallmark of his own personal drawing style. He first used it systematically as a shading technique in his sketches and studies executed for various frescoes and paintings in the 1480s and 1490s.

THE CRAFT OF DRAWING IN PEN AND INK

When I copied Michelangelo's pen drawings with a feather pen and ink, the exercise took much concentration and skill. Reproducing the precise crosshatched lines was time-consuming and required patience—an important indication of the young Michelangelo's artistic development when he copied the frescoes centuries ago.

Michelangelo's early drawings reflect the standard use of pen and ink as the primary tool for Renaissance apprentices. In his treatise, Cennini states that, after your initial drawing exercises, "you may sometimes just draw on paper with a pen. Have it cut fine: and then draw nicely, and

work up your lights, half lights, and darks gradually." Cennini even advises how to cut the pen—a skill that Michelangelo as a young apprentice must have had to master. Cennini states: "[G]et a good, firm quill, and take it, upside down, straight across the two fingers of your left hand: and get a very nice sharp knife and make a horizontal cut one finger along the quill."

The pens that Michelangelo used to make his early drawings were most likely goose or chicken quills sharpened in the manner described above, with the triangular point with a slit dividing it at the end (Figure 19). Unlike modern metal pen points, the natural quill pen point is an organic material—keratin, the same as fingernails. The main difficulty in drawing in pen and ink is to maintain a constant balanced pressure on the nib to control the liquid ink and create even, clean lines. I recall trying to draw with metal pen points and having difficulty with the rigidity and sharpness of the metal nib, which did not flow over the surface and often caught the grain of the paper and spattered. It was only when I found a good goose quill that I understood the true flexibility of the natural point and why it is such a valuable drawing instrument. The natural pen point is sensitive to the slightest pressure: pressing hard will open the cut point to release more ink and produce thick lines. Fine lines are produced by delicately pressing on the point, thus slightly opening up the point to create an even stroke. A goose quill pen point glides over the paper and sometimes is almost too responsive to the pressure put on it. In some cases, too much pressure forces all the ink to flow out all at once, creating a small pool that leaves a permanent spot. Spots like these are visible on many of Michelangelo's early drawings.

What inks did Michelangelo use for his drawings? In the fifteenth century, drawing inks were of two main types: iron gall or carbon-based. Carbon-based inks were prepared in workshops by suspending carbon particles, such as lamp black (soot from the fireplace), in a fluid-binding medium of diluted gum arabic and sometimes red or white wine,

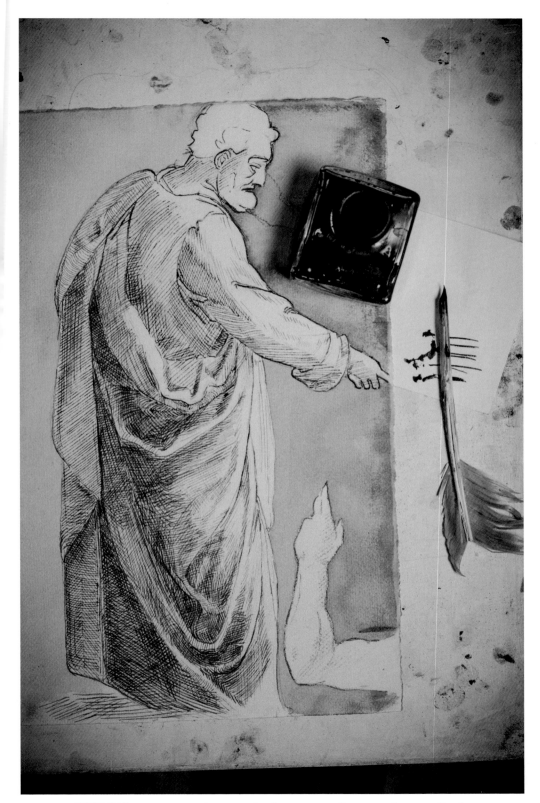

FIGURE 19: Drawing with pen and ink: goose quill pen, and iron gall ink.

according to the traditional recipes. Iron gall inks were made from iron gall—nut-like growths on oak trees—which were ground up and suspended in a binding medium. I managed to find natural iron gall ink in Florence and used it for my copies. Natural iron gall ink, which has a vinegary smell, is of a deep purple color that begins to turn black as soon as it is put down on paper. Both carbon and iron inks are initially black, but iron gall ink, with the passage of time, oxidizes and turns brown. In certain cases, perhaps inadvertently, Michelangelo used these two different inks on the same drawing, which, after centuries, can now be discerned by the black or brown color of the strokes.

But how did the boy Michelangelo draw with the pen? Cennini gives us a clue. The key was the use of charcoal and . . . a feather. "First take the charcoal, slender, and sharpened like a pen . . . for drawing." Cennini mentions using natural vine charcoal, which is soft and friable, made from slowly baking vine twigs in the oven. Charcoal makes a nice dark line on paper but can be easily brushed away with a feather, and before using the pen and ink, Cennini advises that you use it to do your drawing first, which allows you to brush away mistakes: "And if the proportion of your scene or figure does not come out right . . . rub [it] with the barbs of a feather—chicken or goose—and sweep the charcoal off what you have drawn."

Michelangelo undoubtedly executed his early pen drawings according to this traditional technique. Like Michelangelo, I too followed the prescribed sequence when I made copies of his pen drawings: first, I drew the contour lines and shadow shapes with a sharpened charcoal point. Charcoal scrapes and splinters as you draw with it but creates a nice dark line. I carefully brushed away any mistakes with a feather. Although the dark charcoal lines are canceled, the charcoal leaves a faint gray line that indicates where the mistake is and the more accurate correction. This ancient technique works much better than the modern-day eraser, which, ironically, is so good at eliminating mistakes and not allowing you to see where

they were that you also lose what can be useful in correcting a mistake. Often, the artist will repeat the mistake since they can no longer see what needs to be corrected. In the Renaissance method, after the final charcoal drawing is completed, it can be brushed away, leaving the gray lines that show precisely where to put the pen strokes. The faint charcoal lines give all the information needed to apply the pen lines, which cannot be erased or canceled out, in absolute tranquility and confidence. After the pen drawing is completed and dry, the faint underdrawing can be completely removed with a few swift brushes of the feather, leaving the impression that the drawing was done *alla prima*—in pen right from the beginning. This is the secret of drawing in pen that all the apprentices had to learn: first, a careful underdrawing in forgiving and easily erasable charcoal, which is then fixed in permanent ink with methodically applied pen lines.

Making uniform pen lines is not as easy as Michelangelo's early drawings make it look. The pen point has to be sharp and crisp. When dipped into the ink, it cannot have too much ink (i.e., be dipped too far down into the ink), which will drip down to the point, or too little ink (not be dipped enough). I found that, before actually drawing with the point, I had to clean excess ink off my pen with a small cloth in order to avoid drips on the paper. Perfect pen lines are made by slowly dragging the pen point over the paper—which creates a scratching sound as it passes over the grain. Short lines are easily produced, but to make long, even, straight lines, I had to learn to draw with my whole arm and not just my hand. It took dozens of pen copies to understand how to hold my arm and hand just to produce even lines. I also noticed that completing an entire pen drawing took time, concentration, and patience. This goes to show that the apprenticeship process, and in particular the mastering of pen and ink, was not just about the physical act of drawing but also involved a harnessing and concentrating of the student's artistic impulses into a methodical, even meditative, patience.

Patience is a must for drawing in pen since all shading must be done with lines. For beginning apprentices, creating even lines and spacing them regularly was difficult. Beginners' drawings usually have irregular and uneven lines. Apprentices with more practice using a pen were able to produce an even net of pen lines to correctly create forms. To shadow with crosshatching and create the correct effect of a coherent shadow is no easy task and takes some practice. First a series of lines must be drawn in one direction—all equally spaced and of the same thickness. A few moments are needed for the ink to pass through the glue size (the surface coating applied when paper is made to render it slightly less absorbent) on the paper and fix itself into the fibers. After these initial lines are dry, another series of lines are placed over them. Either slightly angled or perpendicular (i.e., crosshatched), this second set of lines must be of the same thickness and equally spaced. If placed on top of the previous ones while they're still wet, these subsequent pen lines will blend with them and create large blots that totally cancel the effect of volume or shadow. The skill of the draftsman can be seen in the thickness and regularity of the pen strokes, spaces between the parallel lines, and strategic, patient use of crosshatching.

The prevalence of crosshatched lines in Michelangelo's copies clearly demonstrates his debt to his master's teachings—no matter the strong denials in Condivi's biography. Ghirlandaio likely taught all his more advanced apprentices to shade in pen using the crosshatch technique.

DRAWING AFTER GIOTTO

Michelangelo was probably sent by Ghirlandaio to go draw in the Peruzzi Chapel to study Giotto's shading and volume. The two figures from the scene of the Ascension of Saint John are two of the lowest figures on the right-hand side of the chapel (Figures 15 and 16). They are in the innermost corner of the chapel near the altar and at the left of the scene.

Michelangelo chose them because he could get the closest to them and perhaps prevent any comparison with other apprentices to avoid the "shame" of not being the best, as Leonardo put it. But how did he actually copy on the go with messy pen and ink? In his treatise, Cennini describes how to create a little glass vial that could be clipped to your belt. With this handy trick, you could hold your drawing board with one hand and draw with your other, dipping your pen in the inkwell attached to your waist. Michelangelo would have had a piece of paper attached to a wooden board that he held in his hand and rested on his thigh. On some of his drawings you can still see red stains on the backside of the sheets, which is a residue of the red wax that was used to stick the sheet to the board.

Based on the complexity of the pen lines, we know that Michelangelo drew the Giotto copy sometime after the Albertina sheet with animals. The complex forms of the folds in both figures' clothing are indicated with an intricate hatchwork of long, even lines and smaller, more descriptive strokes—a complexity that marks distinct advancement from the Albertina sheet. The folds are drawn well but only hint at the monumentality of Giotto. This simple and direct monumentality was what Ghirlandaio probably wanted his apprentices to capture and understand. Other aspects of the copy show Michelangelo struggling with the anatomical details. The foot of the figure at left and the hands of both are redrawn using what is called *pentimenti*—when you "rethink" and try to correct a mistake by going over it with a heavier line. The fingers of the bending figure are heavily redrawn and indicate that the young Michelangelo had yet to master hands—one of the most difficult things to draw, then and now. Overall, the copy is testimony to Michelangelo following the standard Renaissance practice of drawing from frescoes to learn line, shadow, and volume. It demonstrates a gradual refinement of pen technique in the hatching and fine lines but a still-developing understanding of anatomy, such as in the hands and faces. Based on this drawing, Michelangelo was at the same level of many others in the workshop—just another apprentice,

gifted perhaps, but struggling to complete the drawing exercises given to him by his master in a difficult technique of pen and ink.

DRAWING AFTER MASACCIO

In the Masaccio fresco in the Brancacci Chapel, the scene of the Tribute Money with the figure of Saint Peter is above eye level, and Michelangelo probably had to draw it from the opposite side in order to see it better. Why would he choose a figure from the second level? The lowest scenes of the Brancacci Chapel were not done by Masaccio, but by Masolino—as well as Filippino Lippi, who was called in sixty years later to complete them. Undoubtedly, Ghirlandaio advised Michelangelo to draw from Masaccio and not Masolino. Masaccio's figures have even more volume than Giotto's and were a logical jump in difficulty of style for the young artist to study. Ghirlandaio did not want his apprentices copying from works that did not have the force of Giotto or Masaccio.

Michelangelo's growing patience in drawing is clearly demonstrated by the more complex rendering of the figure of Saint Peter. There is a strong volume to the figure imparted by the rich network of hatched pen lines. The grid created by the lines to shade the cloak is sometimes uneven and not parallel, but nevertheless it shows a distinct understanding of how to create form by shadow—something extremely difficult with pen. Here for the first time we see Michelangelo going over areas in multiple directions of pen lines to darken and render the forms more clearly. By copying the drawing, making the lines as he did, I could see that he was now wrapping his mind around the forms and "feeling" them through the maze of hatchings. In addition to more accomplished pen technique, the drawing reveals Michelangelo adding something extra to his copy. When the drawing is compared with the original figure in the fresco, it becomes evident that the young apprentice slightly changes the extended right arm to give it a more natural feel and raises the head to make it sit more

naturally on the shoulders (Figures 17 and 18). In essence, Michelangelo, in his copy, "corrects" Masaccio. It is fairly difficult to copy something correctly—ask anyone who has copied from the Old Masters. It is another thing to correct an error by a master—especially if you are only thirteen years old and just beginning to draw. Without wanting to sound like Condivi or Vasari, let me say that, in my opinion, this copy of Peter shows the first true spark of Michelangelo's natural artistic ability. It shows him confident enough to move away from just copying what was in front of him and instead judge for himself how things should be drawn.

"IF YOU ARE BETTER THAN OTHERS": MICHELANGELO'S BROKEN NOSE

Michelangelo no doubt knew he was getting good. Otherwise, he wouldn't have been so bold as to correct Masaccio. He was no longer a beginning apprentice, afraid of making mistakes and envying the others who drew better than he did. As a second-stage apprentice, he wasn't the small fry in the big pond of the workshop. He was given the responsibility of looking over the drawings of younger apprentices. This change in Michelangelo's status from a beginning apprentice to an advanced assistant who advised others is inadvertently recorded in Vasari's account. Vasari tells the story of one of Ghirlandaio's students who had done a pen copy of a draped female figure. Michelangelo saw the sheet and, taking hold of it, applied his own pen and with a broad stroke "passed over one of those women with new lines . . . to produce a perfect form." Vasari proclaims that it was a "wonderful thing . . . to observe the ability and judgment of one so young," who had so much bold talent as to "correct the work of his master."

Vasari's account is given to suggest that in correcting the student's drawing to make it "perfect," Michelangelo was in essence correcting the forms of Ghirlandaio's original study of the draped female figure, and that

he did so out of sheer artistic knowledge or instinct. But whether that "wonderful thing" is entirely credible, the passage actually does describe Michelangelo correcting a younger apprentice's copy of a Ghirlandaio drawing in the context of the workshop environment. This corresponds exactly to the role of an older, more advanced apprentice, who, in the absence of the master, was expected to supervise and to correct the work of the beginners. In this case, a younger apprentice had most likely copied one of Ghirlandaio's drapery studies, which he executed to people the scenes in his frescoes. Michelangelo had taken it upon himself to impart a lesson and improve the younger boy's work.

Michelangelo's growing abilities and arrogance would get him into trouble. In Benvenuto Cellini's *Autobiography* of 1560, one of the most amusing memoirs ever written by an artist, Cellini fills the book with self-aggrandizing stories but also includes an interview of sorts with Pietro Torrigiani, a fellow student with Michelangelo in Ghirlandaio's work-shop. Torrigiani recounted what happened one day in the Brancacci chapel when all the apprentices were drawing there together. In Cellini's words: "This Buonarroti and I used to go along together when we were boys to study in Masaccio's chapel in the church of the Carmine. Buonar-roti had the habit of making fun of everyone else who was drawing there, and one day he provoked me so much that I lost my temper more than usual, and, clenching my fist, gave him such a punch on the nose that I felt the bone and cartilage crush like a biscuit. So that fellow will carry my signature till he dies."

Michelangelo the hotshot, working on his brilliant drawing, perhaps of Saint Peter, couldn't resist mocking the other apprentices around him who were applying themselves to the same task. Who wouldn't make fun of the others if, at thirteen, you somehow knew you had the talent to be one of the greatest artists around? But Michelangelo paid the price for his cocky attitude—it got his nose broken. For any thirteen-year-old, even a large pimple can be an excruciating embarrassment. Imagine a crushed nose in

the middle of your face. Florentines are traditionally sarcastic, with a cutting, irreverent sense of humor. A typical Florentine, then and now, is quick to pick on any inability or small physical defect in a person and turn it into prime material for ridicule. My Florentine friends have mocked me mercilessly for anything from my worn shoes to my receding, and now vanished, hairline. Cellini's story of Michelangelo making fun of the others is an example of this cutting Florentine humor. He probably didn't expect Torrigiani's response to take the form of a punch in the nose and having to pay the price of his hubris for the rest of his life. The injury could well have had a psychological impact on the young Michelangelo that changed him for life and led the young boy to concentrate even more on his studies, to hide himself or in some ways distance himself from the others. Who hasn't felt that need to become the best at something in order to "get back" at the others? This may be speculation, but true or not, it was at this moment that Michelangelo's drawing took a leap in quality.

MY RENAISSANCE APPRENTICES

In the apprentice method, small things are mastered one at a time and then put together at the end. It is not surprising that Michelangelo was good at rendering drapery but not anatomy. Learning to draw well is not easy, and sometimes certain things come faster and easier than others. I began to see this during my twelve years of teaching for a study abroad program in Florence. The most interesting art class I ever taught was called "The Renaissance Apprentice." This was a course of my own invention and was a favorite among my former students. I still hear from them about it. The course, which was inspired by my own artistic study of Michelangelo, was based on Cennini's treatise—from methodology to materials to using Florence as the classroom.

As the professor or master, I put my students through a mini-apprenticeship beginning with traditional drawing techniques such as pen

and ink and silverpoint and ending with painting in fresco and egg tempera. As apprentices, the students all followed the sequence of copying drawings, then copying from paintings, and then drawing from sculptures—in many cases from the same ones that Michelangelo drew from. I would jokingly tell them that they were on the cutting edge of retro-art by studying like beginning Renaissance apprentices. Many of my students had never drawn before, but nonetheless the system worked perfectly.

Through my students' progress, I began to observe what happens to a novice who is just starting to copy. The results were surprisingly similar to what I saw in Michelangelo's early drawings and what I had experienced myself. In my class, the students were not pressured into making "original" works of art. Their task was to make exact copies, guided by the masters. By copying drawings, the students learned how to handle the materials and grasp basic forms. By the time they got to drawing from paintings, they had a basic handle on how to draw, but they continued to be guided and accompanied by the masters. They always had a point of reference.

It wasn't all smooth sailing, of course. Every year, I was met with some skepticism. After the first drawings I gave them to copy for homework, I could feel that my students weren't happy with me, since they had to spend literally hours working on them on their kitchen tables in their apartments. After the first few rough copies, however, students began to get the hang of it. Even more significantly, they began to learn patience and diligence of execution. Shadow and line slowly came to them more easily, which gave them the confidence to attack the more complex things like anatomy and proportion. After a month or so of copying, I would take them to Rome to draw from the classical sculptures in the Vatican and Palazzo Massimo. These classical works sparked something inside every single one of them, and they executed fantastic drawings. I have fond memories of having my students draw directly from the *Belvedere Torso* or the *Laocoön* and drawing right alongside them. I would never interfere with them as they drew—perhaps only give them quick tips or

suggestions. I wanted them to have an individual encounter with ancient art and let their newfound drawing style translate what they saw into their drawings. Although the copies they did and the drawings from ancient sculptures had strong and weak points, by following the classical sequence the students got better and better—as happened to Michelangelo.

The most interesting thing about this was that, although my students had to make copies and draw from existing sculptures and paintings, their own style emerged—even without them knowing it. Some were more expressive, some more analytical, but without exception, I saw every single one of my students learn how to draw just like apprentices did in the Renaissance. Crazy as it may seem, I can still remember every one of my students' drawings.

By the end of the semester, each student had produced numerous copies and original drawings, and I felt as if all of them had discovered something about themselves—something artistic. Semester's end always left me a bit sad. I knew that many would move on to nonartistic but more lucrative futures. They would leave behind them in Florence that universe of creation that they had discovered inside themselves. But most unfortunate was that they would set aside that ancient flame of artistic passion that I saw each of them work so hard to acquire and put in their works. In any case, the course was special to me. I hope it was for them, too. Perhaps the best testimony of this was when one of my students, a non–art major, wrote me an email about the reaction of his parents when they saw the work he had done with me in Florence. His parents were "shocked," he wrote, and wanted to know what I "did to him," and that they thought I was a "miracle worker" in teaching him to draw so well. I felt like an artistic Dr. Frankenstein bringing young artists to life.

But that is the secret to the whole process, I believe. Copying opens up something in the brain that frees the true creative spirit. Copying creates a sense of security in drawing that allows the beginning artist to develop his or her own style—and eventually, originality.

Coming back to Michelangelo, the drawings we've examined show that the young apprentice had learned what he could from Ghirlandaio and made the most of his copying in pen. He had learned to use a difficult drawing tool, learned the basics of line and shapes and also of rendering volume. The difficulties I encountered in copying Michelangelo's drawings demonstrated their high quality, which some interpret as proof of Michelangelo's precocious skills. In comparison to drawings by teenagers today, the drawings are shockingly perfect. Nonetheless, these drawings were still just good student works and not entirely original enough to be examples of artistic genius. What they do demonstrate is Michelangelo's dedication to learning his profession. He gave himself wholeheartedly to drawing. Without all the technological sirens that distract youths and adults today, Michelangelo had the opportunity to concentrate his entire being on drawing and becoming an artist. His world allowed for that. Studies have shown that the more time you spend on perfecting a skill, the better you will become—the 10,000-hour rule is one pop-culture expression of this. These copy drawings by Michelangelo show that he had spent a lot of time, perhaps thousands of hours, drawing, but he was not yet a "divine genius." For now, he was just a very skilled, broken-nosed young boy passionately absorbed in his desire to get better and become a master.

6

Michelangelo, the Medici,
and a Career Change

THE MEDICI AND SCULPTURE

What was Florence like in the 1480s when Michelangelo was studying drawing under Ghirlandaio? The small city was dominated by one figure, Lorenzo de' Medici, or as he was called, Lorenzo il Magnifico —"the Magnificent." Lorenzo was the grandson of Cosimo de' Medici, a well-educated and shrewd businessman who, in the 1420s and early 1430s, had managed to create an extremely lucrative European-wide banking dynasty and become the banker to the popes in Rome. By means of his wealth, Cosimo took over the city of Florence—even though he never was formally elected as its ruler. Through economic influence and by eliminating his political enemies, he controlled the "democratic" elections of Florence to make sure only his supporters were voted into public office. When Cosimo died in 1464, the city was passed on to his son Piero, who was eventually succeeded by his son Lorenzo. Just like his grandfather and father, Lorenzo controlled the city from behind the scenes, though he wasn't the savvy banker his grandfather was. He was, however, a sage ruler, and competent politician and diplomat. In addition to his

responsibilities to his family's business and to Florence, he dedicated himself to art, music, and poetry. He sponsored public events, sought out the best artists to support with his patronage, and in his personal enthusiasm for the arts became the cultural heart and soul of the city. The Medici Palace in Via Cavour, now called the Palazzo Medici Riccardi, still attests to the dominance and importance of the Medici family.

Everyone in Florence knew of Lorenzo, and many if not all artists in the city sought commissions from him or his family. The Medici were the wealthiest patrons any artist could find. Lorenzo in turn probably knew most of the major artists of the period: Botticelli, Leonardo, Filippino Lippi, and of course, Ghirlandaio. These were all painters, however. In his *Lives*, Vasari says that Lorenzo, who so loved the arts, was frustrated that he couldn't find in Florence any sculptors who were on the same level of skill as the many painters who had their workshops in the city. Lorenzo's grandfather, Cosimo, had commissioned Donatello—one of the greatest Early Renaissance masters—for some of his most important sculptural works in the 1440s. A generation later, Piero de' Medici, Lorenzo's father, commissioned Verrocchio for numerous works of sculpture. Upon assuming the role of leader of the city, Lorenzo wanted to carry on this tradition of the Medici in sculpture. Under his rule, Florence was considered to be the "new Rome" for its magnificence and splendor, and his ambition was to embellish it like ancient Rome and the cities of classical Greece. Besides architecture, sculpture was one of the main means to achieve this and to display and reinforce the ideals of the Florentines. But to commission great works like his father and grandfather, he needed a worthy sculptor.

Vasari relates that one day, in the early 1480s, Lorenzo decided to do something about it and form his own school for sculptors—which shows just how obsessed he was about the medium. From his personal collection of ancient sculptures, consisting probably of figures, busts, and sarcophagi, he moved a number of pieces into a garden space near the church of San Marco that he had originally purchased for his wife, Clarice. The garden

is still there to this day, on Via Larga opposite the monastery of San Marco. Vasari recounts that, after creating the sculpture garden, Lorenzo requested of all artists he knew that they send him any of their students disposed to study sculpture, promising to "provide for their progress." In essence, he was offering scholarships to study sculpture. One of the artists who received Lorenzo de' Medici's call for students was Ghirlandaio. Domenico most likely knew the Medici family personally, given that he had executed numerous Medici family portraits in the Sassetti Chapel in Santa Trinita and the Tornabuoni Chapel in Santa Maria Novella. He had painted both Lorenzo and his mother, Lucrezia Tornabuoni. His working relationship with Lorenzo was to become an important factor in Michelangelo's early development.

According to Vasari's *Life of Michelangelo*, Ghirlandaio sent Michelangelo and his friend Granacci, two of his best students, to Lorenzo's new sculpture academy. Condivi, ever seeking to paint Michelangelo as a boy genius, presents the story differently, however. "It happened one day," he says, that Granacci took Michelangelo to the Medici Garden at San Marco and, when he saw the works Lorenzo had placed there and "savored their beauty," Michelangelo never again returned to Domenico's workshop. Condivi may have romanticized Michelangelo's reaction to the sculptures in the garden, but he was accurate in saying that he never returned to Domenico's workshop. Something did happen in that garden. Michelangelo must have realized that he was not a painter but a sculptor. His introduction to the garden marked not only a clear career change but also something more important—the initiation of his direct connection with Lorenzo.

How old was Michelangelo when he entered the garden, and how much had he learned from Ghirlandaio? Art historians differ on this, but he must have been about fifteen or sixteen and had two or possibly three years of instruction as an apprentice. That would have been long enough to master the initial phase of the first stage of instruction, copying from

paintings and drawings, and achieve the proficiency in pen technique that we've seen evidenced in the copies he made from Giotto and Masaccio. So why would Michelangelo leave one of the most prestigious workshops in Florence to study in a newly formed experimental academy? We'll never know for sure, but perhaps Ghirlandaio, who could in no way refuse Lorenzo's request, sent the young apprentice in order to complement his painter's education. Domenico himself had gone to Rome to study ancient works, and perhaps this was the chance for Michelangelo to do something similar and be exposed to the collections of the Medici.

THE GARDEN

The environment of the garden would probably have been completely different than a Renaissance bottega. The garden was probably just that, an open outdoor space like a courtyard, with room for large works of sculpture but with adjoining indoor spaces as well. Vasari says that the garden was "filled with antique and good sculptures" and that there were drawings, cartoons, and models by Donatello, Brunelleschi, Masaccio, Paolo Uccello, and Fra Filippo Lippi. I can imagine Michelangelo being awestruck by the multitude of antique sculptures—probably a similar experience to entering the Uffizi Gallery in Florence today and surveying the corridor filled with ancient sculptural works. Incidentally, some of them may be what Michelangelo saw. Students of the academy may have had free or controlled access to these works in the hope of stimulating greatness in them.

Although there were amazing works of art to study, I believe Michelangelo was most affected by the manual labor of carving marble. If you have ever carved hard stone, you know that it takes strength to hammer away on a chisel to create something. The first time I hammered into a block of marble, I was in college and had decided I had to sculpt stone. I managed to obtain a piece of Carrara marble from a deconsecrated church

and got my dad to bring it home in his car—almost breaking the suspension. I then called my Uncle Amerigo, who along with my Uncle Arturo had worked on Mount Rushmore in the 1930s. They had been suspended in harnesses over the side of the mountain to carve away the stone—quite amazing. I had never met them personally, as my mother's family members rarely spoke to one another for reasons only Italian families can understand. In any case, I decided to take a chance and called Uncle Amerigo on the phone to see if he could give me any advice. "Do you have a hammer?" he asked me. "Yes," I replied. "Do you have a chisel? And a piece of marble?" "Yes," I replied again. "Then just start hammering; the rest will come naturally." And so it did. As soon as I made that first strike and saw that piece of marble fly away, I was hooked. It was liberating, cathartic, and the more you hammered, the more you wanted to keep hammering. The concept of breaking a million-year-old piece of marble and shaping it the way I wanted it made me feel godlike—I was shaping stone. Your hands hurt after a while and you're covered in marble dust. You can feel the gritty dust in your mouth and taste the purity of the marble. It requires both physical strength and artistic skill—force with artistry. I think the young Michelangelo preferred the harshness of the sculptor's hammer and chisel to the refinement of the painter's brush.

NATURAL-BORN SCULPTOR

Michelangelo's entrance into the garden changed everything. Tasting the rudiments of working with stone must have transformed something in his developing artistic mind—something that made him mentally detach from the painter's mindset and abandon himself to the world of sculpting. He finally found his artistic niche, for he was a natural-born sculptor. Lorenzo de' Medici, after seeing the young Michelangelo execute a faun's head, understood this. He immediately took him into his home and

provided him with everything he could to promote not only the boy's artistic studies but his humanistic education as well. Being "discovered" and taken in by the most important artistic patron in Florence, who was the virtual ruler of the city and head of one of the most important families in Italy and perhaps in Europe, was life changing. Being asked to live in the biggest palace in the city must have made his head spin. It was like getting a full scholarship to Harvard or Yale, with benefits.

Michelangelo not only received a Neoplatonic education from several of the most important humanist scholars of the age, he also mingled with Lorenzo's children, sitting with them at the dinner table. He had been catapulted into the upper levels of Florentine society.

There are both written accounts and several extant examples of the various sculptures Michelangelo made while under the direction of the sculpture garden master, Bertoldo, and the patronage of Lorenzo. Bertoldo di Giovanni was a master sculptor in his own right, who had worked with the famous early Renaissance sculptor Donatello. Bertoldo was not only an accomplished artist but also a competent art instructor. Lorenzo had chosen him personally to teach in his new sculpture academy. Among the works Michelangelo executed there were the famous faun's head (actually, I have seen at least three attributed to Michelangelo in various museums), the *Battle of Lapiths and Centaurs*, and the *Madonna of the Stairs* in the Casa Buonarroti in Florence. And, if I may make my own attribution, a little-known Venus and cupid relief fixed into the wall of the Palazzo Medici Riccardi—so well done it has been mistaken for a Roman work.

To my knowledge, no sources exist that specifically document how Michelangelo learned to sculpt while in the Medici garden. That is the cold hard fact. This does not impede a logical reconstruction based on the traditional approach to the craft of sculpting and the information presented by the sculptures Michelangelo executed while in the garden. One of the best treatises on sculpting, *Modelling and Sculpting the Human Figure*, was written by Edouard Lanteri, a colleague of Rodin, in the early 1900s

and gives an idea of the traditional approach. In the introduction, Lanteri expressly states that, "drawing is the principle foundation of sculpting" and that "no student should be admitted to modeling [i.e., sculpting] in a school, unless first he has done some serious drawing." Although Lanteri's treatise was written more than four hundred years after Michelangelo entered the Medici garden, I believe the same prerequisite was operative in the Renaissance. Michelangelo's admission to the Medici garden was predicated on the fact that he had had already done some "serious drawing" in Ghirlandaio's workshop.

With his basic grasp of line and shading, Michelangelo was well prepared to transfer line and form through sculpting. His initial sculptures show such a general sense of form and anatomy, as evidenced in his *Madonna of the Stairs*—in the face of the Madonna and the folds of her clothing—and especially in the anatomical figures of his *Battle of Lapiths and Centaurs*. But how did he learn? In the craft of carving, the most difficult thing is handling the tools in such a way that they cut into the stone as desired, and expertise comes from doing. In the artistry of sculpting and carving, the most difficult thing is to make the jump from the flat two-dimensional image to three dimensions. Based on the works at hand, Michelangelo began with low relief, or *rilievo schiacciato* (literally "squashed relief"), which most resembles drawing. The *Madonna of the Stairs* is as example of this. Bertoldo would have built on Michelangelo's grasp of drawing to ease him into the transformation of drawn form into relief. After sketching the composition of the Madonna holding her child on a flat piece of marble, the apprentice had to gradually carve back to the lowest levels, leaving forms at various levels. Just as Michelangelo copied from model books to understand line and contour, he would have begun learning to sculpt in the same way—copying in stone to understand relief, volume, and the handling of hammer and chisel.

As Michelangelo progressed in his understanding of volume and mass, his sculpted copies become more complex, precisely like his pen copies

after Giotto and Masaccio with their complex pen hatching. The *Battle of Lapiths and Centaurs* shows Michelangelo tackling complex anatomy, or at least copying from it. Although it is difficult to identify with certainty a specific sculpted example that Michelangelo may have copied from, he most likely had access to an antique source such as a Roman sarcophagus or even a work from his master Bertoldo. The composition contains figures in low relief and high relief, with deep undercutting of the marble, a clear indication of the progression in his carving skills. Every time I see these works in the Casa Buonarroti in Florence, I marvel at their artistry, but they also remind me that it is easy, so to speak, to copy from works that are already complete, with all of the anatomical problems already solved for you. What is difficult is to understand anatomy, form, and volume enough to be able to conceive and create your own figures. In light of this, I think that, although Michelangelo learned to copy forms in marble—which can be done through careful measuring and patience—he still had to learn the finer points of anatomy and gesture to understand completely the forms he was copying or to make his own figures. In order to do this, he undoubtedly would have had to return to the basis of sculpting: drawing.

Although references to Michelangelo executing sculptures are numerous, there is no account of him drawing during this period, so it's difficult to discern how much he did while under the Medicis' roof. In the garden, there was probably no one to formally guide him in drawing exercises—there would have been no need to. When I began to formally study sculpture, I had my hands in clay or holding hammers and chisels and was not once made to draw, just sculpt. I assume that it was the same with Michelangelo in the garden. Masters do preparatory studies for works in sculpture, but students of sculpture must sculpt. That said, there is one drawing in the Uffizi that may be from this period (Figure 20). It is unlike any other among Michelangelo's extant works on paper, for it is executed on gray-tinted paper with black chalk and white highlights. No previous

FIGURE 20: Michelangelo, study of legs (Donatello's *David*?),
metal point on gray prepared paper with white highlights,
272 x 262 mm (10.7 x 10.3 inches).

examples of Michelangelo using such a combination of techniques are known to exist.

What ties this drawing to Michelangelo during the Medici garden period is the stance of the figure. The famous art historian Johannes Wilde observed that it is similar to the contrapposto pose and akimbo art of Donatello's marble *David* in the Bargello. Another art historian and Michelangelo expert, Charles de Tolnay, further observed that the drawing is not a literal copy after Donatello's *David* but shows a nude figure with the legs uncovered. De Tolnay posits that it may have been done from a small model of the figure that was owned by the Medici and was in the garden but has since been lost. Since we know Michelangelo was studying under Bertoldo, who was a former apprentice and collaborator of Donatello, this scenario seems highly plausible. Bertoldo may well have kept models from Donatello that he used in instructing his students. The drawing is on tinted paper and highlighted with white, a technique similar to silverpoint drawing that may be evidence of his instruction under Ghirlandaio. Its existence could indicate that Michelangelo was drawing from models connected only to the Medici collections, but that isn't certain.

NOT A PAINTER BUT A SCULPTOR

In my own artistic development, I came to a similar realization as I think Michelangelo did when he entered the Medici garden. For years, I had drawn and painted but never felt the facility in holding a brush to make anything significant. I had an urge to do something more forceful, more tangible, that allowed me to communicate my ideas more directly. This desire led me to seek out a professor of sculpture at the Academy of Florence, Antonio di Tommaso, and study with him. Professore Di Tommaso was highly respected and a true master, who worked in clay, marble, and bronze. He was a "sculptor's sculptor," who knew his material and how to

create works of art from it and was one of the best at transmitting this knowledge and skill to his students. He was also quick to get angry and get into arguments. He was unafraid to give his opinion about modern sculpture and sculptors. In other words, he knew his stuff and got ticked off when he saw stupid things—whether objects or people.

The first time I entered his dark, dusty, and simply dirty studio in Via de' Pepi near the church of Santa Croce (not far from Michelangelo's house), I remember it was filled with portrait busts, hammers, chisels, and plaster casts of ancient works. Surrounded by the sculptures, I felt at home, and I began to study in earnest with Di Tommaso and made copies of the *Madonna of the Stairs* and did a full-scale copy in clay of Michelangelo's *Battle of Lapiths and Centaurs*. Sculpting came easily for me, much more so than painting, and I didn't have to think about creating—forms directly flowed from my mind to my hands as I sculpted the clay naturally. I didn't have to interpret what I was thinking through the hairs of a brush or through paint. It was in that studio that I accepted the fact that I was more a sculptor than a painter. While studying to be a painter with Ghirlandaio, Michelangelo may have sensed a more natural inclination toward sculpture. Lorenzo's call for students to fill his academy would have been the very thing he wanted and needed.

LORENZO'S DEATH, AND WORKING IN ROME

Michelangelo's time with the Medici came to an end, however, with Lorenzo's death in April 1492. This event thrust the young man into the tumultuous reality of Italian politics. With Lorenzo, he was protected. With Lorenzo gone, Michelangelo was by default "pro-Medicean," which, in the pro-republican, anti-Medicean Florence of the 1490s, would have been a problem for him. It is recorded that after the death of Lorenzo, Michelangelo returned to his father's house, where he bought himself a piece of marble and carved a Hercules figure four braccia high (a *braccio*

was the length of an arm, or between 15 and 39 inches). Also during this period, he began to study anatomy by dissecting corpses at Santo Spirito. In 1495 Michelangelo hastily moved to Bologna, where he was commissioned to execute several figures for the tomb of Saint Dominic. Returning to Florence later in 1495, he was commissioned to sculpt a statue of a young San Giovanni for Lorenzo di Pierfrancesco de' Medici. Finally, in 1496 he sculpted a cupid that was good enough to be sold as an antique. By the time Michelangelo arrived in Rome, in June 1496, he was a mature and competent sculptor.

No longer a student of sculpture but a practicing master in the trade, Michelangelo could now integrate his drawing skills into his works. The number of sculptures he executed during this period—we know of more than ten—proves his proficiency, but he continued to draw. He must have made preparatory studies for his works, and there are a number of sheets of his studies from ancient works—in particular of anatomy studies taken from sculptures. These drawings demonstrate his autodidactic quest to learn complex anatomy, which, although he had sculpted it many times before, he was intent on perfecting.

Two such drawings in pen and ink were probably made while Michelangelo was in Rome. The first is a nude seen from the back that is now in the Casa Buonarroti (Figure 23); the second is a study in the British Museum of the Apollo Belvedere (Figures 24). Both drawings are executed in much the same manner: with heavily reinforced contours and a meticulous crosshatching technique. The heavy contours indicate a concentrated effort to correctly draw the forms of the various muscles. In fact, the contours are near continuous, which is the sign of a developing artist. When I taught drawing, I would tell my students to avoid the continuous "cookie-cutter" contour, the never-ending line around the figure that goes around every form, which has the effect of flattening it out. The contour should be thin and "broken," i.e., following the forms into the body and stopping and starting up again. Michelangelo's contours on

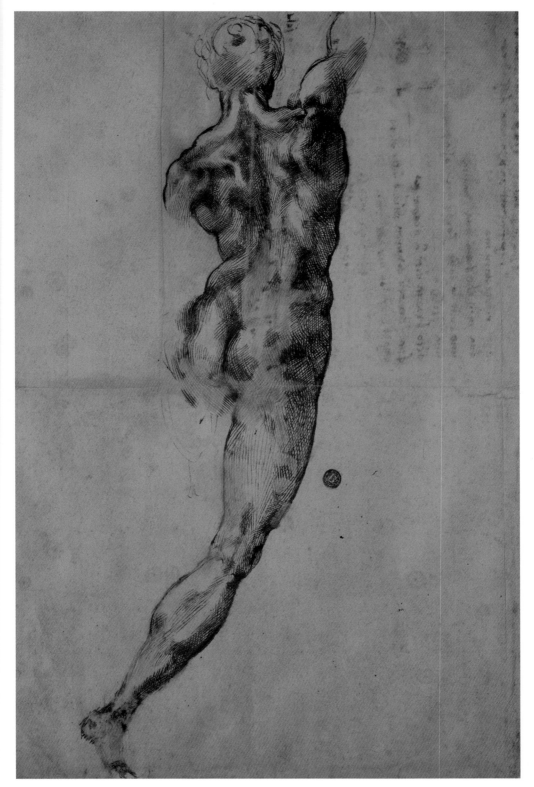

FIGURE 23: Michelangelo, study of nude from back, pen and ink,
409 x 282 mm (16.1 x 11.1 inches).

these drawings don't do this but rather are thick and nearly continuous. The drawings indicate Michelangelo going over the same line so many times to get the forms correct that he creates one thick, almost cumbersome contour.

The pen lines used to shade the figures evince a slight development in drawing technique, especially in the use of shorter, and in some cases curved, strokes. Instead of the long, straight strokes that he used to model the drapery on the copies from Giotto and Masaccio, these shorter strokes isolate and follow the contours of the muscles. Nevertheless, in his approach to shading he is still largely following what he learned with Ghirlandaio, as my sequential copy of the Apollo drawing (Figure 25) demonstrated. First, the general forms of the anatomy were drawn with charcoal. This was then fixed in pen and ink, correcting the contours—hence the heavy line around the figures. Next the large areas of shade were laid in with a band of parallel hatches, as seen on the right side of the figure. Finally, the individual forms were isolated by small groupings of short strokes in various directions to shade and define forms, as seen in the lower belly and upraised arm of the figure.

The British Museum and Casa Buonarroti sheets show that Michelangelo was studying from ancient sculpture to perfect drawing the shadows and volume of three-dimensional works. The halting sense of anatomy, developing pen technique, and the subject suggest they were executed in Rome, probably in the late 1490s, and not in Florence when he a student in the 1480s. I have to admit that they do not correspond to his sculptures at the time, which were plain and simple. The juvenile sense of anatomy and evolving pen technique don't correspond to the fluid anatomy of his works in marble, like the *Bacchus* from 1496 to 1497, the *Pietà*, and even his early relief of the *Battle of Lapiths and Centaurs*. If I were simply an analytical art historian, I would say that, based on the discrepancy of anatomical knowledge, these two drawings must have been made in Florence rather than in Rome. However, being a creative art historian,

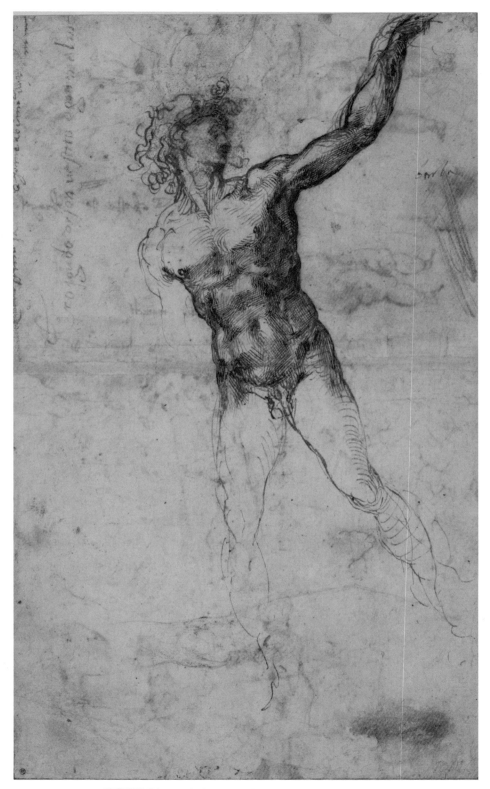

FIGURE 24: Michelangelo, figure study, pen and ink,
375 x 230 mm (14.7 x 9 inches).

FIGURE 25: Alan Pascuzzi, reconstruction of figure study in pen; charcoal sketch, initial pen lines, finished drawing.

open-minded to what my experience as a practicing artist tells me, it seems obvious that, at the time, Michelangelo could sculpt anatomy but wasn't able to draw it.

This may seem implausible to some, but I've had many students who were able to sculpt better than they drew. We feel forms better with our hands, and in sculpting there is a more direct connection between the eye—which sees the three-dimensional object at a remove—and the hand, which models the forms directly. With drawing, what you see has to be translated from three to two dimensions with the use of lines and shading. It is almost like translating one language into another. So it's not surprising that Leon Battista Alberti, a key figure in the early Renaissance who is considered the epitome of the Renaissance man, states in his *Treatise on Painting* that "it is easier to find relief in sculpting than in painting."

In Rome, Michelangelo was trying to obtain work not just as a sculptor, but also as a painter, despite never having finished his painter's education. Several documents related to his Roman period record payments for a panel painting that is believed to be *The Entombment* in the National Gallery in London (Figure 26). The connection between the documents and the painting is speculative and problematic, especially since neither Condivi nor Vasari mentions any painting done by Michelangelo while in Rome. Yet, there is good reason to believe that the Casa Buonarroti drawing (Figure 23) may be a study for the *Entombment* panel. The long curve of the body from the foot to the head in the drawing is comparable, in reverse, to the female figure to the immediate right of Christ in the painting. Once reversed, a female head was added and an arm was placed alongside the body to create the figure.

In addition to this drawing, there is a pen study in the Louvre (Figure 27) of a kneeling female for the figure of Mary Magdalene that is located in the lower left corner of the *Entombment* painting. The drawing is amazing for a number of reasons, the first being the mere fact that it shows a

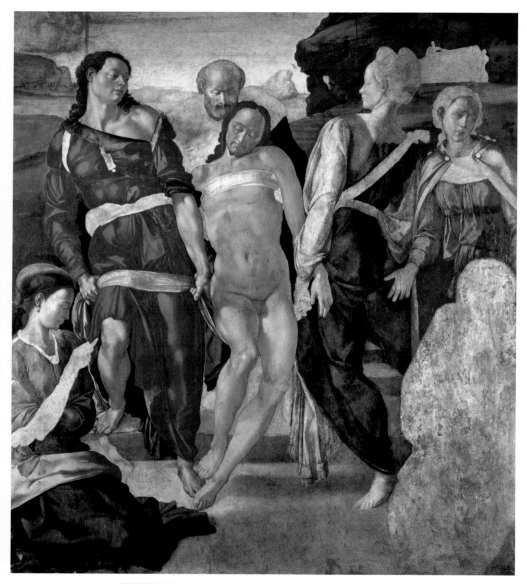

FIGURE 26: Michelangelo, *The Entombment*, tempera.

female nude. It is unlikely that the female figure was drawn from a Roman sarcophagus, as some art historians have speculated based on other drawings from this period. The subtle details of the braided hair, developing breasts, and wide hips instead suggest a living human. Michelangelo must have had a living model pose for him, either a young male whose form he then feminized or, even more incredibly for an artist at the time, a young girl or young woman.

The use of nude models, specifically female models, by Renaissance artists is an interesting topic. It touches on a number of aspects of Renaissance society, from social taboos to artistic practices, that could be the subject of another book. In brief, nude male models were commonly used by apprentices in the workshop to learn anatomy and by the master to make studies for paintings and sculptures. There exist hundreds of drawings of male nudes or mostly undressed youths from this time. Study drawings of female nude models, however, are fairly rare. The majority of female nudes were probably drawn from ancient sculptures or sarcophagi, which were the primary sources of female anatomy generally available to Renaissance artists, apart from their wives or partners. Perhaps the best example is Botticelli's use of a *Venus Pudica* sculpture or the other ancient female nudes in the Medici collections as the likely basis of his painting of Venus. While there are some examples of artists drawing from female nudes—in particular Pisanello—the Catholic religious stigma about nudity and the rigid social rules of conduct for women resulted in only a small number of life studies from the female nude surviving. If the study of the female nude in the Louvre was indeed done from life, it must have been a rare experience for the young Michelangelo—and for any other young artist—given the limited number of studies from live female models from this period.

Aside from the subject, the technical aspects of the drawing also date it to his Roman period. At this point in his career, he had studied mainly sculpture and wasn't completely proficient in the common techniques

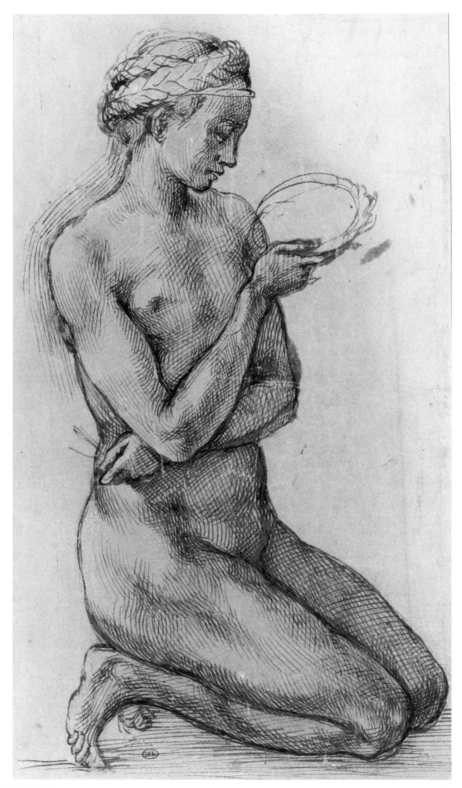

FIGURE 27: Michelangelo, study for kneeling female figure, pen and ink with red tint,
270 x 150 mm (10.6 x 5.9 inches).

known to all painting apprentices. It seems that he extrapolated from what he knew of these techniques and adapted them. For example, the drawing of the female nude is on pink-tinted paper with white highlights, the only instance of this in all of Michelangelo's extant drawings. The tinting is a carryover from the practice in Ghirlandaio's and other Florentine workshops of tinting papers for silverpoint and using white highlights, as exemplified, for instance, in Ghirlandaio's pink-paper studies for the frescoes of Santa Maria Novella. The painting commission required Michelangelo to return to lessons he had learned in the workshop and to mimic his master's process, altering it, though, by using pen and ink instead of silverpoint.

Anatomically, the general form of the body shows once again the tentative, near-continuous outline, with shading done by means of long, straight, crosshatched lines with minimal short and curved strokes—just like the Apollo drawing. Also similar to the previous drawings are the hands and foot of the female, which are out of proportion to the figure and not anatomically accurate—they are not well drawn. The only major difference between the Louvre drawing of the female nude and the previous studies in pen of male nudes for *The Entombment* is in Michelangelo's parsimonious use in the former of finer, more controlled pen lines to create form. Fewer pen lines combine with more open space to create form—less is more, as the accomplished artist knows.

By 1500, Michelangelo had established himself as a sculptor with a number of significant works. The Casa Buonarroti pen drawing and Louvre study of the female show he was still developing as a draftsman and painter. The sheets show him putting into practice what he had learned from Ghirlandaio, such as executing careful studies for his paintings. He was, however, still learning anatomy and how to represent form.

7

Michelangelo Returns to Florence,
1501–1504

RETURN TO FLORENCE

In the years Michelangelo was away from Florence, the city went through a tumultuous political upheaval. Beginning with the occupation of France's King Charles VIII's troops in late 1494, the Medici were banished. A theocratic government was imposed by the Dominican monk Fra Girolamo Savonarola, whom the Florentines eventually turned on and executed in 1498. The upheaval ended with the establishment in 1501 of a republican form of government under Piero Soderini as *gonfaloniere*, or mayor for life.

As soon as the political situation in Florence stabilized—in essence, as soon as Michelangelo thought he wouldn't get beaten up in the streets for being pro-Medicean—he ended his self-imposed exile and returned home. This was in May 1501. When he did so, it was as a sculptor looking for work, and he found it in abundance. In June, after only one month in Florence, he contracted to make fifteen figures for the Piccolomini altar for the Cathedral of Siena. In August, he received his most important

commission from the Opera del Duomo for a giant figure of David. While he was carving the *David*, he signed an agreement to sculpt twelve apostle figures for the Duomo of Florence. In late 1503 or 1504 he received sculpture commissions for the Bruges Madonna and the Pitti and Taddei *tondi* (a *tondo* is a circular work of art). Sometime after this, he took on a painting commission from the rich merchant Agnolo Doni—the *Doni Tondo* now in the Uffizi.

From 1501 to 1506, Michelangelo was commissioned to produce thirty-two sculptures for various patrons in Florence, Siena, and Rome, as well as a large painting. He managed to finish the painting, but of the thirty-two sculptures he was supposed to produce, he only completed eight.

The traditional Renaissance approach for any commission was for the artist to execute numerous drawings for each commissioned work. These consisted of initial idea sketches, composition or presentation drawings for the patron, and numerous study drawings of anatomy from a live model. These anatomy drawings undoubtedly consisted of figure studies and precise drawings of heads, hands, and feet. Several sheets attributed to Michelangelo are directly linked to his sculpture and painting commissions. These sheets reflect a new level in his drafting skills. Two of them are pen drawings in the Ashmolean (Figures 3 and 28) that provide evidence of his self-directed study of anatomy. Both show a concentration on the back of the model, with special attention to the scapulae and the intricate play of back muscles. If you have ever drawn from a live model, you know that drawing the back of a nude figure is not easy. The back is an expanse of flesh with various muscles and bones visible beneath the skin. There are no distinct points of reference that one can use to measure and grasp anatomical elements, unlike the front of the torso, where the nipples, abdomen, navel, pectorals, breasts, and so on, provide points of reference. Further complicating drawing, the back is the complex interaction

of muscles of the deltoid, trapezius, latissimus dorsi, and even gluteals, which all change significantly if the arms are raised or the body is turned. Michelangelo's commissions to do large figures in sculptures and paintings, in some cases in the nude, forced him to isolate and concentrate not only the front of figures but also the back, as these drawings demonstrate.

The first Ashmolean sheet (Figure 3) shows, in the lower left, a drawing of a back in which Michelangelo analyzed the complex relationships of scapulae, latissimus dorsi, external obliques, and gluteals. Every form is carefully rendered with short curving strokes that nearly cover the entire surface. The same approach to drawing the back can be seen on the second Ashmolean sheet (Figure 28). It concentrates specifically on the upper back and shoulders in various positions. There is also a curious complete figure in the center, who looks like he is in the act of digging. If put side by side, the two sheets show similarities in the pen lines, style, and size (both are approximately 260 x 185 mm—10 x 7 inches) that indicate they were used in the same period—and perhaps were even part of the same paper supply. The drawn figures on the two sheets also have the same scale. At this time, Michelangelo gravitated toward drawing figures in a smaller scale—a sign that he was improving, that he had better control of line and was able to draw smaller.

When I was teaching drawing, I made my students use paper that was no larger than 30 x 40 cm (11.8 x 15.7 inches), which for them was small. At first many complained that in other drawing classes they had been given huge pads of paper and drew figures four times larger than they did in my class. I have never understood the value of drawing so large. Not only is it a waste of paper, but I think it's also more difficult since you have to wave your arm all over the place just to do a single drawing. The smaller the drawing, the more you can see all of it and totally conceive of the proportions and gesture. All you have to do the whole time you work on it is move your wrist and maybe your forearm. I used to tell my

students at the beginning of the semester, "Those who can only draw big things well have trouble drawing small things, while those who can draw things small well can draw anything large with no problem." I'm not sure they all believed me (in the beginning of each semester they thought I was loony), but to support my approach I would tell them to look at the size of the drawings of the Renaissance masters—they are all mostly small and

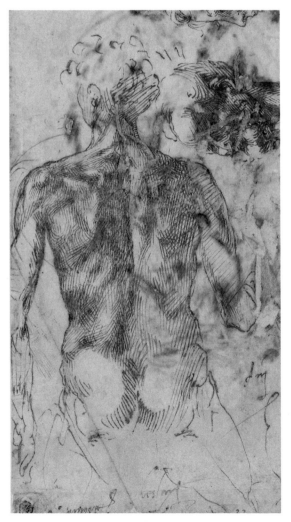

FIGURE 3: (detail)

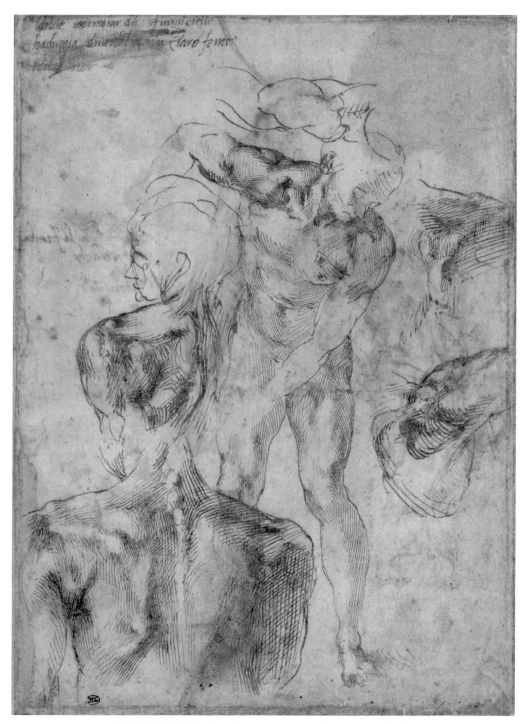

FIGURE 28: Michelangelo, anatomy studies, pen and ink,
262 x 185 mm (10.3 x 7.2 inches).

no bigger than 30 x 40 cm. "If drawing small made the masters so skilled," I would say, "then it is good for you too!" Only at the end of the semester, when my students got used to drawing small and accurate drawings, did they believe me.

NEW APPROACH TO DRAWING

Copying these two sheets revealed a new approach in Michelangelo's drawing at this stage in his life. Up to this point, almost all of the previous drawings I've discussed, apart from Michelangelo's initial student sketches from model books, show an isolated subject, central and almost "composed" on the sheet, with ample space around it. The two Ashmolean drawings aren't composed but have subjects overlapping in various states of completion. Why is this so significant? In my own artistic development, when I was beginning to learn how to draw, I was mindful of making "a good drawing" and carefully locating it on the sheet. After a time, however, this meticulous care in placing the drawing on the sheet fell away, and I began to concentrate only on obtaining a correct drawing of the object studied—sometimes even going off the page. In the haste of studying the backs in the Ashmolean drawings, Michelangelo no longer seemed to care about how the drawing looked; he was concerned only about understanding and recording the forms through the drawn line. This, I believe, is an indication of the change in Michelangelo's mindset—from diligent student completing an assignment to artist burning to learn more.

The first Ashmolean sheet (Figure 3) contains several head studies too. One is a female head, second from the bottom in the lower right corner. It is mapped out, as it were, using the system that every beginning art student learns to correctly draw the features of the face. First you draw an oval. Halfway down is the eye line. Halfway between the eye line and the chin is the nose line. About halfway between the nose line and the chin is

the mouth line. *My God*, I thought when I first copied this small detail, *Michelangelo was mortal! He used the same basic system as anyone else does!* This has to be heartening for any beginning art student.

FIGURE 3: (detail)

The mapped-out female head is not the only amazing thing on this sheet. When the sheet is turned horizontally (which Michelangelo must have done in drawing), you can see a series of three small portrait studies in pen. At right is a long-haired youth who is seen bare-chested. At far left is a profile view of a middle-aged man. Between these two portraits is a study of an older man with a large mustache, beard, and balding hairline. As an art historian, I could cite the interesting visual tracing of the three ages of man, but instead I chose to concentrate on the middle portrait. The portrait of the older man is labeled underneath with the name "Leonardo." *Leonardo? As in da Vinci? Could Michelangelo have made a portrait of Leonardo?* I asked myself. This possibility opens up a number of questions. Historians have always assumed that there was an open antagonism between the tall, handsome, refined, and intelligent Leonardo da Vinci

and the short, broken-nosed, dirty (being a sculptor) Michelangelo. This is based on a number of documents detailing the famous feud between the two over which was the superior art form, painting or sculpture. There is not sufficient space in this book to address the matter, but the small head study of what could be Leonardo raises the possibility that Michelangelo not only knew the older artist—of course, he knew him—but also drew him! But this small sketch is not the only case of Michelangelo openly admiring Leonardo in his drawings. We'll come back to that in the next chapter.

"FOR HIS ART": ANATOMICAL STUDIES FOR THE *DAVID*

These concentrated studies of the human figure coincide with the documented fact that Michelangelo was at this time conducting dissections of human corpses. According to Condivi, Michelangelo made many dissections throughout his life. He recounts one occasion in 1496 when the young artist was provided with a room and dead bodies by the prior of Santo Spirito, whom the artist is said to have known well. Condivi writes that "he worked on so many human anatomies that those who have spent their lives at it and made it their profession hardly know as much as he does." Condivi's account is supported by a short passage in the gossip sheet of the age, the *Anonimo Magliabechiano*, which reports that Michelangelo was cutting up bodies. However, unlike Condivi, the passage in the *Anonimo Magliabechiano* suggests that Michelangelo was caught in the act and apprehended, not just for dissecting bodies at Santo Spirito, which alone could be punishable by death, but for mistakenly cutting up a deceased member of the Corsini family, one of the most important families in Florence! The passage recounts that Michelangelo was brought before Piero Soderini, the magistrate of justice, in order to be tried. Instead of punishing Michelangelo, Soderini absolved him of any wrongdoing, since the youth was studying to perfect his art.

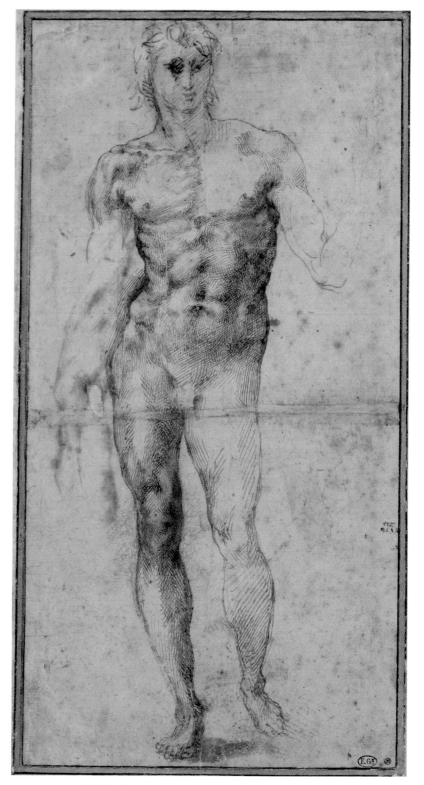

FIGURE 29: Michelangelo, figure study for *David*.

Michelangelo's concentration on anatomy, both surface and internal, is evident in several other studies in preparation for his most important sculpture commission during this period, the *David*. He must have executed many small models, as any sculptor would have done, but only after making numerous drawings from live models. There are four sheets that can be linked with the *David*. Imagine Michelangelo, a competent sculptor, given the task of creating a seventeen-foot work in marble of a nude youth to decorate the most important monument of the city, the enormous cathedral known as the Santa Maria del Fiore. You cannot fake anatomy on a seventeen-foot sculpture. On a smaller piece of sculpture perhaps, but when you have to sculpt that large, you cannot make mistakes. The huge commission must have inspired, not to say forced, Michelangelo to go to great lengths in studying anatomy to get the figure right. In the three years it took to execute the sculpture, a substantial amount of time was spent making drawings before he even began to carve. There are two drawings, one in the Louvre (Figure 29), the other in the Albertina Museum in Vienna (Figure 30), that show Michelangelo studying the human figure in its entirety to record visual information used to execute the marble *David*. These drawings were executed not for painting but for sculpture and fix on paper direct views of the figure to be used in carving. The Louvre drawing has a nude male figure in contrapposto (i.e., with his weight on his right leg, left leg slightly bent) with his right arm down at his side and his left arm up. This is the same position as the *David*. The entire figure is studied with special concentration on the torso and weight-bearing leg. Michelangelo was clearly trying to understand the complex interaction of the rectus abdominis, serratus, ribs, and pectoral as the figure bends under its own weight. The drawing is executed from a strictly frontal view, which provided important visual information for carving the figure from the block of marble.

As the Louvre sheet shows the figure from the front, the Albertina sheet shows a similar figure from the back. This almost complete figure,

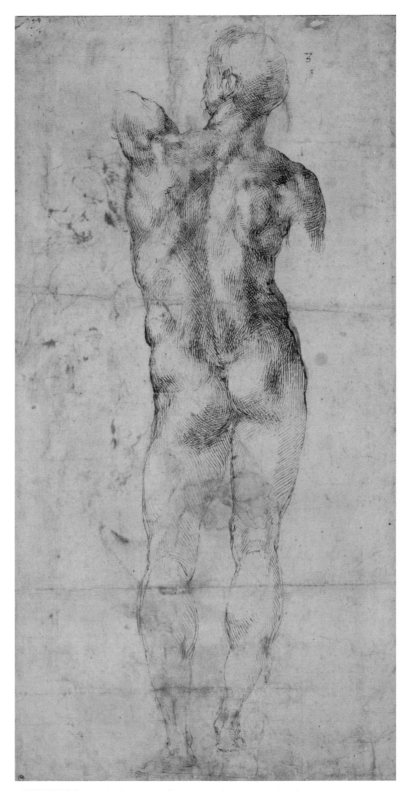

FIGURE 30: Michelangelo, figure study, pen and ink, 390 x 195 mm
(15.3 x 4.1 inches). The Albertina Museum, Vienna.

coinciding with the drawing from the Louvre, shows Michelangelo con-centrating on the back—in a manner similar to the previously discussed Ashmolean sheets of back studies—and demonstrates a sound understand-ing of the interaction of the muscles. Michelangelo could refer to both the Louvre and Albertina sketches for information when he was establishing the contours of the figure on the face of the block and while carving the marble to pull out the muscles.

Both drawings also hint at a sophistication of design process. In the Louvre and Albertina sheets, Michelangelo studied only one particular element (torso, back) and left the other parts unrefined. These unrendered details were to be studied in other drawings. In fact, two other sheets in the Louvre contain two separate studies of the left arm of the *David* figure (Figures 31—which is my exact copy of the drawing—and 32). As if dis-secting the body with a sketch, Michelangelo isolated the left arm to study the ripples of the skin over the bones and muscles of the biceps and fore-arm. The first sheet (Figure 31) shows the left forearm of the *David* as if an *exorchè* study with no skin. On the other sheet (Figure 32) is the same forearm, this time with a layer of skin and attached to the hand and shoul-der. This sheet also contains what is generally accepted to be a study sketch for a small David Michelangelo is supposed to have created for Pierre di Rohan. It also includes the famous short poem related to the *David*, "*Davicte cholla fromba ed io choll'archo, Michelagniolo*" ("David with his sling and I with my bow, Michelangelo"), a reference to Michelangelo slaying his giant with the bow drill (a hand-held drill, powered by string around a bit attached to a bow to turn it) as David slew Goliath with his sling.

These four drawings reflect a new level of pen-and-ink technique in Michelangelo's work. While copying, I noticed that the pen strokes were short and tight and followed the forms. Each form was isolated, evenly shaded, but never overshaded. The rendering of the forms with lines and open areas appears to impart a sheen to them—something difficult to obtain with pen. All of the studies indicate that Michelangelo was looking

FIGURE 31: Alan Pascuzzi, copy of Michelangelo study for *David*, pen and ink, 316 x 152 mm, (12.4 x 5.9 inches). (Original in Louvre.)

FIGURE 32: Michelangelo, studies for *David*, pen and ink, 262 x 185 mm (10.3 x 7.2 inches).
This sheet contains the poem "Davicte cholla fromba ed io choll'arco, Michelangiolo"
(David with his sling and I with my bow, Michelangelo).

for, seeing, and drawing the complex interaction of muscles of the body. They evidence an increased sophistication, density, and refinement of his pen technique. As I was viewing these drawings, it occurred to me that Michelangelo probably isolated every single element of the figure of the *David*, from head to foot—even the toenails. If this was the case, we must be missing hundreds of drawings. I've often wondered if some are still around, hidden in some old trunk in a dusty attic in some palazzo in Florence. . . .

DEVELOPING SKILLS

In addition to the extant drawings related to the *David*, there are two other sheets from this period that provide insight into Michelangelo's creative mind. The first is in the British Museum in London (Figure 33), with eight studies of a small child connected to the *Pitti* or *Taddei* tondi—two round high-relief sculptures done for separate important Florentine families. The British Museum sheet reflects Michelangelo's need to study the pudgy forms of a child's anatomy for the infant Christ in the sculptures, which also depict Saint John the Baptist. The true significance and importance of this sheet is generally overlooked. First, anyone with children knows just how difficult it is to *look after* a one- or two-year-old—they never stay still. Now imagine trying to *draw* from a two-year-old. I drew my children even before they began to walk. You cannot imagine how frustrating it was to try to get the baby anatomy plus all the folds of flesh while they were moving all over the place. No sooner did you render the contours than they moved or turned away. To shade them is even more difficult, and I often had to first draw the contours while the child was in one position and then start another pose, only to come back to the previous position to render it as fast as I could.

This is what I think happened to Michelangelo. First, he had to locate a small child (friend or family), then position himself on the same level

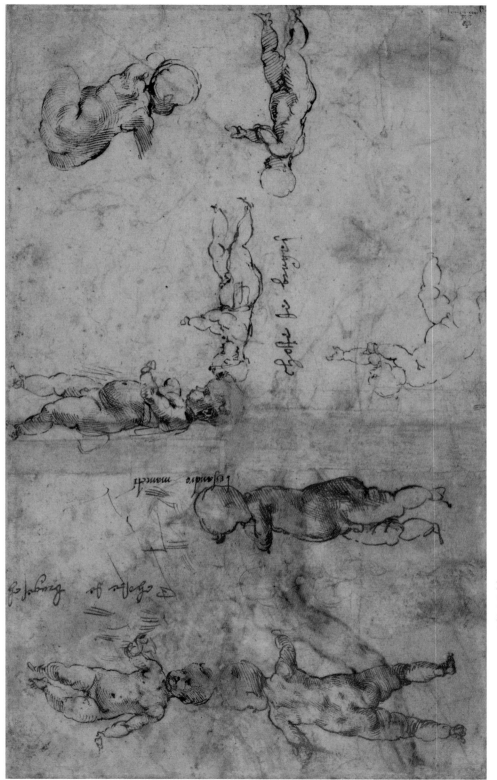

FIGURE 33: Michelangelo, studies of infants, pen and ink, 375 x 230 mm (14.7 x 9 inches).

and have his pen and ink ready to jot down the contours at lightning speed. You have only at most a minute or two before the child walks away or moves. Six of the sketches are no more than contour studies; only two have any rendering. I can imagine him rapidly dipping his pen in the ink, turning the paper (perhaps even laughing or cursing), trying to understand the curves, the pudge, the ripples of the toddler. Drawing from children is perhaps the most difficult thing any artist can do. It requires a high degree of observation, speed, and patience—signs of a maturing hand. I love this sheet because I know what it took to make it. It may have no art historical significance to others, but it represents a small advancement of artistic development that I was happy to have experienced when drawing my own children.

The final drawing to explore from this period of Michelangelo's life is on a fantastic sheet in the Staatliche Museen in Berlin (Figure 34), which can be tied to the *Doni Tondo* executed in the early 1500s. This sheet is important for the small studies that vaguely relate to various elements in the painting: the female head in profile, perhaps for the Madonna, and the small child study in the lower left whose dynamic pose is similar to the energetic Christ child in the painting. However, the elements of the drawing are second to the virtuoso pen technique and the way the heads, faces, and figures seem to blend into one another. The pen technique is complex and renders each and every form to its fullest—a sign of Michelangelo's mastery. He drew what he wanted to, how he wanted to, without hesitation or difficulty. No timid lines, no redrawn contours, no overshaded forms. I remember having great difficulty copying (Figure 35) this drawing, not only for the handling of the pen but to recreate the stream-of-consciousness drawing, rendering, and blending of faces and figures. If there is any drawing that discloses the stream of ideas in Michelangelo's head, it is this one.

In the four years he was back in Florence, he grew artistically, mainly thanks to receiving some of the most important commissions of his time,

including the *David*. Having talent is one thing, but you need big commissions to truly force mastery to emerge. Michelangelo was fortunate to have had large commissions in his early career that challenged him and imposed higher levels of difficulty. This forced him to draw creatively— and learn and grow more as an artist. Good artists always try to push themselves. Self-imposed work sometimes doesn't bring out the truly innovative creative talent of artists, while large commissions with patrons who impose their desires on the artist can push them more effectively to explore new directions that they may have not taken by themselves. The patron with the large commission forces the artist to take more chances, extend himself beyond his artistic comfort zone, and realize innovative art while growing artistically. By 1504, Michelangelo had risen to the various challenges he had been accorded. His next big commission, for the *Battle of Cascina*—in direct competition with the greatest artist of his age, Leonardo—would push him closer to his final formation as an artist.

FIGURE 34: Michelangelo, studies for *Doni Tondo*, pen and ink.

FIGURE 35: Alan Pascuzzi, copy of Michelangelo studies for *Doni Tondo*,
287 x 209 mm, (11.2 x 8.2 inches).

8

The Drawings for the Battle of Cascina

AN ARTISTIC BATTLE

Immediately after completing the *David*, Michelangelo received another large sculpture commission that would take his drawing skills to a new level. Late in the summer of 1504, while still occupied with numerous other projects, he was engaged by the newly reformed Florentine republic to paint a larger-than-life-size fresco representing the Battle of Cascina in the Sala del Gran Consiglio in the Palazzo Vecchio. The Battle of Cascina, which took place on July 29, 1364, resulted in a celebrated victory by the Florentine army over the forces of its rival city-state, Pisa, during a period of constant conflict for control of the region around Florence. Leonardo da Vinci had been commissioned several months earlier to execute a painting in the same room of the Battle of Anghiari, the occasion of another military victory, in 1440, that ensured the city's dominance. For Michelangelo, the project presented a series of firsts: the huge painting was to be executed in the technique of buon fresco, which Michelangelo had never done before. This technique requires painting quickly on wet plaster, and with no opportunity to correct mistakes after the short time it takes the plaster to dry. The commission was the first significant

challenge to the still-developing compositional skills of the twenty-nine-year-old artist; and it was the first time he would be in direct competition with the most skilled and respected artist in Florence and in all of Italy.

Battle scenes were common in city halls throughout Tuscany and Italy. Scenes of victorious armies demonstrated a strong state capable of defending itself and creating a civic identity. An early example is the Sala del Mappamondo in the Palazzo Pubblico in Siena, which has numerous such scenes painted by Lippo Vanni. Battle scenes were not easy to paint, as artists were asked to depict large landscapes with dozens if not hundreds of figures and horses in combat. Compositionally, the difficulty was to create a cohesive scene that clearly told the story of the victorious city-state over its enemies. In the Sala del Mappamondo in Siena, the scene depicted by Vanni was Siena's forces beating Florence's. In the great hall in the Palazzo Vecchio, Leonardo's assignment was to show Florence's army beating the Sienese, while Michelangelo was tasked with depicting Florence beating the Pisans. In both cases, both artists were challenged to conceive, compose, and execute a complex scene of horses, foot soldiers, and combat.

The exact location of both frescoes is unknown and disputed by scholars. Some scholars believe that the frescoes were to be opposite each other, while others maintain that they were to be side-by-side. Scholars do agree that, based on calculations of the walls and decorative schemes, both of the works were to be approximately twenty-four by sixty feet!

Michelangelo's involvement in the decoration of the Sala del Gran Consiglio was a result of the unstable political climate in Florence in the early years of the 1500s and perhaps the artist's flip-flopping political sympathies. Immediately after the occupation of Florence in 1494 by the French army of Charles VIII, and the subsequent fall of the Medici (leading to Michelangelo's departure from Florence because of his ties to his benefactor), the Florentines decided to form a new government based on the model of the Venetian Great Council—that is, with numerous

representatives of the people meeting together in a great hall. Under the growing sway of the fiery Dominican monk Fra Girolamo Savonarola, the new government decreed that a meeting hall should be constructed in the Palazzo Vecchio to house the members of the Great Council. By 1497, the entire hall was nearly finished, complete with coffered ceiling and paved floor.

After the fall of Savonarola and the election of Piero Soderini as gonfaloniere in 1502, efforts were made to enlist the best artists in Florence to decorate the hall. In the autumn of 1503, the new government under Soderini determined that the subject matter should be scenes of Florentine victories over rival city-states. On May 4, 1504, Leonardo da Vinci was commissioned to paint the fresco of the Battle of Anghiari. With Michelangelo's close ties to the Medici now long forgotten—especially after his public acclaim for the *David*—the young artist could now be entrusted with creating a huge propaganda work in the seat of the republican government.

The choice of Leonardo was obvious, as he was already famous for such works as *The Last Supper* in Milan done in 1495 (which, ironically, had already begun to deteriorate due to a faulty mural painting technique), as well as other masterpieces. Their choice of Michelangelo is curious, however, since he was known primarily as a sculptor and had probably never executed a fresco before in his life. Perhaps the only connection Michelangelo had with fresco was his early apprenticeship with Ghirlandaio, the best fresco painter of the late 1400s, yet it's likely he never got far enough to actually paint in the technique before leaving Ghirlandaio's workshop for the Medici sculpture garden. There is no mention in any document of any other artists being considered for the work, even though numerous painters would willingly have taken on the project. No extant documents give the precise date when Michelangelo was commissioned, but several scholars have determined that he began working on the large preparatory drawing sometime in the late summer or early fall of 1504.

FIGURE 36: Peter Paul Rubens (1577–1640), copy of *Battle of Anghiari* by Leonardo.

THE CRAFT OF PAINTING IN BUON FRESCO

But did Michelangelo know how to paint in fresco? In Cennini's treatise on art for apprentices, the section on buon fresco—or fresco painting—comes after sixty-six other short chapters on how to learn to draw and make colors, brushes, and other things one needed to know to become a painter. This means that, before learning to paint in fresco, apprentices had to master not only the artistic aspects—drawing, line, shadow, etc.—but also the craftsman side of painting: making tools, mortar, and the like. When a young boy was deemed proficient enough in his profession to begin painting, he began with fresco.

Fresco is the technique of painting on damp plaster with water-based pigments. The mortar is made of a calcium-based lime paste and sand. Essentially the lime paste is made from marble—a calcium carbonate—that is burned. Burning marble at high temperatures removes the carbon dioxide and "depletes" it. This "depleted" marble, now calcium oxide, is mixed with water and then left to age for a number of years. The result is a sort of Cambell's condensed cream of marble paste that looks just like white yogurt. This is called a calcium hydroxide. This lime paste is mixed with sand to make a mortar and applied to the wall. As soon as it comes in contact with the air, the lime paste in the mortar begins to dry and, losing water, begins to regain the carbon dioxide, thus slowly returning to its original composition as a calcium carbonate, or marble. Before it dries into a piece of marble, however, you can paint on it with water-based pigments. The water mixed into the natural powdered pigments acts as a vehicle for the particles to penetrate until they are fixed into the matrix of the mortar. When the mortar dries, the particles of pigment are literally locked in hermetically and sealed into a piece of marble. That is why fresco is so durable.

The major drawback to this technique is the time factor, which is due to the extremely sensitive nature of the mortar to atmospheric conditions. A cold or damp environment will cause the mortar to dry slowly; a hot or

dry environment will cause the fresco to dry fast. To assure proper execution, fresco artists painted large works in small sections, called *giornate*, literally, "a day's work," which is a small patch of mortar that can be painted in an approximately two-hour time period before it dries. Starting from the top of the composition, fresco artists painted one small patch at a time, then joined the next giornate to it in a sort of jigsaw puzzle method of execution. Painting in fresco requires skill, speed, and above all preparation. When I taught fresco in Florence, I used to tell my students that fresco is 95 percent preparation and 5 percent execution. Colors must be mixed and ready before painting. The wall must be prepared. Most importantly, the subject to be painted has to be completely worked out and established before beginning to paint. Cennini's treatise underscores the importance of knowing how to prepare the materials in making a fresco. The fact that Michelangelo may have had some experience with the craft of fresco in Ghirlandaio's workshop but most likely hadn't become proficient enough to actually paint in it makes his being commissioned to do the *Battle of Cascina* even more amazing.

To execute a large fresco, artists would transfer previously prepared drawings to the wall, which wasn't easy given the limitations of the size of pieces of paper during the Renaissance (typically 30 x 40 cm). It was common artistic practice to begin by making a copious number of drawings in order to work out the general composition. This includes doing numerous individual studies of figures, faces, hands, and in this case, horses, armor, and other military objects to put in the scene. Once all the studies were completed, artists executed a preparatory *cartone*, or cartoon, which comes from the Italian word *carta*, meaning "paper." *Cartone* is a derivative of the word that means "big paper" (in Italian, if you add *-one* at the end of a word, it becomes "big"—e.g., *pizza* becomes *pizzone*, which means "big pizza," etc.). In order to work on a large sheet of paper, artists, or their apprentices, had to glue many normal-size sheets together to make one big one. Based on the preparatory studies, the artist drew his

composition on this large sheet, enlarging things manually—all by hand. The preparatory cartoon was then prepared for transfer onto the wall using various methods, such as the *spolvero* technique, which involves poking small holes through the paper where the lines were drawn. The "pricked" cartoon was then placed on the damp plaster of the fresco and dusted with a pounce bag full of powdered pigment or crushed charcoal. The colored dust went through the holes and were fixed onto the fresco surface, thus leaving a dot matrix line exactly like the line of the drawing, which guided the artist in painting the fresco. Making a cartoon—gluing the paper, drawing the composition on it, pricking the composition full of holes (which can take days), and finally fixing it to the wall to paint the fresco—requires a tremendous amount of precise calculation and physical labor (i.e., both craftsmanship and artistry).

Many do not understand the difficulties in executing frescoes and the close collaboration needed with other craftsmen to bring a large work to completion. I had the opportunity to execute several large frescoes in Italy and in Australia. For these works, which in some cases were more than ten feet high, it took days to glue the paper together to make the cartoon. I spent months doing the preparatory studies and weeks enlarging them by hand onto the large cartoon. In some instances, I literally spent days pricking the holes of the preparatory drawing. This is all in preparation for the execution of the work on the wall, which had to be done in close collaboration with masons. It is the masons who prepared the mortar for the wall to be painted. As artists and craftsmen, Michelangelo and Leonardo knew what had to be done to execute the works and approached them according to the standard artistic practice of the age. We know and have evidence that both men executed numerous preparatory studies for their works and also made large detailed cartoons to be used to transfer to the wall to execute the final work of art. I came across two references to the paper and preparatory cartoon of Michelangelo while doing my doctoral research on Michelangelo's *Battle of Cascina*. There is an amazing

document from October 31, 1504, that records the paper being purchased from the papermaker Bernardo di Salvadore "per il cartone di Michelangelo," that is, "for the preparatory cartoon." Yet another amazing document from December 31, 1504, records a certain Piero d'Antonio, who was paid to "help and paste the cartoon that Michelangelo is making." Michelangelo hired Piero because the cartoon was to be more than sixty feet long—that is a lot of paper and glue. (See Additional Documents Relating to Michelangelo in appendix 1.)

Leonardo and Michelangelo executed their cartoons and set to work on the wall, but things soon started to go wrong for both artists. Leonardo commenced working on his cartoon in 1504 and finished it in 1505. He moved it to the Sala and began the process of applying paint to the wall. Leonardo had had the idea of executing the work not in fresco but in a never-before-tested mural painting technique based on a wax encaustic method. According to various sources, he unsurprisingly had major technical difficulties with the technique and stopped working on the commission in 1505. The frustration must have been great, for after months of preparation and even starting to paint, Leonardo decided he couldn't continue. He eventually released himself from all obligations of the commission and left Florence.

Leonardo's failure to execute the *Battle of Anghiari* could have been a bittersweet revelation for the young Michelangelo. He may have been disappointed not be able to compete with him in a fair artistic fight. I believe, however, that he was probably relieved he would no longer be shown up by the older, more experienced, artist. In the end, Michelangelo's commission didn't fare any better, though. After completing the preparatory cartoon for his fresco, he was called to Rome in 1505 by Pope Julius II to begin procuring the marble necessary for his multi-figure funerary monument, interrupting the work in Florence. Not long after being summoned, Michelangelo was in the mountains of Carrara. The fresco project was put on hold. In the following months, he would return

to Florence repeatedly and make a valiant attempt to execute the fresco, but Julius II kept calling him back to Rome to execute various works. In 1508, Michelangelo was called to Rome to paint the Sistine Chapel ceiling, and never worked on the battle fresco again.

Though Leonardo and Michelangelo's battle frescoes were never finished, both artists executed hundreds of studies and preparatory cartoons, and some have survived. The best idea we have of Leonardo's cartoon is a copy done by Peter Paul Rubens (Figure 36) and other paintings by other artists. The most complete copy of Michelangelo's cartoon is a grisaille (monochromatic) painting by Bastiano da Sangallo that depicts the central portion of Michelangelo's composition (Figure 37). We also have copies of the cartoons, but what happened to Michelangelo's and Leonardo's original huge sheets of paper? No one knows about Leonardo's cartoon. However, some sources record that Michelangelo's battle cartoon was moved around to various locations in Florence until it was placed in the upper hall of the Palazzo Medici (now Palazzo Medici Riccardi) in 1515 or 1516. According to Vasari, it was then "carelessly" cut to pieces by various artists and dispersed all over Italy.

According to a historical account of the Battle of Cascina, Galeotto Malatesta, the commander of the Florentine army, had his troops camp on the outskirts of Cascina, on the Arno River near Pisa. Because of the heat, the soldiers had stripped off their armor and clothes and were bathing in the river, leaving the camp unguarded and vulnerable to the Pisans. Suddenly, one of the soldiers, Manno Donati, realized the possible danger and began rousing the relaxing soldiers with the cry, "We are lost." The soldiers hurried out of the water, put on their clothes and armor, and prepared for battle. The next day the Florentines routed the Pisan army. Michelangelo had had no experience creating large, multi-figure compositions up until this point, let alone a battle scene. He may have gleaned something of the composition process from his master Ghirlandaio when he was working on the scenes of the Tornabuoni chapel in Santa Maria

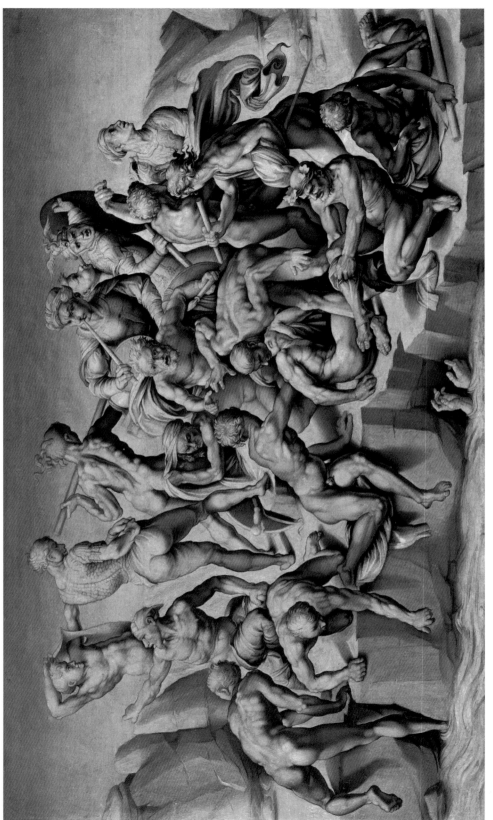

FIGURE 37: Aristotile da Sangallo, copy of *Battle of Cascina*, oil on wood, 76 x 130.2 cm (29.9 x 51.1 inches).

Novella, yet nothing he did or saw with Ghirlandaio could have prepared him for scenes of combat. However, an early example is Paolo Uccello's painting of the *Battle of San Romano*, which is now in the Uffizi and was present in the Medici palace when Michelangelo was living there as a youth. He may have seen this or been exposed to other works of sculpted battle scenes, in the same way that his early work of the *Battle of Lapiths and Centaurs* was probably inspired by an ancient piece in the Medici collections.

Sangallo's copy of Michelangelo's cartoon takes a scene not of the battle but of the moment when Manno Donati sounded the alarm and the nude soldiers scrambled out of the water. Why only nudes and not horses or armed soldiers? This and other extant copies of Michelangelo's *Battle of Cascina* take the opposite tack from typical battle scenes in town halls. The composition is more like a scene from a public pool than a battle. Why? I believe Michelangelo purposely eschewed a battle scene to avoid being shown up or outclassed by Leonardo. In my view, the Florentine government commissioned these two great artists to paint pendant battle scenes in the same hall in order to deliberately create a competition between the young, inexperienced Michelangelo and the older, experienced Leonardo, perhaps in the hope they would try to outdo each other artistically. Leonardo had studied horse anatomy and human anatomy, and his drawings for the battle scene show his mastery in creating a fluid composition of man and beast in brutal combat. Michelangelo chose to depict the one thing he was good at—the male nude—in the attempt to create a composition on the same level as Leonardo's.

MICHELANGELO COPYING LEONARDO?

Michelangelo's decision to use the male nude as his main subject was not his first idea. In fact, his drawings dating from his initial ideas for the cartoon consist of two kinds: studies of horses and compositional sketches of

FIGURE 38: Michelangelo, studies for *Battle of Cascina*, pen and ink,
186 x 183 mm (7.3 x 7.2 inches).
This sketch may have been made directly from Leonardo's *Battle of Anghiari*.

battle scenes between horsemen and foot soldiers. When I was examining and copying these sketches, it became evident, as incredible as it may seem, that Michelangelo had begun initially by copying Leonardo's ideas! A roughly executed sketch by Michelangelo of a complex battle scene that is now in the British Museum may have been taken directly from Leonardo's *Battle of Anghiari* (Figure 38). The hastily drawn pen lines show the basic forms of horses and figures in a swirling, chaotic motion that is typical only to Leonardo's works. It was only when I copied this in pen that I completely understood the scene: the horse at left leaps forward into the center, initiating the movement. There is a fallen soldier below and a standing figure in the center that continue the line of action to the rearing horse just recognizable at right. The leaping horses, distinct actions of the figures, and complex manner in which they are integrated suggest that this was not a first idea sketch. Michelangelo was good, but probably not able to have executed such an elaborate and complicated Leonardesque scene entirely from his own imagination. As I copied the contours of the rounded forms, I realized that none of the figures are shaded (for example, the sketch for an apostle on the top part of the sheet), nor are there are any pentimenti or "rethinking" or redrawn lines to show he was changing his idea. Rather, the careful construction of the composition from distinct elements suggests that it was taken from Leonardo's drawings or cartoon itself.

Further evidence for a connection between Michelangelo's sketch and Leonardo's design can be found in the similarity between the British Museum sketch and Leonardo's preliminary studies of horses for the *Battle of Anghiari*. A silverpoint drawing at Windsor Castle of the right profile of a rearing horse (Figure 39) has the same general action and lines (open mouth and forelegs) as the horse at left in the British Museum sketch. A sketch in red chalk at Windsor Castle (Figure 40) shows a similar rearing horse but with a rider more closely resembling Michelangelo's sketch.

This myth-busting idea that Michelangelo may have begun by imitating Leonardo took shape as I moved on to copy more of Michelangelo's

initial sketches for the battle scene. Another of his preliminary drawings is a large sheet in Oxford with three studies of a horse and a small battle sketch (Figure 41). In the lower left of the sheet is a small sketch of a horseman fighting three foot soldiers. At right in the small group is a horse that rears up, with a rider twisting and leaning forward with his left arm raised, about to strike the enemy. The twisting figure is similar to the movements of the figures in the central group of the *Battle of Anghiari* as seen in the Rubens copy. Above this is a large study of a standing horse—done from life, as demonstrated by its size and the extreme detail of the muscles carefully and slowly executed in long, parallel pen strokes. On the bottom half of the sheet are two studies of the hindquarters of a horse from different angles and stances. The sketches show Michelangelo's pen ability, but, in comparison to Leonardo's twisting, straining, rearing horses, his static, stiff, and even awkward horses clearly indicate his unfamiliarity with equine anatomy.

As I reproduced each of these studies line for line, a couple of things became evident. The British Museum sketch was totally unlike any other I had copied by Michelangelo in its compositional complexity. There were too many similarities between Michelangelo's horses and Leonardo's studies for the *Battle of Anghiari* to be a coincidence, and it dawned on me that I was copying from Leonardo as observed through Michelangelo's pen. Finally, there was a clear disparity between Michelangelo's almost clumsy sketches of horses and battle scenes and Leonardo's flowing composition. I remember putting all my sketches together and trying to arrange them in a sequence of execution. This is what convinced me that, copying Leonardo, Michelangelo had tried to compete with him on his own turf—and failed.

FIGURE 39: Leonardo, horse studies for *Battle of Anghiari*, red chalk, 167 x 241 mm (6.5 x 9.4 inches).

FIGURE 40: Leonardo, horse studies for *Battle of Anghiari*, red chalk,
152 x 143 mm (5.9 x 5.6 inches).

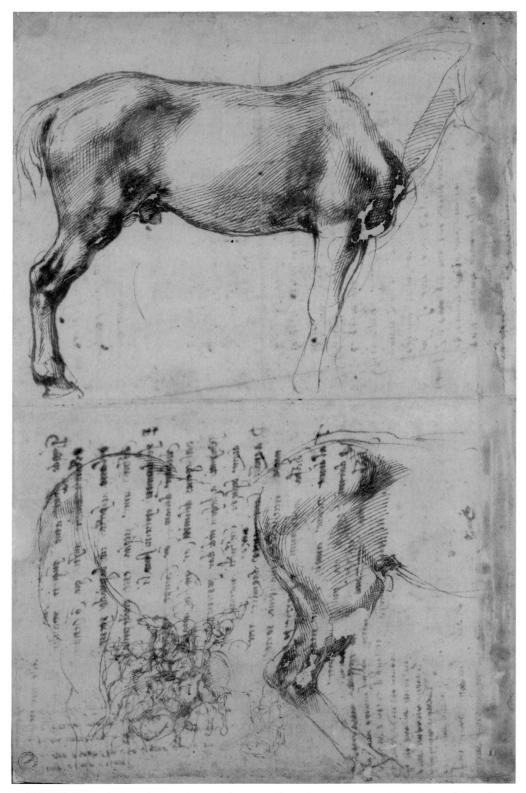

FIGURE 41: Michelangelo, studies of a horse and of a horseman attacking foot soldiers for *Battle of Cascina*, pen and ink, 425 x 255 mm (16.7 x 10 inches).

COMPLEX ARTISTIC RELATIONSHIPS

It seems obvious that Michelangelo and Leonardo must have had to inter-act and collaborate with each other during the commissions for the Sala del Gran Consiglio. However, placing two artists with different personal-ities in the same room can cause problems. Being an artist with a studio in Florence, I know what I'm talking about. In the early 1500s, just as in present-day Florence, all the most important artists undoubtedly knew one another and each other's work. Florence is a small city. Michelangelo and Leonardo would have interacted if only in passing on the street, something that happens to me every day with other artists. Besides this, Renaissance artists undoubtedly had to keep up with the works of other artists and constantly, if only internally, put themselves in competition with each other's skills. From my own rapport with other artists, I know there is a funny mix of mutual professional respect, disdain, and envy when confronted with other artists' work. Painters and sculptors are kind on the surface and may shower one another with compliments, but every word has a double meaning. A typical exchange when two artists cross paths with each other in Florence goes something like this:

ARTIST NO. 1: "Good morning, maestro."

ARTIST NO. 2: "Good morning to you, maestro."

ARTIST NO. 1: "I just saw your Madonna in front of the church in the piazza: it's brilliant. I especially love the expressive quality of the Madonna holding her child, which is absolutely masterful."

Translation: I saw your Madonna, and the arms are too long. After all these years, you never get the arms right.

ARTIST NO. 2: "Thank you. You're too kind. And what are you working on now?"

ARTIST NO. 1: "I'm working on a new large male figure."

ARTIST NO. 2: "I can't wait to see. I am sure it'll be fantastic.
Please let me know when you finish so I can come
and admire it."

*Translation: Your male figure will probably look out of pro-
portion like your other works, but I have to come and see it to
make sure I'm still superior to you.*

I know this sounds funny, but it's what we do. When I look at the works of my colleagues, I instinctively check for flaws or mistakes to justify my feelings of superiority to them, and I know other artists do the same when they look at my works. Even when you're forced to admit that another artist's work is valid, there is always the recourse of the backhanded compliment. For example, one day, a colleague was in my studio looking at my latest sculpture and told me, "You really have gotten much better at anatomy." This conflicted interaction among artists can get distressing when someone is really good or has done a very fine painting or sculpture. The frustration at not being at the same skill level after years of work is unbearable, and all you want to do is get back to your studio and make an even better work of art.

So did Michelangelo and Leonardo ever have an exchange like this? Yes, and we have a record of it. An astounding passage from the Renaissance-era gossip sheet *Anonimo Magliabechiano* reports a curious exchange between the two great masters in the streets of Florence in the early 1500s. According to the story, one day Leonardo was discussing a certain difficult passage from Dante with a group of *uomini da bene*—gentlemen—near the Church of Santa Trinita in present-day Via Tornabuoni. At that moment, Michelangelo happened to pass by, and Leonardo, aware that Michelangelo knew his Dante well, called out, saying that perhaps *he* could explain the passage to them. The young broken-nosed artist, thinking he was being mocked by the older, good-looking Leonardo, angrily replied, "Explain it yourself, you who designed a horse to be made in

bronze but couldn't cast it, and shamefully abandoned it." Having uttered this, Michelangelo turned away and left. Michelangelo was referring to the huge horse that Leonardo had spent months working on in Milan but had to leave aside, never completing the commission. According to the chronicle, upon hearing these words Leonardo became red (*diventò rosso*) with embarrassment or anger. Vasari, in his *Lives* of both artists, repeats this famous exchange, forever establishing the image of their mutual disdain. Their antagonism has been further embellished by modern art historical scholarship, which constantly wants to create an existential conflict between the natures and the beliefs of the two artists to the point of caricature—to wit, the angry, ugly, smelly sculptor in conflict with the serene, handsome, and genius painter.

The general eagerness to envision a conflict between these exceptional artists may have caused art historians to overlook clear evidence for the connections between them. While the two probably did have disdain for each other, that didn't prevent Michelangelo from copying Leonardo. Indeed, Michelangelo's copying may have been required by the commission itself, in a sense, to ensure visual unity between the two battle paintings. The Florentine government must have expected the final results of the "artistic battle" between the two to be a spectacular display of similar battle scenes that worked together in the shared space to the end of civic propaganda.

The question remains: How did Michelangelo's copying of Leonardo occur? Did Leonardo allow it? Or did Michelangelo sneak in and study Leonardo's composition? The drawings clearly show that Michelangelo copied from Leonardo's more finished and complex design. I can imagine him slipping into the great hall when Leonardo wasn't there and rapidly making the British Museum sketch. This could have spurred his thinking about battle scenes with horses and foot soldiers, as shown in the Ashmolean sketch. Ironically, just a few years later in Rome, Raphael would do the same thing to Michelangelo when he surreptitiously entered the

Sistine Chapel to study the partially painted frescoes on the vault—which would influence Raphael's own works in the Vatican. Michelangelo was in a tight spot: he had to create a battle scene, he needed ideas, and he was obliged to get them from his greatest rival—an artist who was superior to him. How he must have suffered doing that quick sketch!

AN IMPORTANT ARTISTIC DECISION

From the small number of drawings that survive of Michelangelo's early ideas for the *Battle of Cascina*, it is evident that he didn't, and perhaps couldn't, reach the same level of naturalism and compositional detail as in Leonardo's cartoon, with its swirling movement and anatomical complexity. The preparatory drawings demonstrate that Michelangelo approached the battle scene in a conventional way, with battle studies, horse studies, etc., but he must have realized that Leonardo simply had more experience with horses. This brought Michelangelo to the most crucial point of his young career. He had to make an important artistic decision: he could either continue following Leonardo's design and create a derivative work that would reveal his artistic weakness and be considered a lesser imitation, or he could follow his inclinations and bring the battle to his own ground, where he could call on his experience with what he knew best— the male nude. Michelangelo chose the latter and never looked back. Fortunately for him, the story of the Battle of Cascina allowed him to concentrate on the nude soldiers emerging from the water and putting on their clothes. As some art historians have rightly argued, Michelangelo probably included a scene of a battle in the background of the composition but kept the nudes as the central theme.

The next series of drawings Michelangelo executed for the battle scene show the young artist making his first and most significant step in thinking as an independent and individual master, free from Leonardo's influence. The first drawing that demonstrates Michelangelo's new approach

FIGURE 42: Michelangelo, compositional sketch for *Battle of Cascina*, black chalk, 356 x 355 mm (14 x 13.9 inches).

to the battle scene is a compositional sketch in the Uffizi of nude figures grouped in various positions (Figure 42). On the sheet are twelve figures roughly indicated with chalk contours. Although the composition is loosely sketched out, we can see muscular male nudes climbing out from the water, putting on breeches, and twisting, turning, and straining— exactly Michelangelo's forte. The sheet shows Michelangelo attempting to harmonize the various figures to create a balanced and dynamic composition. The general composition is similar to the Sangallo copy of Michelangelo's cartoon (Figure 37), including many figures that correspond directly to several separate figure studies.

The Uffizi compositional sketch is in black chalk—a new material for Michelangelo—but he reverted to his trusted pen and ink technique to execute his most detailed studies. One of the first finished studies in his new approach to the battle scene is a figure drawing in the British Museum (Figure 43) of a seated, twisting figure. It not only corresponds to Sangallo's copy but also to the Uffizi compositional sketch (seated, twisting figure at lower right). The sheet is large—420 x 285 mm (16.5 x 11 inches)—and was clearly executed with great care using a live model, and, judging from the pen technique, with great patience. The anatomy of the figure is highly detailed, as seen in the clearly identifiable muscles of the arm, shoulders, torso (with serratus and external obliques visible), back (latissimus dorsi), and legs (rectus femoris, gastrocnemius, etc.). The time it took me to copy this drawing demonstrated the passion Michelangelo put into executing it. The figure is clearly defined with strong contours— some broken, some reinforced (perhaps pentimenti)—and each muscle is isolated and indicated with short, curved, overlapped pen lines. As I reproduced the hatches in the knees and scapulae, I noticed that the lines do not overextenuate the bones, muscles, and tendons of the joints. My application of the pen lines became shorter, more precise, and part of a complex system of shading that showed that by 1504, Michelangelo had complete control of his pen technique. One unique thing about the

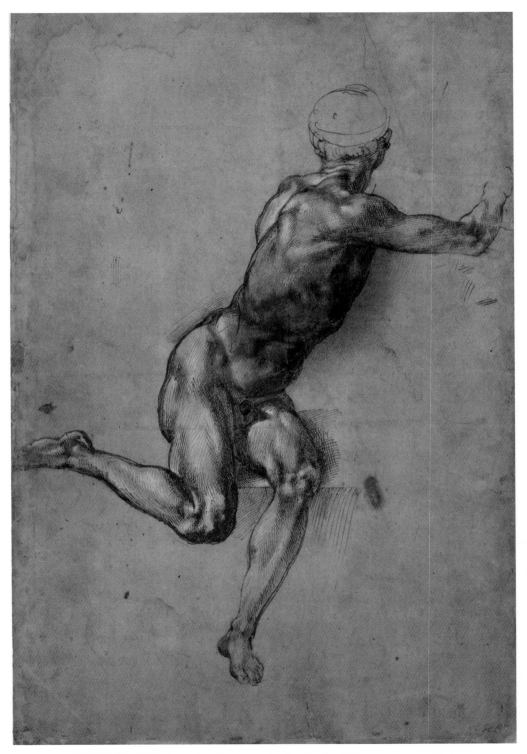

FIGURE 43: Michelangelo, figure study for *Battle of Cascina*, pen and ink and white highlights, 402 x 285 mm (15.8 x 11.2 inches).

drawing is that Michelangelo used white highlights to complete a gradation of tonality in dark (pen), middle-tone (paper), and highlight (white). This would serve him when painting in fresco.

Two other pen studies of nudes correspond to both Sangallo's copy and the Uffizi compositional sketch. A study in the Louvre shows a front view of a standing nude in contrapposto with right arm raised, left arm across his body, head turned sharply to the right, and right leg resting on a short step (Figure 44). This pen study corresponds exactly to the figure on the extreme right in Sangallo's copy, who turns his head and holds his arms in the same position. The other sheet, in the Albertina, contains a front view of a figure striding forward with arms outstretched, and a larger standing figure in profile facing right that hunches slightly and bends at the knee (Figure 45). The striding figure with left arm extended and right arm bent back can be seen to the right in the Uffizi compositional sketch (roughly indicated) and in the center of Sangallo's copy.

While I was copying these two sheets, it became evident from the similarity of pen technique, style, and size that they were executed within a short time of each other. Contours are defined and clear, and all the figures are shaded with short, curving strokes that define and indicate details of the muscles, bones, and joints. Compared to all of Michelangelo's previously discussed pen drawings, these two pen studies show a standardized system of lines used to draw and shade anatomy. In contrast to the larger nude study in pen in the British Museum, these two smaller but more detailed figures (each about 20 cm long) took much more effort to reproduce. Each is rendered using perfectly even-spaced long strokes with tight, curving shorter lines. To render these figures, my hand had to become almost mechanical in order to find the right pressure on the flexible pen point necessary to maintain the same thickness of the strokes while recreating the same spacing between the lines. The short, staccato-like curling strokes also took concentration to reproduce and correctly place in order to define but not overdraw the anatomy.

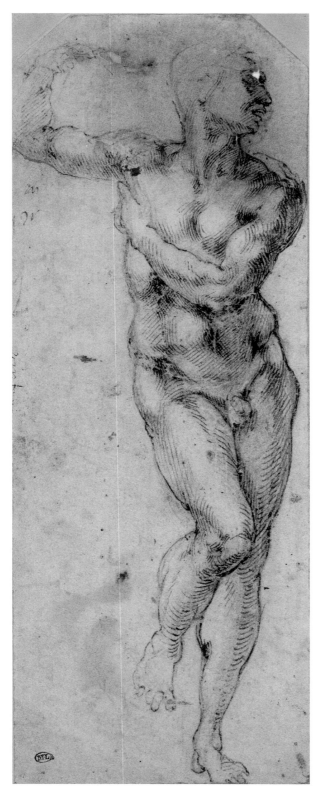

FIGURE 44: Michelangelo, figure study for *Battle of Cascina*, pen and ink,
248 x 95 mm (9.7 x 3.7 inches).

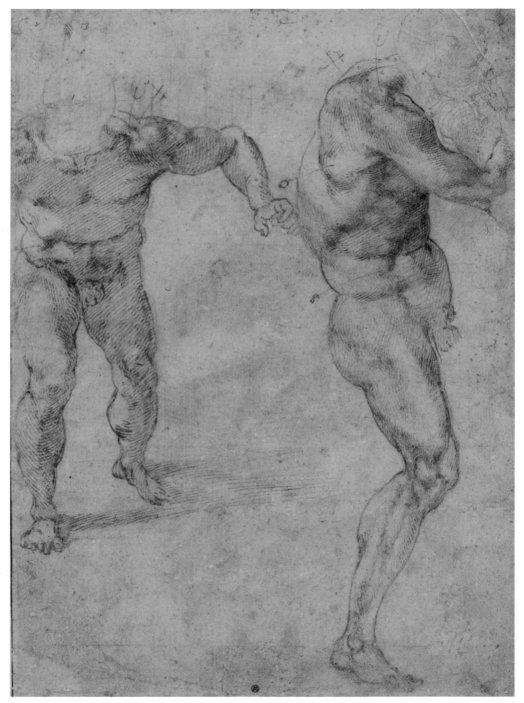

FIGURE 45: Michelangelo, figure studies for *Battle of Cascina*, pen and ink,
266 x 194 mm (10.4 x 7.6 inches).
Notice Michelangelo's system of symbols related to anatomical details on figure at right.

GROWING MUSCULARITY

The most significant aspect of these drawings, besides the refined pen technique that shows a marked artistic development, is the growing muscularity and "weightiness" of Michelangelo's sense of anatomy. Michelangelo's muscular figures had always intrigued me ever since I was a little kid looking at my mother's Abrams coffee-table book. Many disdain (or simply do not like) Michelangelo's muscular figures as being too muscular, but they probably don't understand how he did it. Although it is possible that the models Michelangelo used were muscular, the drawings give evidence of Michelangelo's growing ability to enhance—but not exaggerate—the anatomical structure of a figure by drawing with thicker and more solid proportions. Some might compare this to the skill of those who draw comic book superheroes, but in reality, the representation of muscular figures in a natural, non-bodybuilder manner reflects a refined sense of the human figure.

I began to understand Michelangelo's sense of muscularity when, after years of copying his drawings, it appeared in my own art. While working on my dissertation in Florence during my Fulbright, I would copy drawings and do research at the Uffizi during the day and in the evenings draw for my pleasure. On Thursday nights, I used to go to an open figure drawing class at an art academy by the church of Santa Croce. There I would draw from the live model to study anatomy. One evening, I remember arriving at the studio and being dismayed that the model was an extremely thin and bony young guy who didn't have much anatomy to draw. As he positioned himself on the platform, I saw that he had no body fat and a virtually nonexistent muscle structure. Frustrated at his lack of muscle (I know, it's wrong to body shame) and fearing that the session was going to be a waste of time, I decided to draw him skin and bones and all.

What happened next was sort of shocking. I began in my usual way of first finding the vertical line from head to supporting foot, next measuring the proportions and determining the gesture of the hips and shoulders.

As I started with the anatomical structure, I noticed that, although he was thin, I could just make out his muscles in the strong light. Then something clicked. After copying so many Michelangelo drawings of figures with developed anatomy, I realized I could draw the model as I wanted—with muscles. Combining what I saw on the young man with my knowledge of Michelangelo's volumetric approach to the nude, my hand automatically began to render the figure with Michelangelo's anatomy. It was strange. I found myself looking at a bony arm, feeling the need for more force, and drawing it with a developed bicep and deltoid—like my master. The same for his legs and torso, which I drew with larger, more developed, and weighty muscles. Slowly, the bony figure in front of me was growing like the Incredible Hulk in mass and volume that was not grotesque and fake but refined and anatomically correct. The end result was a thin model transformed into a more muscular, stronger male figure.

As I was finishing my drawing, the people working alongside me began to look at my sketch, then at the model, and then at me. I could see they were trying to understand what and who I was drawing. I myself didn't understand what was happening. The drawing created such a surprise that after the session was over the model himself came to see the drawing. Looking at it, he exclaimed, "Wow, I never knew I was so muscular." In actuality, he wasn't, but not wanting to offend him and burst his bubble by saying I had just added thirty pounds of pure muscle on his skeleton-like frame, I replied, "It must have been the lighting."

I put my drawing in my portfolio and walked home to my apartment, passing Michelangelo's old house along the way. While making my way through the dark streets of Florence, I realized that Cennini's flower and thorn metaphor was true. After so much copying of Michelangelo's drawings, I was beginning to see his style come through as I drew. I may never draw exactly like Michelangelo, I told myself, but I was thinking like him. I was getting myself used to gathering flowers.

A NEW FORCE

I believe that my transformation of the skinny model into a muscular nude was the same artistic process Michelangelo used to draw his figure studies for the *Battle of Cascina*. The three pen drawings of nudes in the British Museum, Louvre, and Albertina evidence what seem to be the first indications of his desire and ability to show nudes in such a way. This was a muscularity unseen in the works of Michelangelo's contemporaries. Perhaps the only precedents in Renaissance art are the painted figures of Masaccio or the sculpted works of Jacopo della Quercia. Michelangelo's muscularity emerges timidly at first, but in the next drawings executed for the nudes in the battle scene, he breaks free of any artistic hesitation and allows himself to show the male nude as he wanted: muscular, strong, and dynamic.

This new force seen in Michelangelo drawings for the *Battle of Cascina* becomes even clearer in two other nude studies in Haarlem and another in the Albertina. While copying his earlier drawings, I had been able to trace the development of his pen technique in each sheet of studies. The early pen studies of nudes for the *Battle of Cascina* are the result of a natural development of his handling of the pen. I could feel the lessons learned from every previous drawing as I copied the careful pen lines of the muscular figures. The next three studies, however, took my hand in a different direction, not only in a more dynamic anatomical approach, but also with a new drawing material—black chalk. This was evidence of a huge shift and marked a sudden, new fluidity in Michelangelo's drawing style.

The two Haarlem drawings of standing male nudes are some of the finest Michelangelo ever did in his entire artistic career. The first is a standing hunched figure seen in profile with raised arms (Figure 46). This figure is nearly identical to the nude study at right on the earlier-mentioned Albertina sheet (Figure 45). The other Haarlem study shows a striding figure holding a baton, with studies for the right arm and legs in the margins on the sheet (Figure 47). Both of the sheets are large (404 x 260 mm

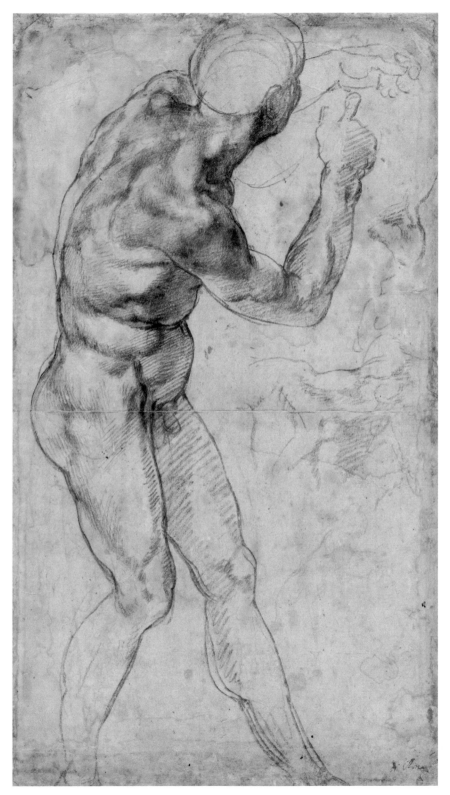

FIGURE 46: Michelangelo, figure study for *Battle of Cascina*, black chalk,
404 x 224 mm (15.9 x 8.8 inches).

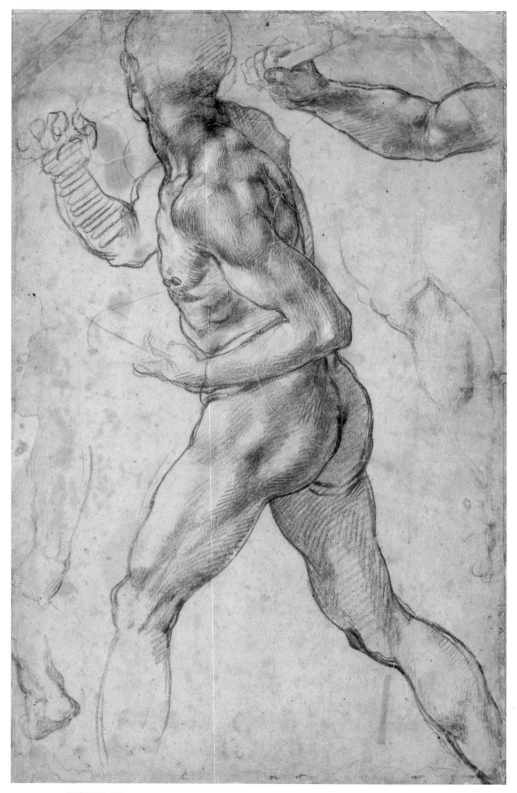

FIGURE 47: Michelangelo, figure study for *Battle of Cascina*, black chalk,
404 x 260 mm (15.9 x 10.2 inches).

for the latter, 404 x 224 mm for the former—roughly 16 x 10 inches for both sheets) and the size of the figures themselves is nearly identical—which would suggest they were done at the same time, perhaps in the same sitting. The two figures show the muscularity of the previous studies but now with an added sense of dynamic force and immediacy. They are not merely posed but seemingly "caught in action." The hunched figure stoops down with the weight totally on his right leg, and the torso twists to show the complex interaction of the external oblique, latissimus dorsi, and scapulae and deltoid. The striding figure also manifests this movement, with the weight of the figure on the forward leg, and with a heavy contrapposto shown with the lowered left shoulder and raised right shoulder. If you have ever drawn from a live model, you know how difficult it is to show the figure in movement in a way that looks natural and believable. Usually, models find a pose that's comfortable, which forces everyone to make a fairly static drawing. No model wants to hold an uncomfortable pose for any length of time.

Why are these two drawings different from what other artists were doing at the same time in Florence? In researching the types of figure studies being done by Michelangelo's contemporaries at the turn of the fifteenth century, I copied approximately one hundred studies done in the workshops of Botticelli, Lorenzo di Credi, Ghirlandaio, and Granacci (Figures 48 and 49). Some were by the masters themselves and others by their apprentices, because, as I've mentioned, drawing from a model in the workshop served not only to provide exercises for the apprentices but was also used by the master for his commissions. The common approach consisted of depicting a posed, rigid, static—even delicate—figure that is proportionally correct, but in many cases, lean and bony with no inner force. All the drawings show the model at rest.

Michelangelo may be following in the footsteps of this tradition, but there is no contemporary drawing that comes close to these two Haarlem studies. First, Michelangelo positioned the model in an active pose. He

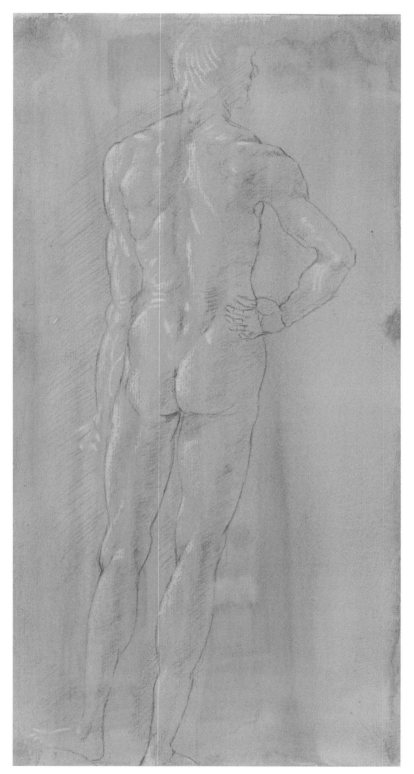

FIGURE 48: Alan Pascuzzi, copy of study of nude male by Francesco Granacci,
silverpoint and white highlights on pink prepared paper,
268 x 141 mm (10.5 x 5.5 inches).

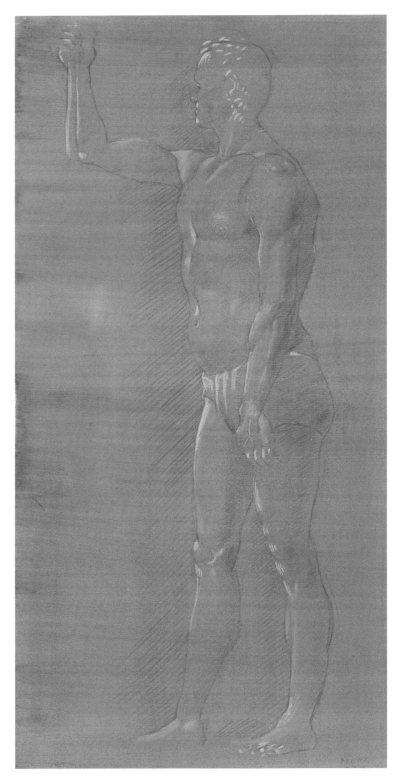

FIGURE 49: Alan Pascuzzi, copy of study of male nude by Francesco Granacci,
silverpoint and white highlights on orange prepared paper,
362 x 178 mm (14.2 x 7 inches).

manipulated the figure in the Haarlem drawings and showed a robust muscularity, motion, and detailed rendering. The active pose, robust anatomy, and detail in the rendering are beyond what anyone else was doing, even, in my opinion, Leonardo. It is as if, with these two studies, Michelangelo finally breaks through to a flow-state in drawing the male nude. He took the traditional approach and brought it to the next level. Most importantly, however, he finally found his own personal artistic vocabulary and could express himself totally in his own style. Leonardo could draw horses better than anyone, but now Michelangelo in his own right could draw the human figure like no one else. He did not need to copy Leonardo anymore.

But why did this happen with these drawings and not with the previous pen studies?

I believe that Michelangelo's breakthrough came about because of his sudden choice to use black chalk instead of pen and ink. The seated nude in the British Museum (Figure 43) is similar in size to the Haarlem drawings but shows a muscularity and dynamism held in check because of the tedious and time-consuming pen-and-ink lines needed to shade the anatomy. After he did this drawing, I think Michelangelo knew he was on to something but needed a new material that was quicker, more expressive, and would allow him to better render and "feel" the anatomical forms. Hence, black chalk.

DRAWING IN BLACK CHALK

Natural drawing chalks are composites of earth pigments suspended in clay, which acts as a binder. Black chalk is a carboniferous shale or soft carbonaceous schist in which the clay acts as a binder for the black carbon matter (Figure 50). Black chalk can be sharpened to a point and used to create both fine lines and large areas of shadow when this point goes dull. This makes it more versatile than the pen, since shading with the pen has

to be done with separate lines. When you draw with a pen, you can feel the ink transfer from the point and soak into the paper, which means you have to have immense control to get the pen line you want. After completing hundreds of drawings with a pen, Michelangelo had developed a brilliant technique to shade figures, as the early drawings for the battle cartoon show. But he still was unable to completely render accurately his idea of expressive, muscular anatomy. A sharp black chalk point gave him more sensibility than with pen, since chalk was dry: he could feel the grain of the paper under the point and change the pressure of his hand to get lighter veils of shade or press harder to reinforce darks without having to create a dense matrix of lines. With this type of sensibility, as the Haarlem drawings show, he could get precise contour lines and shade the anatomy with hatched lines, but he could also create delicate shadows with light strokes.

With black chalk, Michelangelo was able to render every major muscle of the back in the Haarlem hunched nude study, and even the ribs gently pressing through the latissimus dorsi. On the striding Haarlem study, the great trochanter and tendons can be seen pulsing under the skin. Michelangelo also used dark and delicate black chalk lines and shading to show the robust overlapping of the muscles in the torsos of both figures. He could feel the forms from the most delicate anatomy to the harshest chiaroscuro.

BLACK AND WHITE CHALK

Another figure study for the battle cartoon in the Albertina, this one for the lancer at left in Sangallo's copy, shows the same dynamic approach to anatomy through the use of black chalk, but with the inclusion of white highlights (Figure 51). It's difficult to get the intricate mechanics of the back muscles correct, but when I first copied the anatomy and then rendered each of the muscles in this study, it became evident from the delicate

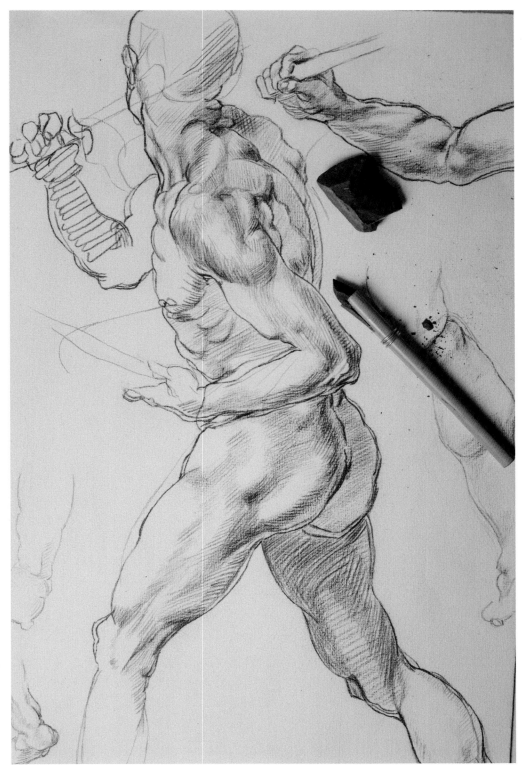

FIGURE 50: Illustration of drawing in natural black chalk.

shading that Michelangelo quickly mastered drawing with black chalk. Every muscle is delicately identified and shaded just enough so as not to make it "over-muscular." The white chalk for the highlights added a new element and new difficulty to an already complex study. The use of white chalk, or white highlighting (usually done with biacca, a white-lead pigment mixed with a binder and brushed on), creates a higher level of detail and was done specifically to give tonal information in painting. It is a technique I had come across in researching other Renaissance figure studies, but these were done in silverpoint on tinted paper. Michelangelo's technique, which is based on the traditional method, is different in that it was done on an off-color paper and on a black chalk drawing rather than a silverpoint one. The difficulty of applying white chalk is knowing just how much to put on. If there is not enough white on your forms, they don't look three-dimensional, as the tonal range from dark to medium to light is not completed. If there is too much white, the forms are flattened and the drawing tends to look overworked. Once again, while copying this, I had to bow to Michelangelo's ability. By complementing the black chalk with touches of white highlight, he managed even to create a shimmering effect, as seen on the gluteals and lower back, which gives the impression of skin.

The use of white chalk on this drawing (which some have theorized was applied by another artist) may have been part of Michelangelo's preparation for the execution of the large battle cartoon in fresco. Silverpoint drawings were done on tinted paper with white highlights to be utilized as guides in painting the darks, middle tones, and lighter areas. Michelangelo may have added the white chalk on the sheet for a similar reason. We know that he added white chalk highlights to the cartoon as well, for Giorgio Vasari's description of the battle cartoon mentions it: "There were innumerable groups [figures] besides, all sketched in different manners, some of the figures being merely outlines in charcoal, others shaded off, some with features clearly defined, and lights thrown in."

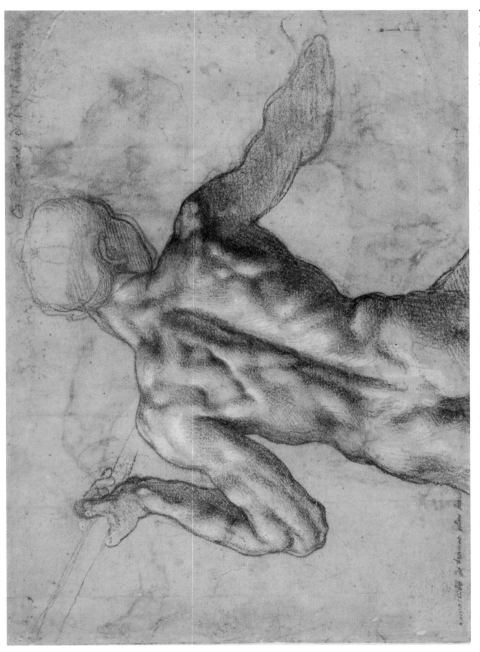

FIGURE 5l: Michelangelo, figure study for *Battle of Cascina*, black chalk and white highlights, 266 x 194 mm (10.4 x 7.6 inches). This drawing in black and white chalks gives an idea of how the *Battle of Cascina* cartoon must have looked.

Indeed, Vasari's account suggests that the Albertina back study may actually give us a glimpse of how some of the figures were shaded in the large cartoon for the *Battle of Cascina*. Rendered for use in executing the cartoon, the back study may have been intended to be held in hand while painting the fresco. I've employed this same technique for my own large frescoes. You need the cartoon to transfer the composition to the wall, but you also need an exact reference to look at while you're on the scaffolding. Among all the copies I made of the drawings for the *Battle of Cascina* cartoon, the highly finished Albertina drawing with white chalk highlights was the one that stuck in my mind. This drawing, and Vasari's description of how the cartoon was rendered, got me thinking about that document that recorded Piero d'Antonio being paid to help Michelangelo "paste the cartoon Michelangelo is making."

First, it meant that Michelangelo had had to work out the practical side of making a fresco, that is, creating a preparatory cartoon. He may have seen Ghirlandaio do this when he was painting the Tornabuoni Chapel frescoes. He could have been given the task of gluing the sheets of paper together. Since Michelangelo had no workshop in 1504 and therefore no apprentices, he instead had to hire Piero to assist him. It was the manual and even menial aspect of Michelangelo pasting paper together to make the cartoon that intrigued me the most as a student of art, for it raised numerous questions: How do you make a huge piece of paper? How do you transfer all of your small studies to a large preparatory cartoon? How do you draw on a huge sheet of paper? Do you change things while redrawing them large on the cartoon? How do you move a huge sheet of paper? What did the cartoon really look like? How did Michelangelo draw it?

A HUGE DRAWING

While copying Michelangelo's studies for the *Battle of Cascina*, I understood that each was intended to be enlarged onto the preparatory cartoon

and eventually executed in fresco. It dawned on me that the cartoon itself was just another drawing but on a much larger scale. But if the cartoon was a huge Michelangelo drawing, and I was copying all of Michelangelo's drawings to learn how he developed artistically, then—boom! A huge thought hit me: I had to reconstruct Michelangelo's battle cartoon, by hand, by myself, to fully understand how he did it and how he grew artistically while doing it. It made perfect sense. So, even though I was immersed in all my graduate research and lecturing and copying his drawings, I decided to reproduce, as big as possible and insofar as possible, Michelangelo's cartoon for his fresco—at least the section in the Sangallo copy. This had never been done before. I knew my professor now must think I was quite insane, but it was something I had to do.

I threw myself into it. I would come home in the evenings from my graduate work and put in time on the reconstruction. First, I researched paper size in the Renaissance. Based on that, I concluded that the paper Michelangelo bought was probably the royal folio size, roughly 30 x 40 cm (11 x 15 inches). I bought several rolls of white paper and began cutting them that size. But as I was cutting the sheets, I began to consider how big to make the reconstructed cartoon. The original was approximately 26 x 60 feet. Where would I find a wall that big? The biggest wall in my apartment was in my living room—I decided it would have to be that size, about 8 x 20 feet.

After I'd cut dozens of sheets, then came the process of gluing them together. Vasari's account prompted another question: What glue did Michelangelo and Piero use? I searched through various Renaissance treatises, but it was Cennino Cennini's *Craftsman's Handbook* that provided a recipe. It called for a flour and hot water mixture with a bit of rabbit ear glue thrown in for good measure. This mixture is perfect for cartoons, since it soaks into the paper and creates a strong bond yet is flexible and elastic—exactly what's needed for a cartoon that has to be rolled up and down continually when painting in fresco. Cennini recommended

spreading the glue "two fingers' width" on the edges of the sheets. With pounds of this water-flour-rabbit ear glue concoction, I set out to attach the dozens of pieces of paper together on my living room floor. After several evenings of work, I had succeeded in creating a huge piece of paper that covered the entire floor of the living room. Now I had to attach it to the wall somehow. I thought to myself, *I wonder if Michelangelo had the same problems too.* After several botched attempts, I came up with the system of nailing a series of hooks into the highest part of the wall to hold wooden rods inserted on the top part of the cartoon.

How do you draw a large cartoon? I soon realized it wasn't easy to draw on a large scale, especially if you have to center the composition. With a large work, the biggest problem is seeing the whole thing in front of you. With a small sheet of paper, you can see just by looking, but with a large sheet you have to step back constantly to get the entire view, or to make sure you don't draw things too big or too small. My major problem was figures. My arm wasn't long enough to draw while I kept an eye on the entire composition. Again, I set to researching Renaissance treatises to see if anyone mentioned this problem. It turns out that Vasari advised attaching a piece of charcoal to the end of a long stick and using this to draw while standing at a distance. It worked! With the charcoal on a long thin rod, I was able to sketch the entire composition correctly. This reminded me of Vasari's statement about Michelangelo's cartoon: "some of the figures being merely outlined in charcoal."

I worked on the cartoon for several weeks, never telling anyone what it was about, since it had nothing to do with what was expected of me as a doctoral student of art history. But it was like stepping back in time; I had all of my copies beside me as I worked on each of the figures in the cartoon. First, I drew the lines with the charcoal attached to a long stick, canceling out my mistakes with a feather. Once I had correctly drawn a figure with the charcoal, I brushed it away lightly, leaving a faint line. Then I redrew the lines in black chalk and worked up the shadows, trying

to render them as in Michelangelo's finished studies. The last step was to carefully add the white highlights, which needed to accentuate and not dominate the shading.

At the end of each drawing session, I was covered in black chalk and charcoal dust. My living room carpet, once beige, was now black. As I worked on the cartoon and drew the large figures, I realized there is a risk of making your figures look cartoonish and clumsy—similar to Vasari's figures on the Duomo in Florence or Giulio Romano's in the Palazzo del Tè in Mantua. I also began to see how crucial the small studies were in the creative process. The detailed drawings gave me all the information needed to draw them bigger. Plus, in enlarging, you have the opportunity to change or correct them in a continued evolution of the design. You understand the forms even more by this point, too, and that allows for an easier execution in fresco. I realized then that the change in Michelange-lo's drawing methods, even the exaggeration of the poses of the figures, may be directly related to the size of the cartoon. He may have switched to black chalk with white chalk highlights for his smaller studies, instead of the time-consuming pen and ink, because he had to use the medium extensively to draw the larger-than-life-size figures on the cartoon and the softer material was quicker and easier to use. The more dynamic poses may have been due to the size of the work, which required active figures to animate the central bather composition. If he wasn't going to show a literal battle, his figures still had to be "battle-like" to give movement to the huge scene: he couldn't merely show nude men dressing. Sitting on my living room floor and just looking at the large drawing (Figure 52), I realized I was reaching conclusions based on my own experience, which was subjective. But the odds were good that no one else was doing any-thing close to what I'd done in reconstructing Michelangelo's process, and if anyone could say something about it, it was me. So I decided to show my work during one of my presentations for a Michelangelo seminar I was taking that semester. I would put my cartoon up in the art history

department lobby and do my presentation in front of it. I hesitated, but when I finally asked my professor for permission, his reply was yes. He was generally quite open to my approach to Michelangelo's drawings, and for this I am thankful to him.

For the presentation, I rolled up the cartoon around my shower rod and cardboard discs to create a sort of large roll of paper. A good friend of mine, Andy from Georgia, who was a graduate student in psychology, offered to drive me and my cartoon to the art department. He had a Volkswagen Rabbit, possibly the smallest car at the time that anyone could use to move a cartoon. All rolled up, it looked like a huge cigar, and it stuck out about four feet from the back of the car. To prevent it from falling out, Andy had to hold one end, which butted up against the windshield, while I was in the back hugging it for all I was worth while trying not to fall out of the open rear door. As we swerved and zigzagged our way through Saint Louis traffic to the Washington University campus, I saw myself in the rearview mirror desperately holding on to the huge drawing and thought, *This is crazy. What the hell am I doing this for?* But in the midst of this artistic existential struggle, my friend looked at me over his shoulder and said in his calm Southern accent, "You know, I think this is really cool. I mean, this really makes me say, 'Wow.' We really need things to make us go 'wow.'" Coming from a psychologist, his sincere words struck home. I realized that all my efforts to discover more about Michelangelo and what it takes to make great art were not so crazy after all.

We eventually arrived at the department and managed to put up the cartoon. The next day, in front of the blank stares of my fellow grad students, I gave my presentation. I explained the drawings, the use of pen and the switch to black chalk, the making of the cartoon, the drawing of the figures—everything. More blank stares. After the presentation, I rolled up the cartoon and put it in the art history department storage room until I could arrange a trip back to my apartment. Several months passed and the semester ended, and eventually I just left the cartoon in the

department. According to my professor, it was cut up or destroyed—he's not sure—but no one knew where it was. Just like Michelangelo's battle cartoon.

The cartoon Michelangelo made for the *Battle of Cascina* was done during the most significant period in his artistic career up to that point. The Sala del Gran Consiglio commission forced him to develop an artistic sense of drawing large-scale figures as well as the technical proficiency to create a design process for executing large preparatory cartoons for fresco. It was during his work on the *Battle of Cascina* that Michelangelo broke away from all artistic influences—in particular from that of Leonardo—and forged his own drawing processes and figural style. This advanced his formation as a draftsman and prepared him for his final step to complete mastery.

At this point in my research, I had executed hundreds of Michelangelo drawings in pen and ink, and now black chalk. Through sheer repetition, I had learned how to use pen and ink and had begun to understand how to use black chalk during my reconstruction of the cartoon. As I was gluing the pieces of paper together for the cartoon, the thought had come to me that I was doing exactly what an apprentice would have done for his master. I was learning how to use drawing materials, make large cartoons, and prepare for large painting commissions. It gave me a weird but contented feeling to know that I was doing something so anti-modern and rooted in the past, and I looked forward to seeing what I could learn from the next set of drawings—the studies for the Sistine Chapel ceiling. These drawings for Michelangelo's greatest painting signified the final ascent to his becoming a master. And I would be right behind him.

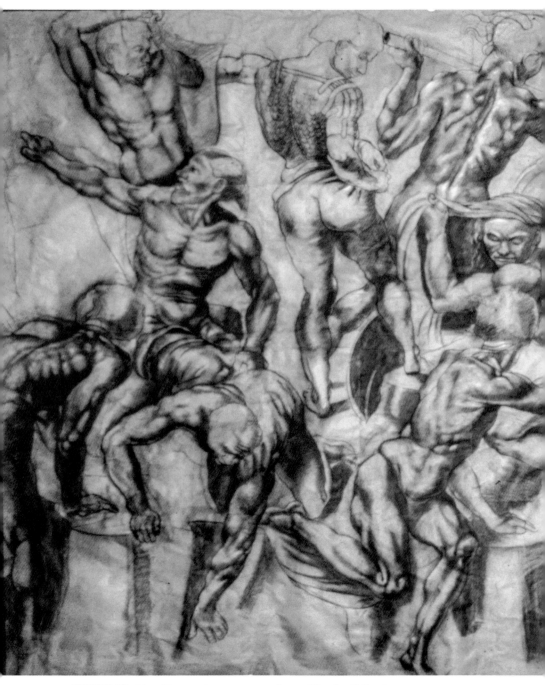

FIGURE 52: Alan Pascuzzi, reconstruction of *Battle of Cascina* cartoon, black chalk and white highlights, 8 x 20 feet.

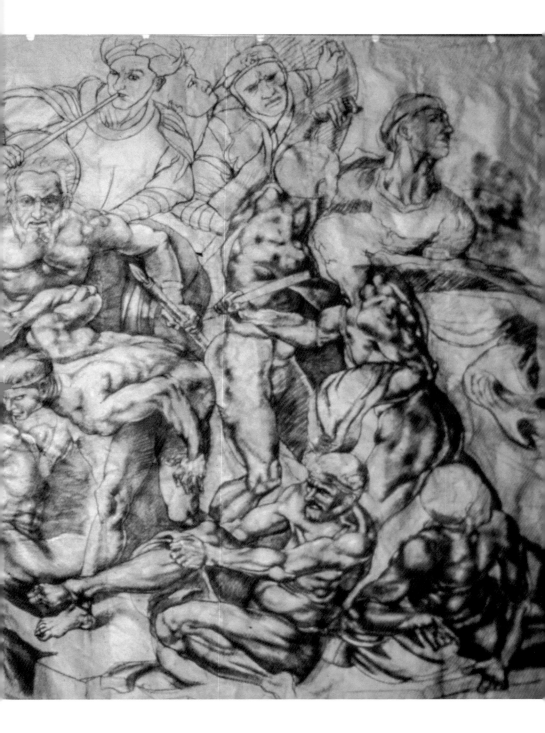

The Drawings for the Sistine Chapel, Part I

UP IN SMOKE: MICHELANGELO'S LEGACY

On a cold day in Rome in February 1564, the eighty-nine-year-old Michelangelo was just a few days away from death. He gathered dozens of his studies and cartoons amassed over a lifetime, went to the courtyard of his house in Macel De' Corvi, and set them on fire. As the flames grew, he watched decades of work go up in smoke. What would lead a man so close to the end of his life to hobble out of his house on a cold February day to burn his precious drawings? What did he want to hide? We will probably never know for sure. Perhaps the more important question, though, is why he kept certain drawings while burning others. What was he leaving to posterity?

While in Florence preparing the manuscript for my PhD thesis, I had some doubts about the truth of this story, so I wrote my professor, in St. Louis, one of the world's leading experts on Michelangelo, and asked him if he believed it. He responded that, yes, he did. Michelangelo probably burned certain drawings that revealed all the behind-the-scenes hard work in designing the ceiling of the Sistine Chapel, as well as for all his other

finished works. According to my professor, the logical inference in relation to the Sistine Chapel in particular was that Michelangelo didn't want people to know how hard he had toiled to create all the figures on the vault. This didn't make sense to me: Why burn his best drawings for his great works, perhaps some of them great in themselves? What if this story was just made up so that no one would ever go looking for them? What if they'd been purloined and are sitting forgotten in some attic in some palace in Rome? What if dozens of his drawings remain hidden in the Vatican?

After studying all the extant drawings for the Sistine Chapel ceiling, though, I decided my professor's assumptions were generally, if not totally, correct. Michelangelo probably did destroy his drawings to hide his artistic struggle with the vault. However, copying the drawings and exploring them from the inside helped me understand that there was probably something more to Michelangelo's destructive act. The extant preparatory drawings for the Sistine do in fact illustrate Michelangelo's struggles to conceive and compose the dozens of figures for the vault. But, by the same token, they also reveal the ways in which he taught himself to become a true master draftsman and take his final steps to artistic maturity. Recreating the drawings line for line, using the same materials Michelangelo had, I discovered the traces of a craftsman-like approach, i.e., organized and methodical. His artistic skills developed visibly, until he reached, in the last studies for the ceiling, an almost sublime, creative state of composition and execution. In the eighty-nine-year-old's final act of destruction, it may be that, instead of merely eliminating evidence of how hard he had toiled, he sought to obliterate any record of having been a methodical craftsman. If such drawings became public, they might link him to his traditional training in a Florentine workshop and to his master Ghirlandaio. This would contradict the myth of his genius and the legacy of his divine ascent from boy prodigy to master.

During the four years Michelangelo spent working on the Sistine Chapel, he must have made hundreds of studies for the figures on the

ceiling, but only seventy-one studies on a number of sheets survive. Many of the drawings that do survive, however, are some of the best he ever executed. Seen as a coherent whole, they reveal a culmination of his artistic journey from young apprentice to his ultimate formation as a master artist, as I will demonstrate in these last two chapters.

THE SISTINE CHAPEL COMMISSION

With the Sistine Chapel commission, Michelangelo's career was once again intricately tied to the political turning points of the early 1500s. A few months before Michelangelo began working in Florence on the cartoon of the *Battle of Cascina*, in November of 1503, Giuliano della Rovere was elected pope, assuming the name Julius II. Julius, a warrior pope, was bent on unifying Italy under papal rule. He was also determined to bring the best artists of the age to Rome to work on his projects, mainly to glorify himself. As soon as he was elected, Julius called upon Michelangelo to design his burial tomb, an immense pyramidal structure with dozens of sculptures. Though still occupied with the battle fresco in Florence, Michelangelo was obliged to travel to Rome and begin procuring marble blocks for the commission. In addition to planning his burial tomb, Julius commenced renovations on the Sistine Chapel, which had been built and decorated by his uncle, Sixtus IV. The planned renovation work included completing its decoration and replacing the original Quattrocento ceiling design by Piermatteo d'Amelia, which consisted of a blue sky with stars. The pope wanted a modern design with figures instead of a star-studded firmament. The Piermatteo d'Amelia ceiling was old art; Julius wanted something new and better.

The first evidence that the young artist, who was still best known in Rome as a sculptor, was being considered for the paintings dates from May 1506, before he had abandoned work on the battle fresco in Florence. A letter dated May 10, 1506, written by Piero Rosselli in Rome to

Michelangelo in Florence, conveys the pope's interest in having Michelangelo paint the ceiling and points to some of the intrigue surrounding the commission:

When the Pope had finished supper, I showed him certain drawings. He then sent for Bramante and told him that Sangallo was going to Florence the next morning and would bring back Michelangelo. Bramante, replying to the Pope, said: "Holy Father, Michelangelo won't do anything of the sort. I have been on very familiar terms with him about this matter, and he told me many times that he did not wish to have anything to do with the chapel though you wanted to burden him with it, and that, moreover, you did not pay any serious attention either to the tomb (of Julius II) or the painting of the ceiling. Holy Father, I believe that Michelangelo would lack the necessary experience in figure painting, and in general the figures will be set high and in foreshortening, and this brings up problems which are completely different from those met in painting at ground level."

Bramante was the architect working at the time on the new Saint Peter's Basilica. In this letter, Rosselli depicts him telling the pope that Michelangelo wasn't interested in the ceiling, not just because of conflicts of personality between the pope and the artist but because Michelangelo didn't have the painting experience. Michelangelo's biographers Condivi and Vasari give a different account. They write that Bramante and others in the papal court *wanted* Michelangelo to paint the ceiling so he would fail. In doing so, he would prove to be inferior to Raphael, who was Bramante's relative. This would destroy his reputation as an artist and force him out of Rome. It seems clear now that Condivi and Vasari give a biased view of the rivalries and politics in the papal court, although there must indeed have been tremendous competition and intrigue around such a major commission. The one common thread in all the literary sources is that everyone— Rosselli, Bramante, Condivi, and Vasari—agrees Michelangelo did not

have experience in painting, of any type. Michelangelo himself knew that painting a vault was a difficult task and pleaded with the pope that it was not his specialty. According to Condivi, Michelangelo's objections began to irritate the pope, and it was only when he realized the pope was losing his temper that he agreed. On May 10, 1508, Michelangelo records signing the contract to paint the Sistine ceiling and refers to himself as "Michelangelo sculptor," his one last feeble protest against being forced to do the commission. (See Additional Documents Relating to Michelangelo in Appendix 1.)

The thirty-one-year-old Michelangelo truly wasn't equipped to paint a vault the size of the Sistine Chapel ceiling. To this point, he didn't have experience with the fresco technique and probably had never done a fresco on his own from start to finish. Had he been able to finish the *Battle of Cascina*, he might have been able to learn the technique from his colleagues in Florence, but he abandoned the commission for this new work. If the decoration of the Sistine vault with frescoes was beyond his painting abilities, he would have to rely on his drafting skills alone to execute it. Michelangelo was already a more than competent draftsman. But the difficulties inherent in the size and complexity of the commission would push his drawing skills to the limit.

When you visit the Sistine Chapel, look up at the ceiling and try to imagine it blank and having to fill it with figures, but with nothing to rely on except your own creativity. The Sistine vault contains 319 figures (I counted them with my ten-year-old son, Gioele, one evening), and a good deal of them are larger than life. It is difficult even to think of 319 different positions, let alone draw them. Every single position for every figure had to be worked out and refined to fit perfectly into the overall decorative scheme. Michelangelo then had to come up with a general composition for all the scenes, study all the figures individually, and enlarge everything on the cartoon. Oh yes, and after that he had to paint them in fresco! As I copied every drawing, I began to see that each sheet

was intricately related and manifested Michelangelo's artistic design process. Michelangelo's method of composition is slow and tedious at first, but eventually becomes streamlined and efficient to facilitate painting the vault's scenes and figures. The gradually increasing complexity of the drawings, or rather the efficiency in how they capture Michelangelo's ideas and transfer them into the composition, reveals his growing ability.

THE FIRST DRAWINGS FOR THE CEILING

To replace the star-studded ceiling, Pope Julius II originally commissioned Michelangelo to paint the twelve apostles on the twelve pendentive-like areas that carry the curved vault down to the walls between the windows. Three drawings by Michelangelo record his preliminary ideas for the intended apostle theme for the vault. The first is a large sheet in the British Museum in pen and black chalk (Figure 53). On the left side of the sheet is a quick pen sketch that shows Michelangelo's idea of having the apostles seated on thrones between the spandrels, with the vault above divided into diamond-shaped, rectangular, and circular framed elements. On the right side of the sheet are four studies of hands and forearms, probably for the figures of the apostles. Michelangelo relied on the drawing tool he had used the most since he started studying art—the pen—for the quick idea sketches for the ceiling. For the more detailed anatomical studies, however, he utilized his trusted black chalk, with which he could obtain detailed contour lines and subtle tonalities of shade. Since the *Battle of Cascina*, black chalk had become his tool of choice for detailed studies.

Other extant drawings for the early stages of the Sistine ceiling reveal that Michelangelo was brainstorming the positions of the apostles. Since the twelve figures had to be seated, the poses in compensation needed to be dynamic as well as fit into the architectural space and create a certain symmetry. This was not an easy task. In two extant sketches in the Uffizi, Michelangelo can be seen manipulating the apostle figures to find the right

FIGURE 53: Michelangelo, early study for Sistine Chapel ceiling, pen and ink, black chalk, 275 x 386 mm (10.8 x 15.1 inches). At left on the sheet are early ideas for geometrical decoration of ceiling with apostles; at right studies from life of forearm and hands for apostle figures.

poses. The first sketch depicts a small figure done in pen holding a book in his left arm (Figure 54). The second, also in pen, depicts the same figure with the same pose but in reverse, with the book on his right (Figure 55).

These two small sheets were undoubtedly cut from one larger sheet and separated, since Michelangelo didn't draw on paper this small (109 x 62 mm, 4.2 x 2.4 inches). That they were both small pen sketches showing a seated figure in mirror poses holding open a book to display the contents of the Gospels tends to suggest they were done close together in time.

As any professional artist knows, the initial stages of trying to come up with ideas for figures for a commission can be stimulating but also frustrating. It is a moment when the point of the pen has to combine line, anatomy, and feeling for the pose to give birth to an idea that can be gotten down on paper before it evaporates in your mind. Here, the contour lines of the small figures are secure, gesture is strong, and anatomy is generally indicated. The smaller the sketch, the easier it is to conceive of the figure in its entirety, and these two figures were undoubtedly drawn side-by-side to see which worked better. In some cases, as an artist, you come up with a pose that seems to work but needs to be reversed for it to flow. But in this case, Michelangelo may have been reversing the pose in order to generate other poses. In other words, from the outset he was apparently taking best advantage of all his ideas for the figures by reversing them or changing them slightly in order to create multiple figures from one idea. For the *Battle of Cascina*, in which there were only sixteen main figures in the central scene, he had the luxury and time to concentrate on each individual pose in his studies for the separate figures. For the Sistine Chapel, the vast number of figures he had to create meant that he had to innovate a design system that was far more productive. He quickly realized that he could solve this problem and maximize the positions he sketched through this process of slightly altering or reversing a figure in order to generate other, seemingly different positions and attitudes from his initial concept.

FIGURE 54: Michelangelo, early idea sketch for apostle figure, pen and ink,
109 x 62 mm (4.2 x 2.4 inches).

FIGURE 55: Michelangelo, early idea sketch for apostle figure, pen and ink,
109 x 62 mm (4.2 x 2.4 inches).

The two small Uffizi drawings (Figures 54 and 55) are the nucleus of his first ideas and the beginning of the next four work-filled years of his life. Fresco painting requires an immense amount of work, which many do not understand. To be able to paint a figure or an entire multi-figure composition in fresco requires months of preparation. The whole process begins with idea sketches, but these small sketches have to be developed by numerous other studies and hours of labor. The first sketches for the positions of the figures are the basis for eventual larger figure studies, then drapery studies, then studies of heads, hands, and feet. All of these have to be assembled and redrawn on the large preparatory cartoon to create the final figures, which have to be pricked for transfer. Color studies have to be done and then and only then can you even think of executing it in fresco. From the mixing of the paint and plaster to the need to apply it quickly without the chance for correction after the paint dries, it is a highly stressful process. It was probably extremely stressful for Michelangelo since he hadn't finished his apprentice training with Ghirlandaio on how to paint in fresco and, as far as we know, had never executed one.

Other drawings for the Sistine ceiling also show Michelangelo attempting to compose and study all aspects of the apostle figures. There are no extant anatomical studies for the apostles, which would be the next logical step following his initial idea sketches, but there are drapery studies for seated figures. Two large studies of draped figures, one in the British Museum (Figure 56), and another in the Musée Condé (Figure 57), show Michelangelo doing an original drapery study for the first time—and reveal his apparent difficulties. In order to get to this stage of composing a draped figure, the anatomy first has to be established—for example, the position of the legs beneath the garment. Once the pose has been studied, a mannequin is set up in the same position and draped with cloth to generate the folds. A strong light source is needed to create contrast on the draped cloth. Positioning the draped mannequin is the easy part of doing a drapery study, though still harder than you might think. The hardest

part is actually drawing the folds. It's true that Michelangelo had already drawn and carved draped figures, as seen in his earliest copies of Giotto and Masaccio in pen or the *Pietà* in Rome, but coming up with and drawing a totally new draped figure presented fresh difficulties.

The Musée Condé sheet contains a seated draped figure with legs crossed and right arm drawn across its body. When I copied this drawing, I noticed that Michelangelo first drew in the heavy anatomical features of the body and then "dressed" it by adding the drapery. The entire figure was shaded with short and long curvilinear strokes, in the same pen style of his studies for the *Battle of Cascina*. On finishing my copy, it became clear that it was, in essence, not finished. Many of the folds were left undefined, and in some cases the forms were simply not drawn well (i.e., not rendered enough to give clear information for painting the figure). After further reflection, I could see that the figure's position is awkward and the drapery unnatural and almost clumsy. *My God!* I thought. *This is a bad drawing by Michelangelo!* I felt like a heretic to think such a thought, and I would bet there are very few people who have put "bad drawing" and "Michelangelo" in the same sentence before this.

Michelangelo had done numerous copies in pen of draped figures in the frescoes of Giotto and Masaccio. Those are all beautifully rendered, but in every case the figures are standing and the drapery consists of long, vertical folds. This drawing of a draped figure was different, since it was of Michelangelo's own making and not a copy. The weakness of the drawing demonstrates inexperience in composing draped figures based on his own ideas. His complex positioning of the figures perhaps did not lend them to being draped—contorted figures make for complex folds—and he was finding this out the hard way.

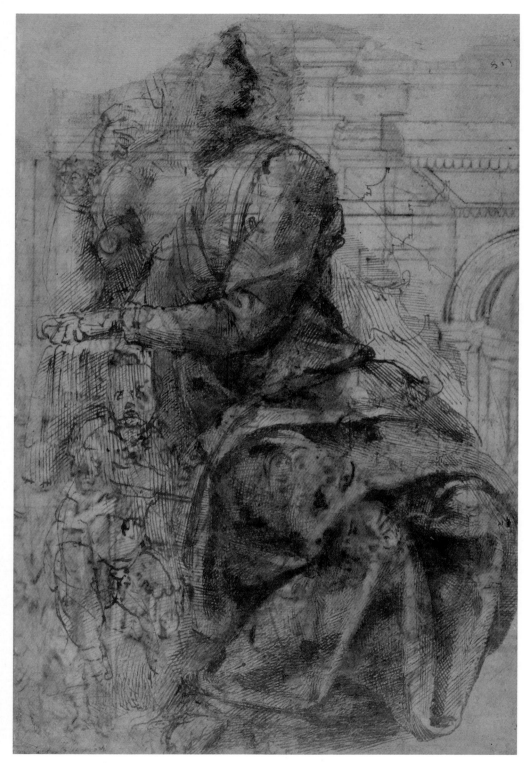

FIGURE 56: Michelangelo, drapery study, pen and ink, ink wash,
414 x 280 mm (16.2 x 11 inches).

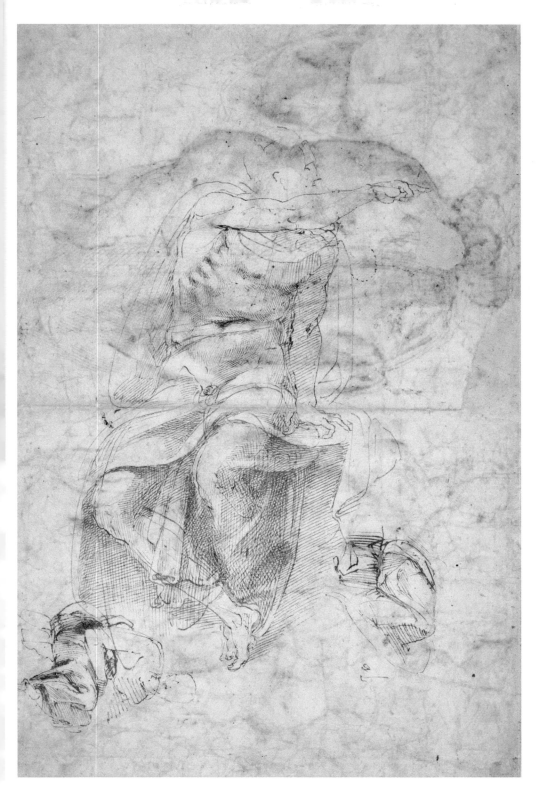

FIGURE 57: Michelangelo, drapery study, pen and ink,
263 x 385 mm (10.3 x 15.1 inches).

BAD DRAWINGS

While working on my dissertation, I became fascinated by Renaissance drapery studies. I copied dozens of such studies in silverpoint in the Uffizi collections. Some, such as the drawings by Lorenzo di Credi, Ghirlandaio, and of course Leonardo, are among the most beautiful works on paper I have ever seen. It was magical to copy them in the same material as the originals. After dozens of copies of drapery studies, though, I felt the need to explore for myself just how the Renaissance artists actually did them. I knew they used life-size mannequins, which are not easy to find. Instead, I purchased a small foot-high wooden mannequin with moveable joints that beginning artists (mistakenly) buy to learn gesture and anatomy. Following the traditional method, I carefully cut small pieces of cloth, dipped them in liquid gesso (or plaster of Paris) and "dressed" the mannequin, then fixed my light source on my kitchen table and began to draw. After finishing the sketch and putting on the white highlights, I saw that my study was, in every sense of the word, horrific. My folds and ceases were clumsy and heavy and seemed unlike cloth draped over a figure and pulled down by gravity; rather, they comprised a separate entity unto itself. I understood the figure underneath, but not how to draw the folds on top of the anatomy. They created abstract forms—I could not make visual sense of what I was seeing, and it was like learning to draw all over again. I humbly realized that I was not as good as I thought and had a lot of work to do.

Based on Michelangelo's drapery drawing in the British Museum and a few others executed at the outset of designing the Sistine Chapel ceiling, I think he also realized just how hard drapery studies are. They opened up a whole new universe of visual difficulties—not only in the drawing of draped anatomy, but also in how to render it, and with what tools. Michelangelo must have understood that to fully execute a drawing of this nature with the rich network of pen lines would take too much time to do, especially because he had to do it for twelve apostles.

The drapery study in the British Museum, on the recto of one of the initial designs for the ceiling, exhibits the same difficulty with the clothed figure (Figure 56). Here too, the draped figure is not a successful drawing. This appears to be an initial idea for one of the apostles—perhaps the reverse of the figure of the prophet Isaiah that is on the vault—which Michelangelo was trying to develop based mainly on draping a figure. What he seems to have been doing in this study and in the Musée Condé study was to take shortcuts (i.e., work out the underlying figure only superficially and do the rest with drapery). That simply doesn't work. The accuracy of the folds depends entirely on the accuracy of the figure underneath. If your underlying figure is not done well, the drawing of the folds will not be credible. This British Museum sheet shows just that. The figure is positioned awkwardly with the left leg bent back in an unnatural position. The folds are heavy, clumsy, and the shading doesn't clearly define the forms. Michelangelo tried as best he could with his brilliant pen technique to render the forms, but it didn't work this time. There are even traces of ink wash—which he had used in his copies of Giotto and Masaccio—but that didn't help either. Michelangelo had done another unsuccessful drawing.

Still another sheet in the British Museum (Figure 58) reiterates his problems with the draped figure. In the center is a study of drapery done in black chalk and ink wash, something never seen up to this point in any of his drawings. The knees and legs of the figure are visible beneath the heavy folds. The figure's seated position corresponds to the other studies of the seated apostles, which links this study to a more advanced stage of Michelangelo's ideas for one of the figures. However, the awkward mixture of black chalk and ink wash shows Michelangelo looking for a way around the use of pen, as if this more painterly and quicker technique would allow him to better render the forms of the folds. It also demonstrates his unfamiliarity with the task at hand. When I tried to reproduce the same tonality as the shadows on the drawing, the ink wash combined

with the carbon of the chalk and created a gloppy black mixture. Black chalk was good for the contours but took too long to do all the shading. Pen lines would also have taken too long to shade. Perhaps this is why Michelangelo resorted to using ink wash with a brush. The result? Another bad drawing by Michelangelo.

The Musée Condé and British Museum drawings indicate that early on in his work on the Sistine ceiling Michelangelo was having trouble composing satisfactory draped figures and finding the right material to render drawings of them. The uncharacteristic lack of finish in these drapery studies suggests Michelangelo's frustration with his inability to establish definite or satisfactory drawings for the apostle figures. I know a bad drawing when I see one, having done hundreds myself. These three drapery studies were bad drawings by Michelangelo, and he most likely knew it. Judging from their unfinished state, he was trying to cut corners, go right to the finished studies to save time, but the results were not acceptable.

If these drawings weren't up to his usual standards, then why did he save them from the fire? I'm not sure, but perhaps one reason is that the backs of some of these sheets contain studies for the ceiling that are some of the finest.

Michelangelo may have been following in the footsteps of Ghirlandaio and trying to utilize his master's system for composing figures in these drawings. The common element of most of the major fresco cycles in Florence—from Giotto's Bardi Chapel and Masaccio's Brancacci Chapel to Fra Angelico in San Marco and Ghirlandaio's Tornabuoni Chapel (Figure 9)—is the draped figure. The scenes for all these frescoes are constructed with groups of draped figures seated or standing. The major task of fresco artists, therefore, was to make dozens of studies of draped figures, often without doing a nude study underneath, and complete them on the preparatory cartoon by adding on studies of the faces, hands, and feet. Those who had undergone and completed a traditional apprenticeship

FIGURE 58: Michelangelo, drapery study, black chalk, ink wash, 119 x 275 mm (4.6 x 10.8 inches).

would have been well schooled in drawing drapery and capable of constructing naturalistic clothed figures without doing nude studies for them initially. Michelangelo, not having completed his painter's education, was not so well versed. His drapery studies have solid structure but no life, and clearly don't have that energy so characteristic of Michelangelo's other studies. What logically followed was Michelangelo's realization that something had to change or he would prove Bramante right. Just as he done for the *Battle of Cascina*, where he revised his central theme to nude figures after realizing he couldn't compete with Leonardo's masterful battle scene, for the Sistine ceiling he needed to alter his approach and change the subject from large draped figures to something else. A more sensible composition based on his skills would concentrate on the nude figure, with a reduced number of dressed figures.

"A POOR AFFAIR"

After numerous surprisingly bad drawings, Michelangelo understood that the apostle theme was going nowhere and communicated this to the pope himself. In a letter to Giovanni Francesco Fattucci, Michelangelo reported: "After the work was begun, it seemed to me that it would turn out a poor affair, and I told the pope that if the apostles alone were out there, it seemed to me that it would turn out a poor affair. . . . Then he gave me a new commission to do what I liked, and said he would content me and that I should paint down to the histories below." How Michelangelo persuaded the pope of the need for a different composition isn't known. Perhaps he made a show of the sorry state of his drapery sketches. Julius seems to have listened and gave him the go-ahead, although it is highly unlikely Michelangelo was granted complete control over what to paint on a ceiling as significant as Sistine Chapel's. As a devout Catholic, he was familiar with biblical stories, but he wasn't a theologian with knowledge of the intricacies of both the Old and New Testaments. In

addition, this was a commission for the most important chapel of the Vatican. Michelangelo was just an artist, and he certainly would have consulted or been closely advised by theologians or other learned men on what scenes should decorate the ceiling. The new theme was to be based on the story of Genesis—which allowed Michelangelo more room to be creative and freely use the nude figure as his main element. A variation on the initial idea of seated figures was to remain (this he could not avoid), but the project for the central portion called for larger scenes with a multitude of nude figures.

The new scheme for the ceiling vault (Figure 59) included nine major scenes from Genesis: the Separation of Light from Darkness; Creation of the Sun, Moon, and Stars; Separation of Land from Water; Creation of Adam; Creation of Eve; Temptation and Expulsion; Sacrifice of Noah; The Flood; and the Drunkenness of Noah. Five of the scenes would have four nude youths holding medallions on all four corners. The curved lower part of the vault was to include a variation of the initial seated apostle idea, including twelve prophets and sibyls (female prophets). The seven male prophets were: Jonah, Jeremiah, Ezekiel, Joel, Zechariah, Isaiah, and Daniel. The five female sibyls were: Libyan, Persian, Erythraean, Delphic, and Cumaean. The lunettes, or semi-circular spaces between the prophets and sibyls, were to be filled with the ancestors of the House of David. The spandrels or pendentives (four corners) of the ceiling were to be decorated with various biblical scenes: the death of Haman; Moses and the Serpent of Bronze; David and Goliath; and Judith and Holofernes.

A NEW BEGINNING

The next series of drawings for the Sistine Chapel reveals the immense manual labor that was involved in designing the vault. It required the execution of many dozens, if not hundreds, of studies for the large Genesis scenes as well as for the prophets, sibyls, and nudes. This number doesn't

FIGURE 59: Sistine Chapel ceiling.

include the architectural details and figures on the pendentives, either. As I carefully copied each extant sheet one by one and redrew every line of every sketch, it became clear that every figure, hand, or leg on the sheets was not only important for its visual value (in other words, how it worked in its own terms and as related to the overall design of the ceiling) but for what it represented about Michelangelo's thought process. Each element offered a peek into his mind inasmuch as each was a visual record of ideas that he had translated to sketches on paper. In copying them, I was in effect trying to make sense of Michelangelo's thought process and his ideas for each figure on the vault. It was as if I were reading his mind.

Many art historians will cringe at this approach and consider it far too subjective, bordering on Freud's psychoanalysis of Leonardo in his *Leonardo da Vinci: A Memory of His Childhood*. But, in fact, my method offers a rational interpretation of every study, sketch, and drawing—be it of a leg, torso, or complete human figure—and it leads to a coherent view of how Michelangelo came to organize his thoughts and create the studies to execute one of the most important fresco commissions of the High Renaissance. Though certainly some of the preparatory drawings are missing, what we have of the drawings spans four years of intense labor and allows for a coherent reconstruction of Michelangelo's stylistic evolution as well as his artistic achievement.

The drawings related to the new composition can be categorized as follows: initial idea sketches for the Genesis scenes, first idea sketches for figures, secondary studies for figures, individual studies of body parts, and finally head studies and drapery studies. Two small studies in the Uffizi record what may be his earliest ideas for the composition of the Flood, which according to Condivi his biographer, was one of the first scenes Michelangelo executed on the vault (Figures 60 and 61). The first sheet (Figure 60) shows a quick compositional sketch for the figures in the circular boat, which corresponds directly to the fresco itself. The horizontal, oval pen line at left on the sheet represents the circular raft. In the lower

FIGURE 60: Michelangelo, study for scene of Flood, pen and ink, 100 x 248 mm (3.9 x 9.7 inches).

left-hand corner is a crouched figure that appears to be climbing in. There are abbreviated ideas for other figures that can be easily identified and found in the final frescoed scene of the Flood. Comparing the two is fun.

The other Uffizi sheet (Figure 61) contains similar preliminary idea sketches for the Flood figures. In the center is a group of four figures who appear to be covering themselves with a sheet, indicated by a series of jagged, parallel lines. This image of figures shielding themselves ties in the sketch to the right portion of the Flood in the fresco, which contains a group on an outcropping, huddled under a makeshift tent. Some of the ideas for figures on both sheets were used directly in the fresco; others were altered or discarded. This alone demonstrates the intermediate nature of the sketch. Michelangelo was making executive decisions for finalizing the figures as he went along. The one large head study, rather out of place on the sheet of small sketches, can be directly traced to the small face of a bald man, visible between the women carrying their possessions to safety in the central lower foreground of the finished fresco.

The two Uffizi sheets recall the small compositional studies Michelangelo executed for the *Battle of Cascina*, especially in the way he studied separate groups of figures that would be joined in the final scene. As I was copying them, I noticed they shared rather odd characteristics—both sheets were small and asymmetrical (i.e., somewhat oddly shaped, as if cut by hand). Based on the large size of Michelangelo's other early drawings for the vault discussed previously, it became obvious that these were most likely cut from a larger sheet to isolate the various figural groups—especially the head study. In copying them with my pen, I noticed several arching lines above the head study that ran off the edges of each sheet. This was especially evident on the extreme left of the smaller sketch of the Flood. There were also faded black chalk lines on both sheets.

Fairly excited that these two sheets could be related, I asked an attendant in the Uffizi drawing cabinet if I could open the passe-partout of the drawings and place them side-by-side. When the sheet with the head

FIGURE 6l: Michelangelo, study for scene of Flood, pen and ink, 149 x 212 mm (5.8 x 8.3 inches).

study was placed vertically and adjoining the left side of the smaller sketch, the arching lines on both sheets met up perfectly and combined to form part of the horizontal curving line that indicates the raft (Figure 62). Eureka! I had reunited two pieces of one larger sheet of Michelangelo's studies! I was ecstatic. I tried to explain what I had discovered to the attendants in the drawing cabinet, assuming they would break out the champagne and immediately call reporters. Much to my dismay, the reaction was, *"Ah, bene." Oh, that's nice.* I sat on this small discovery for twenty years, and you, readers, are the first to know of it.

The reunited sheet demonstrates that Michelangelo was working intently to come up with interconnected groups. He tried out one combination of figures and then turned the original sheet sideways to work on another group in an open space. These sketches seem to be around a central head study, given that the faded black chalk lines on both sheets combine to form the side of a neck and head with the face missing. Sometime later, to make two (or perhaps even three) Michelangelo drawings out of one, someone cut up the sheet to isolate the small sketches.

On the reunited Uffizi sheets, Michelangelo was sketching out his initial ideas for figures in pen and ink, as per his standard practice. Similarly, a large sheet in the Casa Buonarroti for a later section of the vault indicates how he began the design process for the multitude of nudes on the ceiling (Figure 63). The sheet contains a sketch of a cornice in the upper left, a larger seated figure at the upper right, and five smaller studies for figures on the bottom. Three of the small figures were first executed in natural graphite—a material similar to our modern pencil—which allows for small, detailed sketches. One of the figures in the top left of the lower right-hand quadrant was then redrawn in pen and ink, thus establishing it and rendering it more visible. The inked-over figure is a mirror image of the figure next to it, once again showing Michelangelo trying out positions in reverse while generating multiple positions from one.

FIGURE 62: Illustration of united drawings with detail.

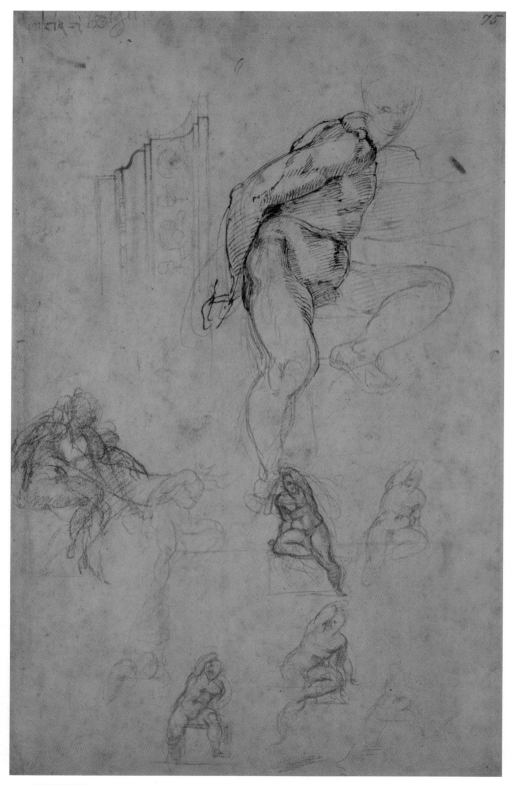

FIGURE 63: Michelangelo, studies of nudes, graphite, black chalk, and pen and ink, 414 x 271 mm (16.2 x 10.6 inches).

The larger figure was executed in the same method: first in graphite, then inked over with minimal pen lines to indicate shadows and anatomy. The twisting anatomical forms of all the figures—especially the larger semi-inked one—were a pleasure to copy, and I could feel the undulating and fleshy anatomy under my pen point. The movements of the figures were easily grasped, and the simple pen lines gave clear volumetric mass to the twisted body.

But I wondered about this sheet. There was something about the juxtaposition of the larger, semi-rendered figure and the small sketches that didn't make sense. In essence, this was a sheet of idea sketches for architecture and figures. Clearly, Michelangelo had executed them off the top of his head, guided by his knowledge of anatomy. The larger figure, however, was extremely complex anatomically and appears to have been done from life. The twisting torso and fleshy folds created by the muscles and bones that can be seen under the skin were undoubtedly observed from life. If Michelangelo had had a live model in front of him, wouldn't all the drawings be anatomically accurate? Perhaps Michelangelo did have a model to draw from, but not as we usually would think.

In graduate school during a Michelangelo seminar, my professor made each of us get up one at a time in front of the entire class and mimic the position of one of Michelangelo's nudes that he displayed on the screen. (We, of course, remained dressed.) Amid extreme embarrassment, physical pain, and some perplexity as to why he was making us do this, I remember standing on one foot, twisted like a pretzel, torso going one way, legs going the other in front of a room of stressed-out grad students, all terrified at having to do the same after me. As I stood there trying to dislocate my left shoulder in order to wrap it around my back to achieve the precise position, it came to me that if Michelangelo used models to draw his nudes, he must have put them through hell. Many of the positions of the figures on the chapel ceiling and on the Casa Buonarroti sheet are simply painful, and no model could hold them for long.

Copying and reflecting on the Casa Buonarroti sheet with the large figure study, I began to think, *And if Michelangelo didn't use a model? What if he used himself to draw the sketches and even the large drawing?* If he did this, he could "feel" the poses and truly capture the energy of the anatomy. But how could he draw from himself? The answer is . . . by using a mirror. Perhaps, just perhaps, for these initial sketches in which he was brainstorming and trying out new figure positions, Michelangelo sat in front of a mirror and sketched his own figure to capture the movement he was looking for. It may seem surprising to some that Michelangelo would have had to draw from life, given his understanding of anatomy. But I believe you never completely master anatomy; you can master how to observe it and draw it, yet the more you understand of anatomy, the more you realize its complexities and the need to draw from life.

Another sheet of studies in the British Museum has sketches on the recto and verso similar to those on the Casa Buonarroti sheet. On the verso (Figure 64) are several studies for the nudes above the Delphic Sibyl (beside the scene of the Drunkenness of Noah) in the finished Sistine Chapel ceiling. At right in the sketch are three small figures—first idea sketches, based on the simple lines—which appear to be early ideas for the pair of nudes above the Erythraean Sibyl. These were first drawn in graphite and then fixed over in pen. The larger figure at left, for a nude not identifiable in the fresco, is more detailed and perhaps drawn from life. The sheet gives a rare sequential view of the way Michelangelo worked and thought: small sketches first in graphite, then penned over in ink, then larger drawings perhaps done from life. The larger sketch, just like the drawing on the Casa Buonarroti sheet, is not finished and seems to show Michelangelo's impatience with the time involved doing detailed anatomy studies in pen and ink.

An important aspect of all these studies is how they show Michelangelo's thought process flowing from first idea to more distinct positions of figures to secondary studies. It is impossible to know if he approached

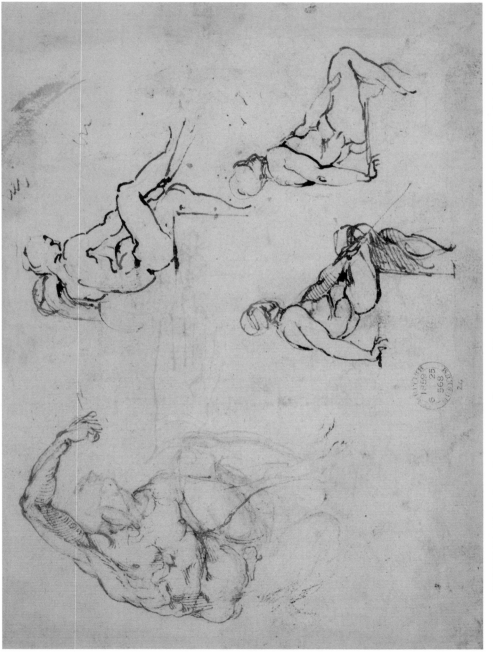

FIGURE 64: Michelangelo, nude studies, graphite and pen and ink, 257 x 205 mm (10.1 x 8 inches).

designing the ceiling scene-by-scene with the related group of nudes or simply began to compose figures that he then distributed where needed in the composition. He must have tried out hundreds of visual solutions in the process of conceiving poses for dozens of figures before finalizing any of them. Ideas from one sheet are developed on other sheets. While doing this, he had to make precise enough studies to then transfer to the cartoons used for painting. After having copied a number of the Sistine drawings, I realized that, although only a small number survive, all of them were in some way connected.

The interrelatedness of the sheets and the need for precise figure studies can be seen in two studies for the pair of nudes above the prophet Isaiah in the finished Sistine Chapel. The two sheets, one in the Louvre (Figure 65) and the other in the Uffizi (Figure 66), contain studies of a seated figure closely related to the small idea sketches on the Casa Buonarroti sheet (Figure 63). They are directly related to the pair of nudes on the finished vault. Although they are two separate figures, it is evident when they are placed side by side that the drawings are mirror images of each other. We first saw this reversal of one position to make two figures in the two small sketches in the Uffizi (Figures 54 and 55) for the original ideas for apostles. In this case, however, the contours and scale of both figures are so similar as to suggest that Michelangelo may have traced one from the other in order to create two separate drawings. This is easily done by putting one drawing up on a window and tracing it onto a blank sheet placed on top, using the window as one would a modern-day light box.

Michelangelo must have executed both drawings close together, attempting to find the best aesthetic combination for the figure in either format. The Louvre figure is done in black chalk and in its medium and state of completion resembles the previously discussed studies for the *Battle of Cascina* cartoon. The figure is large, the outlines are securely drawn with few pentimenti, and black chalk is used to create simple and strong shading. The shading is fairly general but gives volume and anatomical

details. The head is roughly drawn, indicating that Michelangelo wasn't interested in drawing the face. The hands and feet aren't drawn at all. These were done in separate studies.

The Uffizi sketch of the figure in reverse is less complete than the Louvre one—but shows that Michelangelo was specifically concentrating on the anatomical details of the folds of flesh in the bending abdomen and in the muscles of the thigh. These details, which he couldn't render accurately with the soft black chalk, were restudied more precisely with the harder graphite point. Such flip-flopping from black chalk to graphite is fairly odd in an artistic process. It would seem that the black chalk didn't completely satisfy his drawing needs in making both clear lines and general shadows to produce precise studies. But if black chalk was too soft, graphite may have been too hard. In drawing with natural graphite, I found that even getting a point was extremely difficult. To use it, I had to break the graphite into small pieces and sharpen it. This was fairly difficult, since it has a layered consistency and flakes when sharpened. Sometimes I found myself drawing with an oddly shaped wedge-like point that didn't allow me to shade minute details. Though Michelangelo used graphite for this drawing and for some of his underdrawings for pen sketches, eventually he abandoned it, probably due to the technical difficulties and, perhaps, in my opinion, the less appealing cold gray color.

EVOLUTION OF CREATION:
BODY PARTS, TORSOS, ARMS, LEGS, AND HEADS

The two drawings discussed above reveal something else important about Michelangelo's process. To create pendant figures for the first pair of nudes, he most likely created the Uffizi sketch from the Louvre sketch to serve as a general model. He could then alter this model and add new extremities to create a "cloned" but slightly different pendant figure. After copying these two drawings, he began working on numerous other

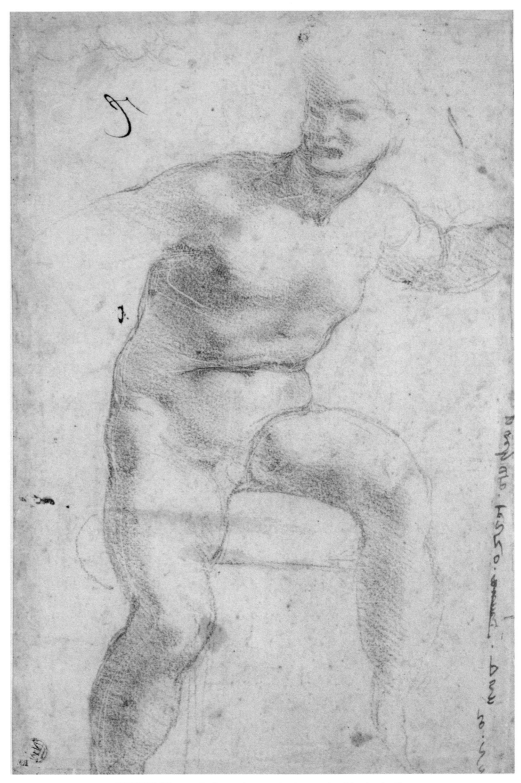

FIGURE 65: Michelangelo, study for nude, black chalk,
305 x 210 mm (12 x 8.2 inches).

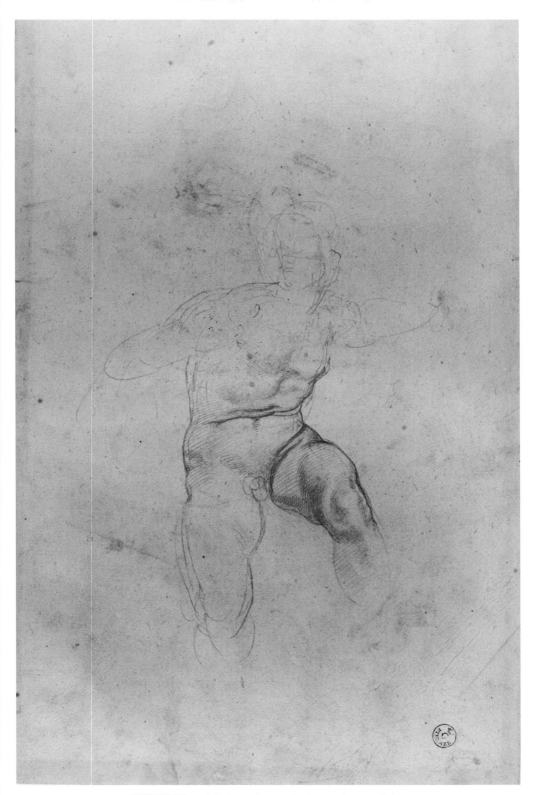

FIGURE 66: Michelangelo, study for nude, graphite,
419 x 265 mm (16.4 x 10.4 inches).

smaller studies of arms and legs. As I looked through his other studies for the ceiling, I began to see that there was a large number of body parts. At first, I couldn't understand what use individual arms and legs might have. But as I drew them and noticed where they ended up on the fresco, I began to see them as pieces of a puzzle for composing figures. Some were used more than once. The pressure of working on the Sistine ceiling undoubtedly forced Michelangelo to develop this method, in which perfectly drawn anatomical parts (the result of his more finely honed drafting skills) could be used and reused, as though the products of a craftsman's workshop, to create dynamic figures.

TORSO CORE

Michelangelo's overall approach could be summarized as follows: After conceiving of the general position of a figure, Michelangelo isolated the torso as the foundation for the ideas of his figures. From this torso core, he moved on to study the arms, legs, and heads separately, to be used as stock body-part drawings to be mixed and matched in creating new figures. The best example of one of these core torsos is on a sheet in the British Museum (Figure 67). This study, done from life in black chalk, isolates a twisting, powerful torso with the extremities only slightly indicated, as seen in the sketched-in head and basic lines of the muscles of the right arm. The contour of the torso was drawn in first; these general outlines are heavy and thick and include some pentimenti, which may suggest the speed with which the sketch was executed. After the contours and indications of the internal anatomy, the next step was to render the shadows of the anatomy, which Michelangelo did by first putting on a light zone of shadow to define the rectus abdominis, serratus, clavicle, and pectorals. The deeper areas of shadow were put on last to add the strategic touches of the final chiaroscuro, such as in the sternum area on the right side of the abdominals, giving the drawing an anatomical heaviness and

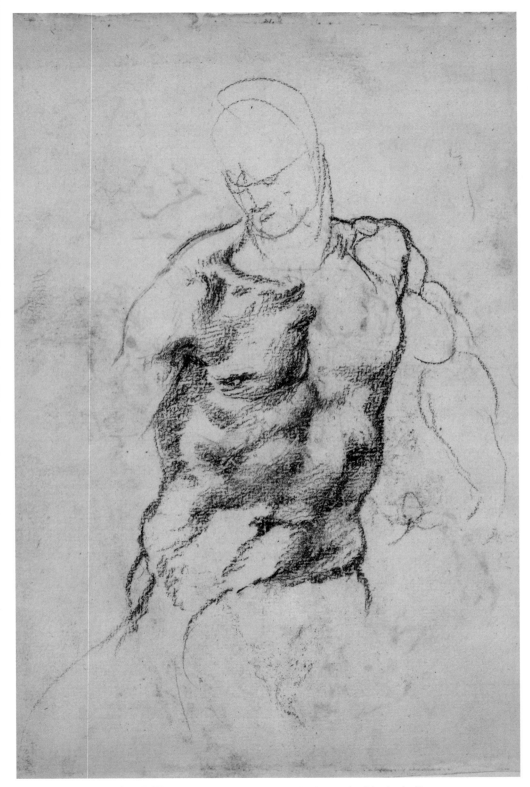

FIGURE 67: Michelangelo, torso study for nude, black chalk,
257 x 205 mm (10.1 x 8 inches).

force. In a drawing executed in probably just a few minutes, Michelangelo was able to capture the form of the torso, isolate the muscles, and infuse it with a force similar to his finest studies for the *Battle of Cascina*.

Aside from the artistic importance of the drawing, the lack of head, arms, and legs reveals here again the assembly-line nature to his evolving and more efficient design process. The torso with no extremities was the initial element of the idea for the figure. Separate body parts were studied separately in various positions and could be reused, mixed, and matched to create other figures. Other, more specific studies were needed to understand how to join the parts and make them fit anatomically. The trick was to study where the parts attached—at the hips, shoulders, and so on—to create a believable and anatomically correct transition so the figure would seem a coherent whole. This process was much faster than trying to come up with a completely new figure.

ARMS AND LEGS

Several existing studies for legs and arms can be related not only to other drawings, but also to the frescoes themselves. A sheet in the Casa Buonarroti (Figure 68) contains a study of the legs of the nude at left of the prophet Isaiah (who is located below the Sacrifice of Noah). The two studies are isolated on the sheet and drawn in clear contours that record the muscles of the leg and articulation of the knee. The shading is succinct but describes the general volume, providing adequate information to execute it in fresco. The simple studies could easily be adapted or added to a preexisting torso, as demonstrated by comparing it with the final nude on the vault. A large sheet in the Uffizi (Figure 69) contains a quick study for the raised right arm of the same nude above Isaiah. Close scrutiny of this drawing reveals Michelangelo studying the left side of the figure as well as the ribs and right pectoral in an attempt to create a correct anatomical attachment to the already executed torso study.

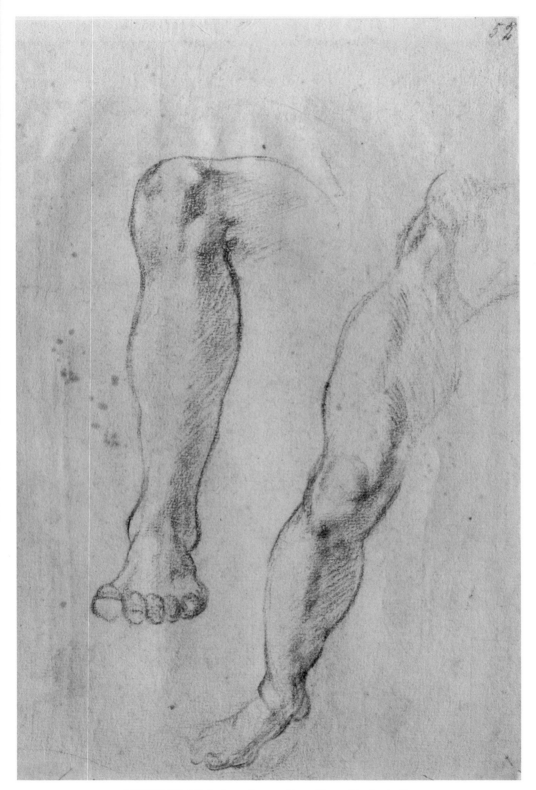

FIGURE 68: Michelangelo, studies of legs, black chalk,
260 x 196 mm (10.2 x 7.7 inches).

FIGURE 69: Michelangelo, studies of arm and leg for nudes, black chalk, 254 x 350 mm (10 x 13.7 inches).

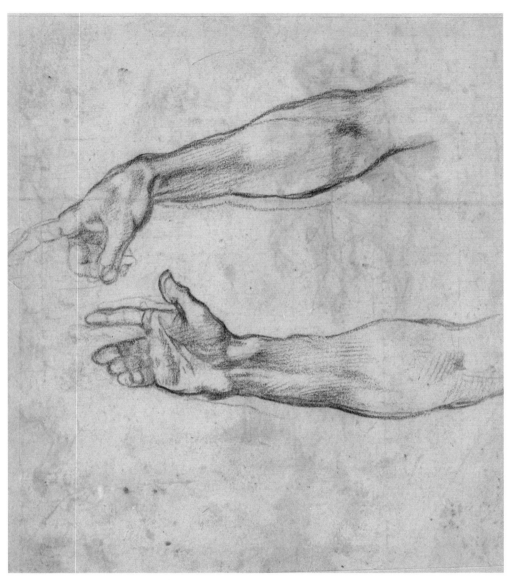

FIGURE 70: Michelangelo, arm studies, black chalk,
206 x 93 mm (8.1 x 3.6 inches).
Study of arm above used in scene of Drunkness of Noah and also
for arm and hand of God the Father in Creation of Adam.

Another example of studies of isolated body parts is a sheet with arm studies in the Rotterdam Museum Boijmans (Figure 70). This small study shows two right forearms with hands in different positions. The one on top is the iconic pointing hand that needs no introduction to a modern audience—although, when Michelangelo did the sketch, he probably had no idea how famous it would become. The pointing hand was used first for one of the *genii*—or small childlike figures—to the right behind the prophet Joel and then was placed in a pile of stock body part drawings for later use. Michelangelo retrieved this study from his drawing pile and exploited its full dramatic effect when he used it for the hand of God in the Creation of Adam—a scene in the second half of the ceiling that was painted two years later.

While I was in the final stages of writing my dissertation in 1996, there was a conference at the Dutch Institute in Florence on Michelangelo's drawings. Many of the leading scholars on the subject were scheduled to give papers on their research. Frankly, I didn't feel like attending because I didn't want to hear new research that might blow my thesis out of the water. I just wanted to write my dissertation and get it done. Finally, I bit the bullet and made my way to the Dutch Institute. As I sat waiting for the conference to begin, I promised myself that under no circumstances would I dare ask a question or try to controvert anyone who may have different ideas about Michelangelo's drawings.

For the next few hours, I listened to papers good and bad that dealt with various aspects of Michelangelo's drawings: technical analysis, attributions, Neoplatonic interpretations, etc. Fortunately, none came close to what I was doing. Then, to my horror, one of the last scholars to present put up several of Michelangelo's drawings for the Sistine ceiling—including the arm study in the Rotterdam of the pointing hand. I gulped when I saw it on the screen. The presenter then announced, "I am the first to see that this arm was used several times by Michelangelo on the Sistine ceiling." *Oh damn*, I thought, *he just stole the thunder from my thesis*. As he

went on to repeat several times that he was the absolute first to see this—hoping for applause, perhaps—I realized he'd seen only the detail but hadn't fitted it into the big picture.

This small drawing was one fragment of the larger puzzle of Michelangelo's assembly-line strategy that I was piecing together. With every ounce of restraint that I had in my body, I resisted the urge to raise my hand and say, *That's very nice, but actually, there is much, much more to it.* I kept silent and let him speak, just beginning to grasp how antithetical my approach was. Everyone else was observing Michelangelo drawings externally as historians and connoisseurs, writing catalogue descriptions with attributions and bibliographical references—while I was experiencing them as an artist, internally, as Michelangelo had, by drawing them with pen and ink, graphite, white chalk, black chalk, and red chalk.

HEADS

Keeping in mind Michelangelo's interchangeable body part method, many other drawings for the Sistine ceiling begin to make sense. Instead of being treated as individual drawings that are associated with the frescoes, they can be placed within Michelangelo's general process for creating new figures. This is best exemplified by three extant head studies for various figures that are remarkably uniform in technique and style and recall the head studies done by Ghirlandaio.

The first is a sheet in the Louvre with a head study in black chalk and white highlights of the nude at left above the prophet Isaiah in the Sistine Chapel (Figure 71). Done from life, this quick study of a youth concentrates on the basic forms of the smiling face. The chiaroscuro is clearly indicated, with black line shading and touches of white as seen on the nose and right cheek. Another study in Turin's Biblioteca Reale (Figure 72) for the head of the Cumaean Sibyl is similar in style, size (about 16 centimeters, or 10 inches, in diameter), and technique, with the same use of black

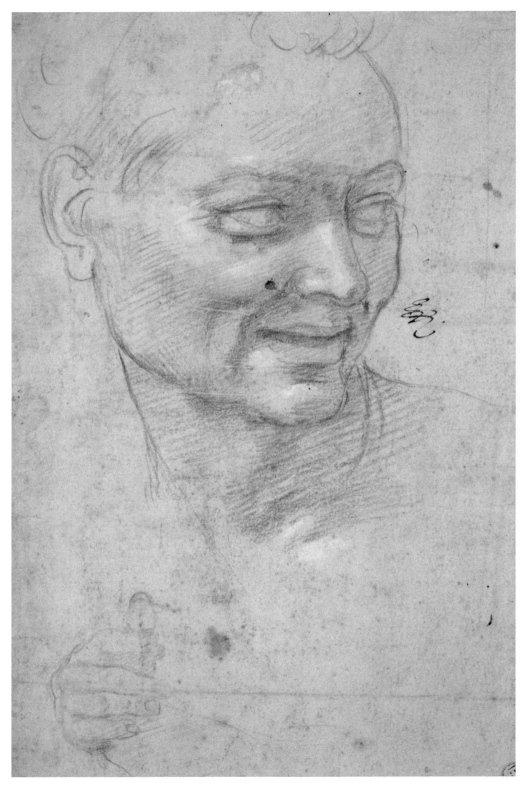

FIGURE 71: Michelangelo, head study, black chalk with white highlights,
301 x 210 mm (11.8 x 8.2 inches).

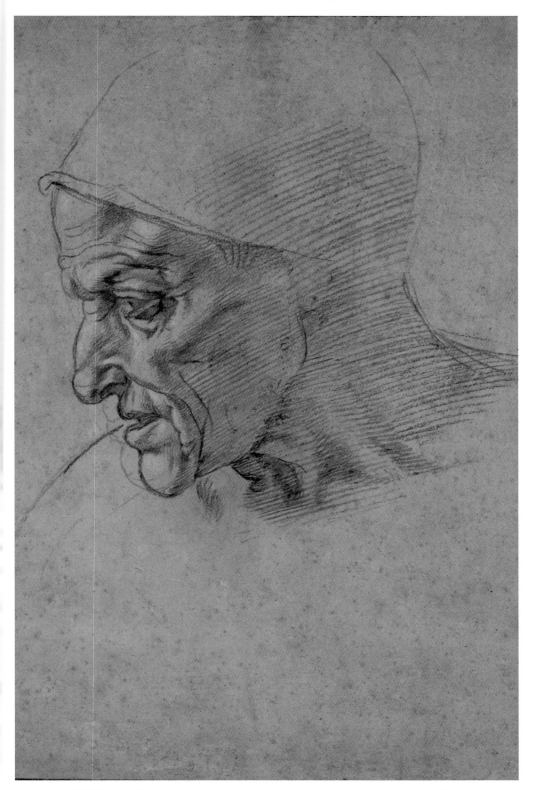

FIGURE 72: Michelangelo, male head, turned left, study for Cumean Sibyl, black chalk with white highlights, 230 x 315 mm (9 x 12.4 inches).

chalk and white highlights, to the one in the Louvre. For this study, Michelangelo intensified the light source—from a window or a candle—to bring out the wrinkles in the old face. The profile is done in secure contours, and the shading is rendered in quick, parallel, pen-like hatchings then reinforced to create the "super-darks," such as on the cheek and nose.

Both the Turin and the Louvre head studies are isolated in the center of the sheet, with the hair or headdress only slightly indicated; these were left out purposely and would be added later on the cartoon. Another head study in the Uffizi (Figure 73) shows the same stylistic characteristics as the Louvre and Turin sheets. This one, for the head of Zechariah, is done in black chalk with the same simple and direct shading. It is interesting to note that in the study Michelangelo draws the figure with a full head of hair, while in the frescoed figure Zechariah is bald. It's possible that, as he was drawing the study, he decided that the prophet was to be bald and simply didn't finish the rest of the head so as not to waste time.

Viewed together, these three drawings demonstrate by their similarity one of the types of studies Michelangelo executed as part of his assembly-line creative method to complete the design of each figure. There must have been many more in black chalk with white highlights—one for each of the figures on the early part of the ceiling—but these few survive, and more than any of the other early studies for the vault, they clearly point to a methodical, mechanical, craftsman-like approach to creating and assembling figures.

Although he never completed his painter's education in Ghirlandaio's workshop, from being there and copying his master's drawings he must have retained some idea of how to organize and execute studies for large fresco projects. Not only is the division of work similar, but the style of the drawings is too when compared to Ghirlandaio's black chalk head studies for the frescoes in the Tornabuoni Chapel in Santa Maria Novella (Figure 13). Notice the way Ghirlandaio isolated the head on the sheet,

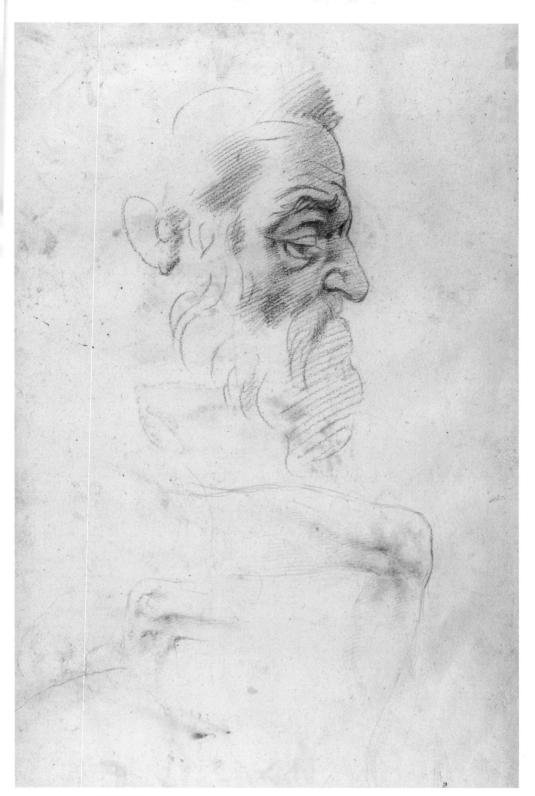

FIGURE 73: Michelangelo, head study for Zechariah, black chalk,
153 x 277 mm (6 x 10.9 inches).

shaded the strong chiaroscuro with parallel black chalk lines, and finished it with white chalk, thus giving all the tonal indications to paint it in fresco, just as Michelangelo would do later.

However Michelangelo came to use a craftsman-like method to his work on the vault, whether reluctantly or willingly, he had finally found a work pattern that allowed him to systematically create figures. The drawings indicate that he had to spend time making numerous studies for every figure, but it was time well spent. He was making progress. With black chalk as his main drawing tool, he created a pool of drawings of torsos, arms and legs, hands, and heads from which he assembled his figures. Although many drawings for the first part of the ceiling do not survive, the distinct characteristics of the surviving drawings and a comparison of the figures on the vault give an idea of what the missing sheets might have looked like. A good forger could, with this information and the right materials, make some very interesting drawings.

A DRAPERY STUDY

Although the theme of the vault was altered to allow Michelangelo to make the male nude the main compositional element, he couldn't avoid having to paint the draped figures of the eleven prophets and sibyls that appear in the final Sistine Chapel ceiling. How did he learn to draw them? The only drapery study that survives is a large sheet in the British Museum (Figure 74). There must have been others—one for every prophet and sibyl and for any other draped figure on the ceiling—but this one for the Erythraean Sibyl is the sole example. Why? We don't know. But this drawing demonstrates that Michelangelo was developing artistically and had finally mastered drapery studies. The folds and creases of the cloak are rendered in pen and ink in parallel and crosshatched lines and enhanced with ink wash that vividly recalls his early draped figure studies done as an apprentice under Ghirlandaio. In addition, the way the folds are

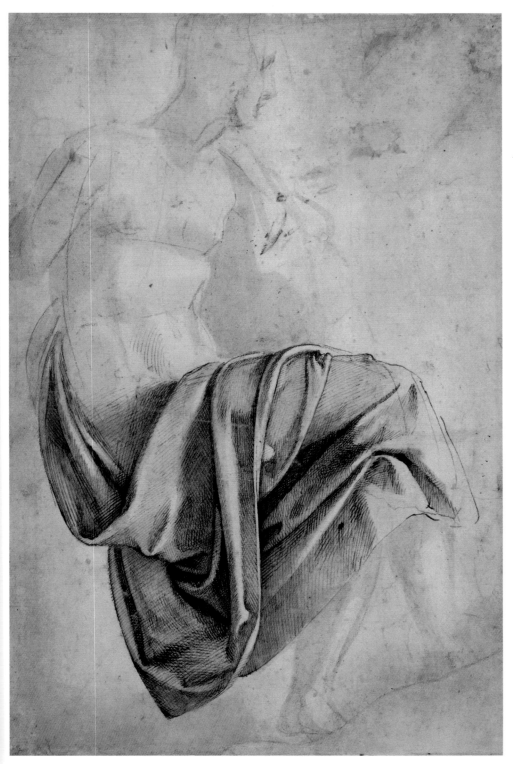

FIGURE 74: Michelangelo, drapery study, pen and ink and ink wash,
384 x 260 mm (15.1 x 10.2 inches).
This study was done from a draped mannequin, which Michelangelo indicated with ink wash.

rendered with small hatched lines is similar in style to Ghirlandaio's drapery studies for the Tornabuoni Chapel, done in the same technique as seen in Figure 12. Michelangelo was again following the footsteps of his master. Just how much he had improved is evident from a comparison with his early drapery studies. Folds are vibrant and clear, cascade in a credible manner over the legs, and are rendered to give volume and depth. The light ink wash indicates that a mannequin was under the folds. Since a model has to move to take a break every so often, the folds would be disturbed, and it is almost impossible to reconstruct them in the same manner. Mannequins are needed because you can drape the figure and leave it there for hours or even days with a fixed light source. This allows you time to both draw the forms and render them. Drawing drapery takes time, and this study fully demonstrates just how much effort was involved: getting a mannequin, setting it up, sculpting the folds, and also the effort (pen lines, ink wash) spent on just this one type of study for the vault.

I spent two hours copying this drawing (Figure 75). It isn't just a pen drawing but almost a painting in itself. The ink folds are rendered in delicate pen lines to give the darkest areas and the beginning of the middle tones. The rest of the shading was done in extremely delicate ink washes, which render the highlights by leaving blank areas of paper. I had to find the right mixture of ink to water, as well as the right pressure on the brush to create the delicate tones. *This is so unlike Michelangelo*, I remember thinking as I was copying. *Michelangelo is strong forms, bold shading, and forceful highlights.* This was none of the above. Refined forms, delicate shading, and complex highlights—worthy of Leonardo himself. Compare this with some of Leonardo's brilliant drapery studies and that becomes clear. As the drapery drawing demonstrates, Michelangelo had not only recalled how drapery studies were done but had taught himself how to position the mannequin, sculpt the folds, and execute the drawing with enough visual information to paint it in fresco.

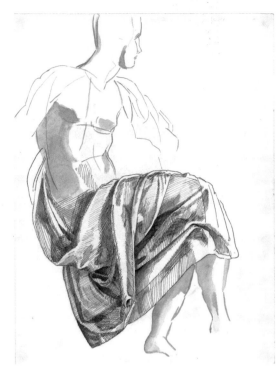

FIGURE 75: Alan Pascuzzi,
copy of drapery study
384 x 260 mm
(15.1 x 10.2 inches).

These were tasks familiar to the old artisan-painters of the Quattro-cento, not a modern master like Michelangelo. I have many friends who are old artisans who have their workshops near my studio in San Frediano in Florence. These are true craftsmen—almost monk-like in their devo-tion to their art—who have dedicated years of their lives in solitary, almost meditative, work. Unfortunately, they are a dying breed, left to extinction by modern society. I consider them prophets to be valued and preserved at all costs. Some have been working with their hands for more than half a century, and I gladly listen to what they have to say. They stop at my workshop and chat, and often leave golden pieces of philosophical advice on art and artistic creation. (I'm sure the same thing happened to artists in the Renaissance, Michelangelo included.) One day, while we were talking about the difference between artists and artisans, one of these artisans

said, "Craftsmen work better when they work with the creativity of an artist, and artists work better when they work with the diligence of a craftsman." I remember thinking how these words perfectly described Michelangelo's work for the Sistine vault—an artist drawing with the diligence of a craftsman.

MICHELANGELO AS CRAFTSMAN

As I began to amass my copies of Michelangelo's drawings for the Sistine ceiling and look them over periodically, a general trend began to emerge. There is no doubt that Michelangelo was put to the ultimate artistic test when he was commissioned for the ceiling. He had to pull out all of his creative skill—his brainstorming skill, in essence—to come up with ideas for the figures. His major development artistically was that his drawing skills became more succinct, more direct, and more efficient in realizing his ideas. What's strange, however, is that this happened precisely when he had to become more like a craftsman. When he developed his method of constructing the figures, in essence he returned to the Quattrocento approach—methodical, careful, tedious, and effective. He reinvented the wheel but did it in his own forceful style.

The drawings for the first half of the ceiling show that he essentially taught himself what he would have learned in Ghirlandaio's workshop had he continued there and never gone to the Medici sculpture garden. The first drawings for the apostles evidence his inability to conceive of them effectively. Through trial and error, he recreated the design process that true painters, like Ghirlandaio and Leonardo, had already mastered. In fact, as we saw, the drawings executed near the end of the first half of the ceiling are exactly like the studies that Ghirlandaio executed for the Tornabuoni Chapel. They are also like the drawings Leonardo did for *The Last Supper* in Milan (i.e., figure studies, head studies, and drapery studies).

Bramante and the others were in the end correct. Michelangelo had no experience in designing scenes for the Sistine vault. However, the experience he lacked wasn't so much in drawing but rather in organizing his thoughts adequately to make the preparatory studies for painting the composition. Michelangelo had to learn this all by himself and, in his thirties, complete the education he had begun when he was thirteen but abandoned two or three years later. When he does learn this craftsman-like approach to designing the ceiling, it allows him to generate in profusion the drawings necessary to paint its expanse.

After relying on this system, however, he transcends it and begins to change his approach and his drawing materials. The next half of the ceiling demonstrates that Michelangelo went beyond being the craftsman and ascended to a new level of artistic creation. In the next series of drawings, he entered a flow state—when ideas are clear in your head and they flow to the finished work. The preparatory drawings for the remainder of the Sistine Chapel ceiling are not studies to be combined with others to compose varied figures but are the completely realized ideas of a mature artist.

10

The Drawings for the Sistine Chapel, Part II

A CHRONOLOGY FROM CRAFTSMAN TO GENIUS

Michelangelo began work on the Sistine ceiling in the winter of 1508–1509, and we know he completed the frescoes for the first section of the vault around August 1510. The first section is generally believed to have consisted of the first three Genesis scenes, the Temptation, Creation of Eve, and all the adjacent prophets, sibyls, and nudes, as well as the lunettes.

In comparison to the studies for the first half of the ceiling, Michelangelo's drawings for the second half manifest a significant change in content and style. There are fewer isolated studies of arms, legs, and torsos and no large sheets with examples of Michelangelo reversing figures. The extant drawings suggest that as Michelangelo entered completely into the commission after months of drawing, he had refined his skills as a draftsman and relied less on compositional devices to save time and effort. Instead, he was now relying more on his creative ability to conceive and produce new figures. It is not that he abandoned his craftsman's approach but rather that he built upon it and took it to the next level. This is what may be considered genius.

The frescoes on the second half of the ceiling evidence this change in Michelangelo's general approach to composing the scenes and figures. Many art historians have pointed out that the early scenes with numerous figures are busier and harder to read from below. Michelangelo may have realized just how busy they were only after taking down the scaffolding and looking up for the first time. I can imagine his *Oh, damn* reaction when he saw that they were difficult to discern. In contrast, the scenes from the second half are larger, with simplified but strong compositions consisting of fewer figures.

As the compositions became simpler, the figures in and around the scenes became more complex. They are in active positions full of vitality and seem to burst out of the architecture. The nudes, in particular, are no longer pairs of slightly altered twins but individually conceived. They show a multitude of original, complex, and expressive positions—a true sign that something was changing in Michelangelo's method of composition and in his artistic mind. The limited number of drawings provide only an intermittent glimpse of Michelangelo's new working methods but nevertheless offer a fascinating view of his final maturation as an artist.

By August 1510, Michelangelo had completed the first section of the vault up to the Creation of Eve. Needing money to continue work, he made trips in September and December 1510 to see the pope, who was in Bologna at the time, and procure funds. After various delays taking down the scaffolding for the first section and putting it up once again for the second, he returned to work sometime in February 1511 and began painting the Creation of Adam. There is a series of drawings for the scene of the Creation of Adam so interrelated one can consider them a cluster that shows perhaps the most significant change in all of his drawings done up to this point: he switched to red chalk as his primary drawing tool. For his early studies for the Sistine ceiling, Michelangelo primarily used pen, graphite, or black chalk with white highlights—just like any

Quattrocento painter would have done. Now, for the first time in his life, he began to use sanguine, or red chalk, instead.

When I began copying this series of drawings, I had to go out and get a different material to be true to them. Being in Florence, I went to Zecchi's art supply store and asked for natural red chalk. I still remember the store clerk placing a huge container in front of me filled with what looked like reddish-orange stones. In fact, red chalk is not red but a deep orange-red with a certain zing or snap to it, similar to the color of paprika or red brick or terracotta. I carefully chose several small pieces and paid for them. I was used to red conté crayons and red chalk pencils—neither of which I had liked, because of the "dead" or flat red color. This, however, was the real stuff, the real sanguine Michelangelo had used. I brought my small pieces home and hastily got out a piece of drawing paper to try them. As I dragged the nib across the paper, I was amazed at the pure, vibrant orange-red color of the lines, which had a warm glow to them.

DRAWING IN RED CHALK

Natural sanguine or red chalk is in essence an iron oxide or red hematite, which comes from the Greek word *haematitis*, meaning "blood red." It is found in the earth and is formed by the fusion of clay and iron oxide. The difference in concentration of the clay to iron oxide determines the tonality: more clay to iron oxide gives a light orange color, more iron oxide to clay produces a reddish-brown color, and even amounts of both give a rich red color. Although tonally less strong than black chalk, red chalk is seductive not only for its rich orange-red color but for its warm hues that give a vitality to lines and shading—especially on anatomy studies.

Drawing in red chalk requires a careful selection of the sanguine followed by the preparation of the points. The best sanguine to use is the orange-colored (more clay to iron) or reddish color (equal clay to iron), which both hold a good point. The points are made by carefully cutting

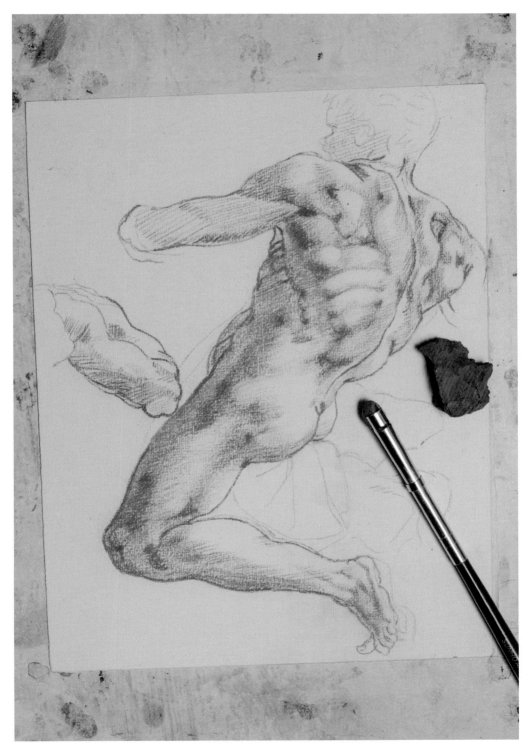

FIGURE 76: Illustration drawing in red chalk: natural
sanguine and sanguine point in holder.

smaller pieces from a larger piece. These small pieces are then inserted into a holder, or in Italian, *prolunga*, which can be metal or a bamboo shaft (Figure 76). With the point firmly fixed into the prolunga, it is sharpened with a penknife. To complete a drawing, several of these points from the same "mother" piece are necessary, since the tip does not last long and the color should stay consistent. One other aspect to red chalk is that it is best used with no charcoal preparatory drawing (as can be used for pen and ink and black chalk). This means that it takes an extra-skilled hand to draw with it, since a drawing must begin and be completed without the aid of a charcoal underdrawing.

Red chalk was probably known to artists before the Renaissance, but it was never used by Florentine artists until the late 1400s. In the 1490s, Leonardo was the first to explore and master the technical and tonal qualities of the material. He fully understood the aesthetic innovation and used red chalk to produce beautiful anatomy studies in which the naturalism of the red color lends itself perfectly to creating flesh and muscles. This can be seen in the various studies of figures and faces for *The Last Supper* in Milan.

Leonardo was constantly experimenting with new techniques, so it's understandable he would switch to red chalk to make studies for his large commissions. But what prompted Michelangelo to make red chalk his primary drawing tool? As any craftsman would tell you, you don't change the main tool of your trade without reason, especially midway through the largest and most important commission of your career. If a craftsman does make this switch, it's likely because the new tool it significantly more responsive and better suited to the task at hand. The early drawings for the Sistine ceiling show that Michelangelo searched persistently for the right tool to respond to his particular graphic demands and serve his creative needs. Many sheets show him using pen and ink, ink wash, graphite, black chalk, and even a mixture of all the above. In some cases, he used three different media on the same sheet. It is only in this last series of drawings

that Michelangelo finally seems to have found the one responsive medium that satisfied what he was looking for in a drawing tool—and that was sanguine.

The biggest difficulty for me when I first began copying Michelangelo's drawings in sanguine was in switching my "tonal vision" from dark media like black chalk and ink to a lighter, warmer range of hues. If you want to render a dark shade in sanguine, it takes a while to conceive that no matter how hard you press with the chalk, it will never be dark, just a deeper red. Offsetting that difficulty, however, is this technical consideration: red chalk has the ability to render soft tones in a light red that, if done correctly with the highlights, seems to make any anatomy shimmer. After months of copying Michelangelo's red chalk drawings, I managed to learn to control it, but later on I rarely used it in the figure or portrait studies I did for my own commissions. I needed the security of black chalk and the dark shadows it produced. Several years later, when I began to make studies of my infant son in black chalk, I realized that the dark color of the black chalk was too harsh and aggressive for the soft, chubby forms of my little son. I wanted to capture the soft warm "pudge," but cold black chalk cannot do that. That was when I recalled the delicate nature of red chalk and took it up again—and it was perfect. The sanguine's soft red lines and warm shade lent themselves perfectly to the soft fleshy folds of my little son's anatomy.

Only as I was sketching my son in red chalk did I realize what the use of this substance means to an artist. If you consider the body of drawings from the Renaissance, red chalk seems to be taken up when the artist reaches a level of aesthetic refinement that requires material for soft, yet descriptive rendering. Red chalk signals that they have arrived at a high point of technical and aesthetic maturity, especially in drawing naturalistic anatomy. Leonardo started to use red chalk when he reached a mature level in his drawing skills, as seen in his sanguine studies for *The Last Supper*. Raphael did only after he got to Rome for the studies of his

frescoes in the Vatican. Michelangelo began to use red chalk in the final stages of the Sistine ceiling.

Michelangelo began using red chalk because of its appealing technical capabilities. The greater technical responsiveness of sanguine may be directly tied to the change in his drawing scale in the second half of designing the vault. In relation to the earlier sketches, the studies after 1510–1511 are on smaller sheets of paper, have a greater range of subtle tonality, and are more exacting and precise. In essence, while the drawings are smaller, the rendering is more detailed. The dense red chalk allowed him to fully exploit the hatched lines of his pen technique but also to shade larger areas better than with black chalk.

The cluster of drawings for the Creation of Adam that offer the first evidence of Michelangelo using red chalk as his primary drawing tool comprise six studies, the most that exist for any one scene on the ceiling. The sheets contain studies for Adam, God the Father, and the supporting angels. They correspond almost exactly to the fresco, with no trace of the trial and error sketches among his earlier studies. These were executed as direct preparatory drawings for the figures.

THE CREATION OF ADAM, AND TO FIND THE FACE OF GOD

There exists today no complete drawing for the body of God, but there are isolated studies for the parts not covered by drapery, and from these the entire figure can be "reconstructed." At the Teylers Museum in Haarlem, there are three interrelated sheets containing red chalk studies for the figure of God the Father and supporting angels that can be considered a cluster in themselves (Figures 77, 78, and 79). Two sheets (Figures 77 and 78) have studies of God's left and right arms, including the famous hand with the iconic pointing finger, which is studied twice over. Michelangelo had drawn the same arm and hand in black chalk for the

Drunkenness of Noah, which is at the Museum Boijmans Rotterdam (Figure 70), and the Haarlem studies are remakes of that. The fact that Michelangelo did multiple sheets with sketches detailing the hand demonstrates that, by the time he started working on the Creation of Adam, he knew how much weight the hands—and the scene—carried for the whole decorative scheme of the Sistine Chapel. Now Michelangelo drew the hand larger, in the first Haarlem study (Figure 77) that was ultimately transferred to the cartoon and painted in fresco. Part of the same torso as well as arms and hands on both Haarlem sheets were studied separately as individual elements that correspond to the giornate. The drawing of separate details of the figure on a single sheet is a refinement of his earlier body-part system in which one figure was studied part by part on separate sheets of various sizes. This cluster of three drawings contains all the details of the figure and they are significantly smaller.

The third Haarlem sheet (Figure 79) contains studies of both legs of God the Father. If viewed horizontally, the study of a right foot and a right leg from the mid-thigh down correspond exactly to God's leg in the fresco. The series of lines that extend from the lower calf of the more complete leg also indicate the position of the right leg resting behind, as seen in the frescoed figure.

The only other studies needed to complete the figure of God the Father are of the drapery, torso, and head. The drapery study no longer exists, but is there one for God the Father? I think so. When I was copying these drawings in the British Museum, I had the chance to observe every line and shadow on every drawing, front and back. On the verso of the study of Adam (Figure 1)—yes, the one that I contemplated purloining—in the space alongside a head study for one of the nudes, is, I believe, a faded charcoal study for God the Father (Figure 80). I recognized it while I was copying the small head study from the original in the British Museum. As I did so, a series of faded black lines caught my eye. Upon closer scrutiny,

FIGURE 77: Michelangelo, studies for God the Father and angels in
Creation of Adam, red chalk, 279 x 214 mm (10.9 x 8.4 inches).
Studies for both arms of God the Father including arm above (upside down),
which is the restudied version of the arm and hand with pointing finger
(studied twice on sheet) first seen on the drawing in Rotterdam (Figure 70).

FIGURE 78: Michelangelo, studies for angels and God the Father in
Creation of Adam, red chalk, 265 x 198 mm (10.4 x 7.7 inches).
Hand of God restudied fourth time, slightly turned to see more of the palm.

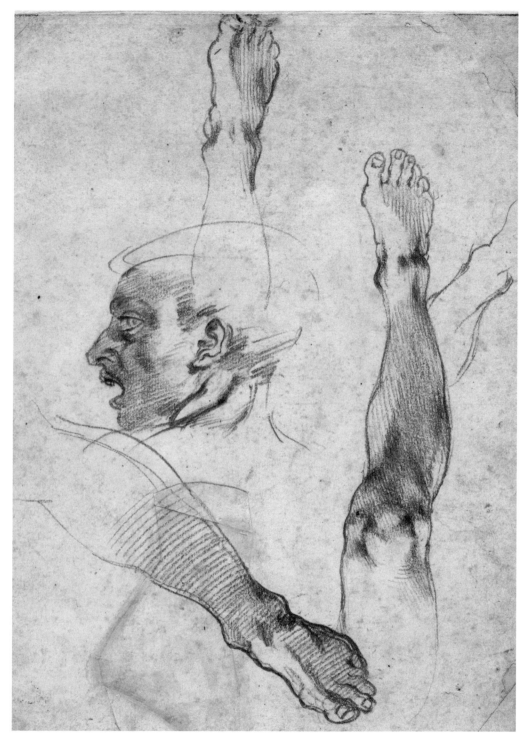

FIGURE 79: Michelangelo, studies for legs of God the Father in
Creation of Adam, head of nude, red chalk,
265 x 198 mm (10.4 x 7.7 inches).

I began to make out, as if the face was materializing before me, the profile with the long nose, sensuous lips of the mouth, eye, and unmistakable flowing hair of the fresco image.

I couldn't believe my own eyes. I hadn't seen this detail before in the various reproductions of the drawing in books. (In fact, it does not show in reproduction—that's how subtle it is. The face won't be visible in the image reproduced here.) The more I looked at the lines, however, the clearer the face became. I contemplated saying something to one of the attendants in the drawing room, but remembered the disinterested reaction I got the last time I presented a "discovery." Deep inside, I knew the head was there. I put the drawing back in its case. In my dissertation, I mentioned in an endnote my "possible discovery" of a hidden head of God, but no one considered it important.

After I completed my PhD, the head of God on that sheet still was on my mind. Ten years later, in January of 2006, I made a special trip to the British Museum to view the drawing once again and to confirm that the head was there. I requested the drawing, and, after setting it up in front of me and examining it closely, I saw the face once again.

I immediately called the director of the British Museum drawing room to show him what I had found. The director, a distinguished English art historian, was at first almost amused at what I had presented to him—the faded head of God the Father on the back of one of the most important drawings by Michelangelo. With a skeptical look on his face, he patiently listened to what I had to say and then offered to "give it a look." With the drawing propped up in front of us we both peered at the sheet, and I pointed out the faint black lines. After several seconds, he lost his skeptical look, became silent, and got even closer to the drawing. In one motion, he suddenly took the drawing in his hands and said, "Come with me."

We went down some stairs to the restoration laboratories to look at the drawing under UV light. One of the older restorers was there, and she too looked at the drawing when we put it under the purple light. As we all

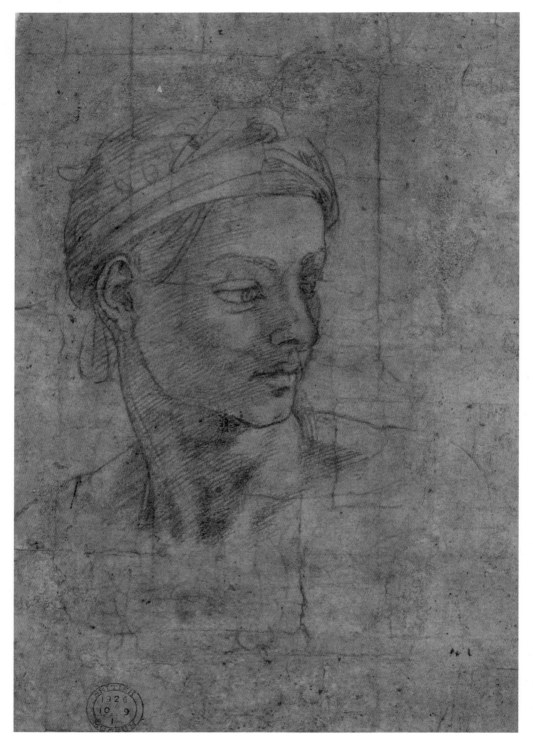

FIGURE 80: Michelangelo, head study for nude, red chalk,
190 x 237 mm (7.4 x 9.3 inches).
Infrared reflectology photo would reveal faded study for
head of God the Father located to right of head.

stood there in the darkness, bathed in an eerie purple light and looking in silence at the sheet, the restorer said, "Yes! I see a nose, and an eye . . ." I was ecstatic—someone else had seen what I saw. Right at the peak of my excitement, thinking that I had discovered the head of God and that art historical stardom was imminent, the director bluntly said to her, "No, you don't." The woman, cut dead in her tracks by the director, fell silent.

"There is nothing there," the director said. "Just some stains that look like a face." I remember looking at the restorer, who gave me a look as if to say *what can I do; he's my boss* as we went back upstairs with the drawing. The director placed the Michelangelo drawing back in its box and politely took his leave of me.

And that was that. I left the drawing room thinking the director was going to steal my discovery. But there was nothing I could do. I know it's there. Twelve years after this event, for the publication of this book, I made a formal request to photograph the drawing using infrared reflexology. Infrared reflexology is a process by which all unseen marks on drawings—like faded charcoal sketches—become evident and can be photographed. My request was denied. The reason for not allowing me to analyze the drawing? According to the museum, the supposed head of God is nothing but "stains left by restorers" when they restored the sheet some time ago. My only response is that the restorers are extremely good draftsmen. I remain hopeful that someday I'll be able to demonstrate that it's there.

The three Haarlem sheets with red chalk anatomy studies—as well as the still undiscovered head study of God the Father—show again that Michelangelo was able to take his idea for a complex figure, fragment it into separate studies, and then reassemble it. Near the end of his designing the figures for the Sistine Chapel, however, he had refined his approach even more. While craftsman-artists like his master Ghirlandaio did this in a traditional way, Michelangelo upgraded the system and streamlined it, concentrating every type of study—arms, legs, heads, and hands—on a

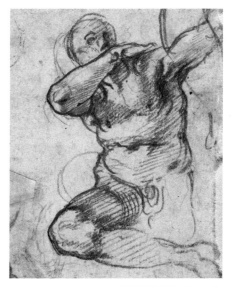

FIGURE 78: (detail)

limited number of sheets. Studies for God's attendant angels found on the same sheets in Haarlem demonstrate this streamlined system. One of the sheets discussed above (Figure 78) contains a study for the angel directly behind the head and extended right arm of God. There is also a study for the angel figure below God on the sheet. It has the right leg crossed over the left and a sketch of the back and buttocks of the *putto*—or small child—under the figure of God that supports his legs. Both legs of God the Father are studied on another Haarlem sheet (Figure 79), which contains a study of the entire right leg and smaller sketches of both feet. On the third sheet (Figure 77), studies for the angel figure are partially embraced by God's left arm and directly above God's left shoulder.

While copying these small sheets, I noticed that they were "composed." In other words, while they contained numerous separate studies that in some cases were unfinished, the studies were carefully placed so as not to overlap. This was unlike any of Michelangelo's earlier sheets that I'd encountered. The studies had also become smaller—which indicates less time spent on execution and greater skill in drafting. As I mentioned earlier, drawing things small and accurate is the true sign of an artist's skill. These small sketches were all alike in one way: all were unfinished or left incomplete precisely where they might overlap the other figures in the actual fresco. What this demonstrates is that Michelangelo studied only those portions that were to be visible and didn't bother with completing the whole of each figure. See, for instance, the torso embracing God's arm, which is transparent in the right of Figure 77. This suggests that he had a clear idea of where he was going not only with the figures, but also

with the entire composition. He wasted no time on superfluous portions of the figures—only what was to be painted was studied. Michelangelo had achieved a more complete artistic vision, involving less trial and error in composing figures and a streamlined drawing approach (smaller sketches) to get the vault done.

The sheet in the British Museum with the red-chalk figure study of Adam (Figure 1) evidences a further refinement of Michelangelo's method of composition and representation of the human form. This is arguably one

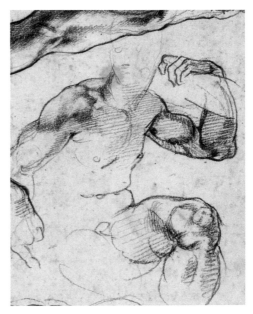

FIGURE 77: (detail)

of Michelangelo's best drawings of the male nude. The subtle but powerful rendering of the anatomy and the impression of the warm, rippling flesh demonstrate that Michelangelo had found his artistic stride and mastered sanguine. In this drawing, he exploited the tonal and technical capabilities of sanguine to their full effect. Copying this from the original (Figure 2), I had the opportunity to "feel" the secure outlines of the forms, with a few pentimenti on the left thigh, which give the figure a dynamism and movement. The anatomical forms of the chest and rectus abdominis are shaded with fine lines, strengthened with dense patches of red. What was difficult to render was the extremely light areas of shade, such as on the left side under the extended left arm, which gives a glow to the muscles even though it is a shadow. After struggling with this copy, though. I prided myself in being able to capture that seductive, sensual sheen effect of the combination of subtle red chalk shading and the untouched paper, which reads as though the highlight. When I'd finished and was comparing my drawing with the original, I realized where my

mentor Michelangelo had taken me. I had followed him to the highest level of his drawing mastery. And my copy was so good in my eyes that I'd played with the thought of switching it with the original, but did not.

The Adam study, besides its aesthetic importance, reveals a secondary approach to composing figures that Michelangelo used in addition to the kind of studies seen on the Haarlem sheets. For some of the figures in the fresco, Michelangelo executed near-complete figures with torso, legs, and arms all connected, leaving only the head, feet, and hands to study separately. For the Adam study, the figure is complete, with indications of the head and hand. He restudied the hand under the torso. The head was done on another sheet. The Adam drawing suggests that after years of work drawing and painting on the vault, Michelangelo had developed the ability to conceive, realize, and establish a figure in fewer preliminary sketches than he had done earlier. His method now consisted of executing near-complete figure studies, leaving only the head and extremities to finalize. This simplification of his design process perhaps reflects increased efficiency to save time and further speed up execution of the frescoes. It is more likely, however, that as Michelangelo designed figure after figure, he no longer needed to develop poses through numerous idea sketches but was able to conceive and execute figure studies in one sitting. This, combined with his complete control of the technical capabilities of red chalk, allowed him to produce some of his most amazing drawings for the ceiling.

MASTERFUL, SENSUAL FIGURES

Three figure studies, one in the Albertina in Vienna (Figure 81), another in Haarlem (Figure 82), and one in Cleveland (Figure 83), are perfect examples of Michelangelo's new approach to making preparatory studies. All three are similar to the study of the Adam figure in their central and dominant placement on the sheet, handling of the sanguine, and near completeness. It was the completeness of the study that made it a challenge

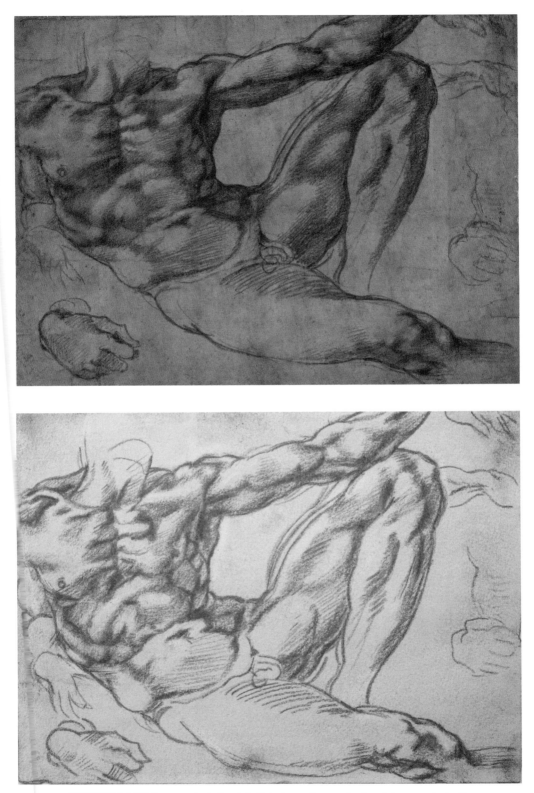

FIGURES 1 AND 2, repeated: (top) Michelangelo, study for Adam, red chalk, and (bottom) the author's copy.

to copy. Instead of concentrating on separate body parts as in previous studies, I now had to deal with proportion, movement, the intricate interaction of muscles, and the sensual rendering of the figure with an exquisite red chalk technique. Struggling to reckon with all these elements together in order to produce a decent copy, I understood that Michelangelo himself had met the same challenge. The three figure studies should not be viewed as individual works of art, as many catalogues or exhibitions present them, but a summary or perhaps a culmination of all the drawings Michelangelo did from his first drawing exercises as a young boy to a mature artist in his thirties. All the pen studies, black chalk studies, anatomical drawings; the mastery of hatched lines, shading, composing the figures—all of these aspects evolved in Michelangelo's mind and hand to finally produce what I would call a perfectly realized style that we know as Michelangelo.

All three drawings are so similar in their format and style that a detailed description of one is valid for the others. All are drawn to the same scale and are almost complete figure studies that include a rough indication of the head as well as other isolated sketches of the extremities in the margins. No other extant drawings by Michelangelo are as similar in style, format, and technique as these three. The force, movement, and brilliant technical use of red chalk are the same in each. Crisp and sharp contours are drawn with hardly any pentimenti; shading is done with veils of red so delicate as to use the grain of the paper to create the impression of flesh over the muscles. Darks are created with strategic solid concentrations of red; and subtle tonal changes are carefully hatched in with fine lines. Michelangelo had found his true drawing style.

The Albertina study shows a twisting mass of muscle and flesh, rendered with a complex play of light and shadow on the left arm, torso, and legs. The subtle shading in red chalk produces a shimmer on the powerful deltoid, triceps, and muscles of the elbow. The Haarlem study is a prime example of a perfect fusion of movement and muscles of the latissimus

dorsi, external obliques, gluteals, and leg. The Cleveland drawing shows almost all of the muscles of the human body, with every single muscle of the torso, arms, and legs rendered and highlighted with dark patches of red chalk combined with subtle shading. With the red chalk, Michelangelo was able to give the sensation of the skin stretching over the muscles of the torso. After copying these drawings, I realized that the subtle shading with complex hatching suggests that these were first drawn from a model and then carefully finished (perhaps without the model) by Michelangelo, who took a craftsman's pride in rendering them to perfection.

A comparison of these three red chalk drawings with the two previously discussed figure studies in black chalk—the torso study in London (Figure 67) and the full-figure drawing in the Louvre (Figure 65)—reveals just how much Michelangelo's approach and rendering of the human figure had evolved. The London and Louvre drawings show movement and anatomy, but the three nude studies clearly show a more refined, powerful, and secure drawing style, a clear demonstration of his true mastery. He had already achieved a high level of drafting skill when he began the Sistine Chapel, but the red chalk drawings show that he made that last—and most difficult—jump to ultimate mastery when even study drawings become masterpieces.

You can imagine how much I struggled copying these three figure studies. The style is extremely refined and harmonic in the balance of forceful anatomy and subtle shading. The most difficult aspect was to correctly draw all the complex movement of the muscles and shade them without overshading. As I copied them, I reflected on how Michelangelo drew them. How do you execute drawings like this? He must have begun with some sort of small sketch, perhaps in pen, of the idea of the figure. I suspect he went right to the model and began by positioning him to get the proper combination of torsion of the arms, legs, and torso. Next, he established a strong light source—perhaps in front of a window or with candles—and set himself up to draw with a sheet of paper on a drawing

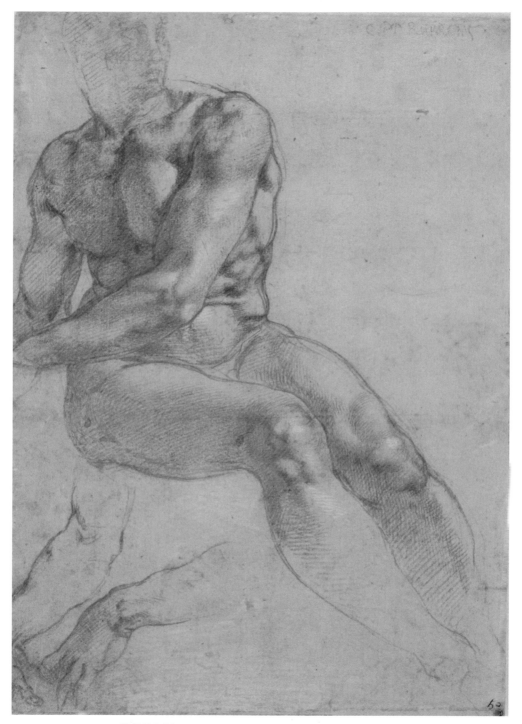

FIGURE 81: Michelangelo, study for nude, red chalk,
271 x 190 mm (10.6 x 7.4 inches).

board. The first marks were probably general lines to get the gesture. These were followed by more accurate contour lines of the torso, legs, and arms and perhaps some of the internal details of the anatomy. The anatomy was then lightly shaded with the red chalk to find the correct placement of the muscles and the interplay of bone, muscle, and tendons mainly in the joints—the knees and elbows. The final stages consisted in creating the general shadows and the chiaroscuro interplay on the larger forms—torso, arms, legs. These subtle shadows were carefully reinforced where necessary, with absolute dark patches that consisted of a denser concentration of red chalk to show the harsher contrasts of shadow and the insertions of the muscles.

MAKE YOUR OWN COPY OF MICHELANGELO

If the reader wishes to understand just how difficult these drawings are to copy, I suggest acquiring a piece of paper the same size as one of these studies, roughly 280 x 200 mm (11 x 7.8 inches). Try to procure a red chalk pencil or even some natural red chalk. Select the figure study you prefer and place the color image next to your piece of paper. Start with the gesture lines of the figures—the slant of the arms, legs, and torso. After the gesture, move on to the contours, and concentrate on the external curves of the muscles. Once this is done, work on defining the muscles inside the figure—the abdomen, muscles of the arms and legs. Once the figure is set up, the shading is next. First, indicate the general areas with a light shade of chalk to get volume, and then work on reinforcing the muscles with dark patches. One important thing: do not be afraid to make mistakes. Sometimes mistakes are a sign that your own style is coming through. If you want to gauge whether your copy is accurate, place it next to the image of the original drawing and look at both in reverse in a mirror (a hand mirror will suffice). This is a trick that Leonardo himself advised young artists to try in order to check their works. If you compare

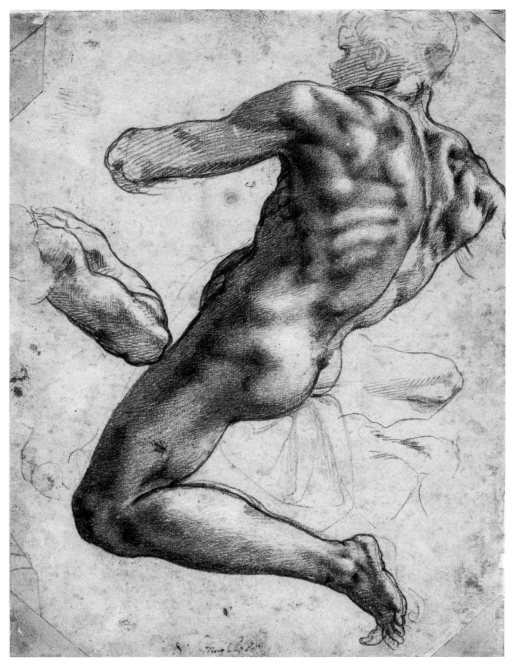

FIGURE 82: Michelangelo, study for nude, red chalk,
279 x 214 mm (10.9 x 8.4 inches).

your drawing to the original in reverse in the mirror, all the inaccuracies will pop out, and once you see where the mistakes are, you can correct them. I used to have my students use the mirror as a final check, though I knew they hated it. It can be humbling, for sure, but it's better to see the in mirror where the mistakes are rather than hear it from someone else.

In a sense, copying these drawings is like playing them, the way a musician plays a piece of music on an instrument. You may have to start over a number of times, but if you concentrate on the lines and forms and let your hand be guided by Michelangelo, you'll be surprised at what you can do. There is a funny story about how Michelangelo once employed a stonecutter to help sculpt some of his works for a large commission. According to the story, Michelangelo stood behind this particular sculptor as he was hammering away and said to him, "Take off this bit here, take off that bit there." After a while, the sculptor began to see the figure emerging from the marble and was shocked at how good it was. He turned to Michelangelo and said, "Thank you." Michelangelo, confused at this reaction, replied, "Why are you thanking me?" The sculptor replied, "Thank you for bringing out in me a talent I never knew I had." Although this story purports to be ironic, if you do a good copy of one of Michelangelo's drawings, you too will be surprised at the talent he'll have brought out in you. If you keep practicing, your drawing skills will doubtlessly improve (remember, as Cennini wrote, "your hand and your mind, being always accustomed to gather flowers, would ill know how to pluck thorns"), and you'll come away with a deeper appreciation of the mastery of the drawing's creator.

HEAD STUDIES

The heads of nudes, prophets, and sibyls were an important part of the scenes of the Sistine Chapel ceiling, and the extant studies for them demonstrate Michelangelo's growing artistic efficiency and confidence. As in any painting, faces are the culmination of the movements of the

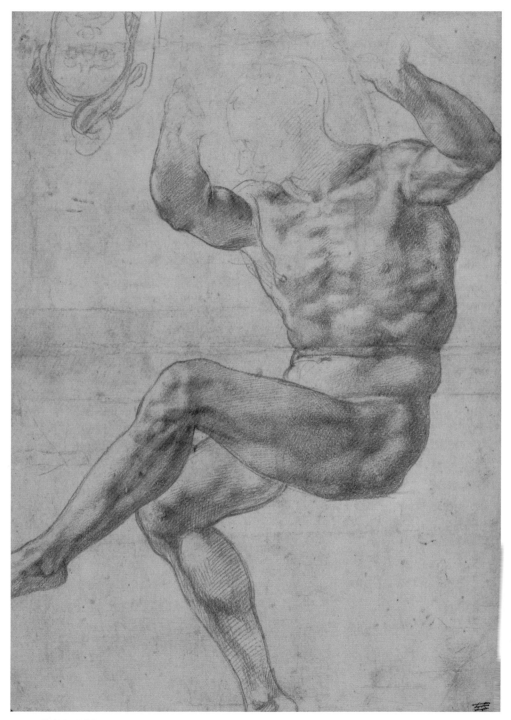

FIGURE 83: Michelangelo, study for nude youth over prophet Daniel, red chalk;
343 x 243 mm (13.5 x 9.5 inches): secondary support: 344 x 244 mm (13.5 x 9 inches).

figures and had to be done well. Michelangelo's head studies for the first part of the ceiling are large and show him concentrating specifically on drawing the faces correctly, with the corresponding shadows. They were done in black chalk and isolated on large sheets. In the second half of the ceiling, he began to execute smaller head studies in red chalk. These are either on the same sheet as the figure study or, in at least two cases, on other, closely related sheets. In the first of these, a different angle of the head of the Haarlem study (Figure 82) is on the sheet of studies for the legs of God the Father in the British Museum in London (Figure 79). This face is small and situated among other quick studies. In the second, the head of the Albertina figure discussed earlier (Figure 81) is found on the back of the Adam study (Figure 80) and is slightly larger than the head study in red chalk on the drawing in the British Museum. The faces in Figure 79 and Figure 80 are in red chalk, in contrast to the head studies in black chalk discussed earlier. They are small, quick studies that seem to be done from life but only to get the correct play of light for use as a general reference before transferring it to the cartoon.

A BEAUTIFUL FACE: STUDIES FOR THE LIBYAN SIBYL

Michelangelo's careful, concentrated approach to the figures is best demonstrated by a series of studies for one of the last large figures painted on the Sistine Chapel, the Libyan Sibyl (Figure 84). The fresco image of the sibyl is arguably the most dynamic on the entire ceiling. It represents the ultimate in Michelangelo's manipulation of the body, rendering of drapery, sense of complex composition, figural dynamism, use of color, and general aesthetic sense of power and beauty. Perhaps this is why, out of all the drawings executed for the Sistine ceiling, Michelangelo kept the most for this figure. The extant drawings are unique in their content and allow a near-complete reconstruction of the entire figure and even the putto next

to it. It could be that this is what Michelangelo wanted us to see: how he created one of his best figures. Not like a craftsman, but as a genius.

A sheet in the Metropolitan Museum of Art in New York (Figure 85) shows the primary figure study for the Libyan Sibyl. The study of the back of the figure with arms raised is a continuation of the three previously discussed figure studies for the nudes (Figures 81, 82, and 83): complex anatomical vitality heightened by veils of red shade created by hatched sanguine lines, which give a sensual, shimmering, tactile impression of warm flesh. The strain of the muscles imparts an immediacy to the drawing. You can imagine Michelangelo asking the male model to *turn a little more*, or *hold your hands up higher*, and *hold that pose!* The drawing is impressive for the way it shows the muscles of the arm and back and the bones that push through the flesh.

After executing the primary study of the torso, Michelangelo went on to restudy the left shoulder, left hand, and left foot. The two studies of the big toe—with which it appears that he had some trouble—are perhaps the most famous toe studies in the history of art. I have had to draw big toes on feet, and for some reason the forms of the toenail and fleshy part of the underside of the toe are not easy to get. When he first studies the foot, the big toe is too close to the other toes. Next, he restudies it (at right on the sheet) with the toe extended; then, perhaps realizing that the model couldn't extend it any further without detaching it, he just drew the big toe by itself, which he eventually attached to the rest of the foot on the fresco, leaving more distance from the second toe. This may seem like an insignificant detail, but, as seen on the final figure of the Libyan sibyl in the fresco, the strong diagonal of the entire figure is what gives it strength and movement. This dynamic movement starts from her left foot and big toe.

The Metropolitan study exhibits the same technical and aesthetic quality as the other nude studies in the Cleveland Museum of Art, the

(opposite,
FIGURE 84: Libyan Sibyl
Sistine Chapel ceiling

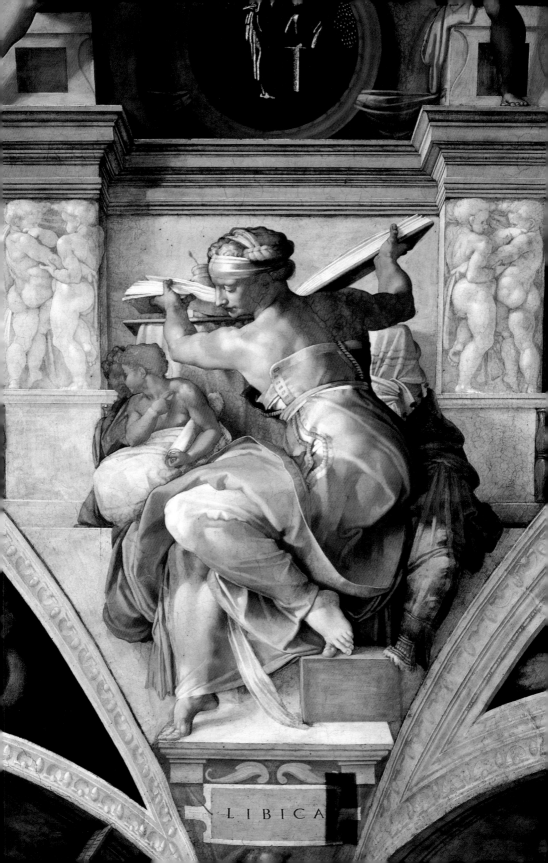

Albertina in Vienna, and the Teylers Museum in Haarlem. The head is included here as elsewhere, but the way it is rendered is unique and gives the entire drawing an emotional weight more than usual for a preparatory study. The head on the torso is one of the smallest and most completely rendered in all of his studies for the Sistine ceiling. The accuracy and precision of the face allows us to see that it was, perhaps surprisingly to modern viewers, done from a male model, whose strong features are easily discernible. Since this was to be a study for the female sibyl, the male features had to be morphed and feminized. In the left corner of the sheet, Michelangelo executed a less precise, less intense, but softer, more feminine version of the face that more closely corresponds to the fresco's version.

This is something not seen before in the extant drawings for the ceiling. Calling on his own artistic invention and sensibility, Michelangelo redrew and altered the face that he had first drawn from life. This concept may seem difficult to conceive for the nonartist, but sometimes when you want to render a face that expresses a feeling you have in your head, you rely less on what you see and more on what you feel. Here, the transition from the accurate male head study to the idealized and beautiful female drawing offers a rare glimpse of Michelangelo imposing his concept of beauty.

One detail many overlook on the Metropolitan sheet is the small "splotch" of red pigment on the lower right-hand corner. This can be none other than a drop of red ochre that fell from his brush as he was painting above his head. After finishing the ceiling, Michelangelo writes a poem about the physical problems resulting from his work on the vault and mentions the drops that kept falling on his face as he painted. He probably had this sheet close by him on the scaffolding when painting the torso of the sibyl, for he must have needed the reference in order to paint such a complex figure. I realized this years later when I saw the same splotches on drawings of mine that I'd used in fresco commissions.

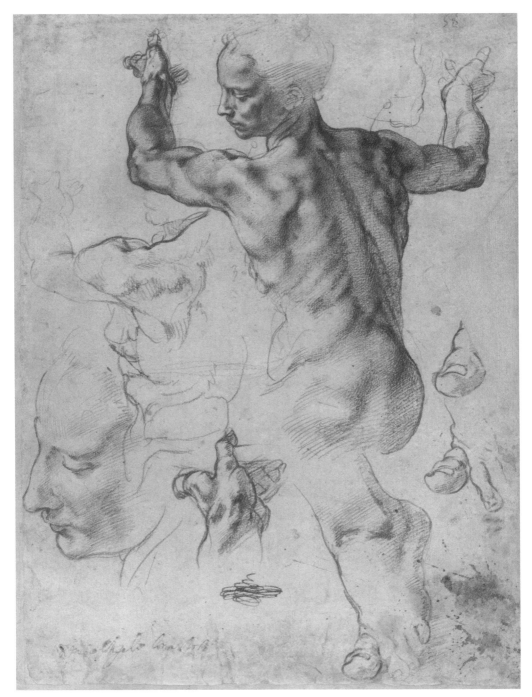

FIGURE 85: Michelangelo, study for Libyan Sibyl, red chalk,
288 x 213 mm (11.3 x 8.3 inches).
At bottom center, a pen scribble to test out the point, and, at lower left,
spots of pigment from brush while painting vault.

The remaining studies for the Libyan Sibyl figure are on the backside of the Metropolitan study (Figure 86) and on a sheet in the Ashmolean (Figure 87). The Ashmolean sheet contains a sanguine sketch of the left hand of the sibyl and a figure study of one of the accompanying putto. As in the sibyl study, Michelangelo drew only part of the putto torso and ignored the legs—which on the fresco are completely covered by a white cloak and did not have to be drawn—yet another time-saving decision. The small pen studies on the same sheet are for the slaves for the tomb of Julius II, which he was also working out while painting the ceiling. They may give an idea of the type of near-complete figure studies that served as the initial ideas for the red chalk drawings.

The Metropolitan sheet with the black chalk study of legs, which in the fresco are visible under the drapery, completes the studies for the figure of the Libyan Sibyl. Only the drapery study is missing. But why is this one in black chalk? As I was putting all these drawings together, the leg study in black chalk didn't make sense at all. It doesn't seem this sketch was done earlier, before he switched to red chalk; the shading of the great trochanter and gluteal corresponds exactly to the red chalk study on the recto. It appears that in this case, Michelangelo used black chalk because he needed only the general position, contours, and shading of the legs that were to be covered up anyway. He didn't have to waste time with red chalk, since the rest of the work on the legs would be done on the drapery study. The missing drapery study most likely resembled the one for the Erythraean Sibyl in the British Museum (Figure 74).

After copying so many of Michelangelo's drawings and understanding his system, I had the forger's urge to "recreate" the Libyan Sibyl drapery study and couldn't resist it (Figure 88). I can't say for sure that Michelangelo did his study like this, but it must have been similar. With this final piece, the entire figure can be assembled, as Michelangelo must himself have done on the large preparatory cartoon.

FIGURE 86: Michelangelo, study for legs of Libyan Sibyl, black chalk,
288 x 213 mm (11.3 x 8.3 inches).

FIGURE 87: Michelangelo, studies for hand of Libyan Sibyl and putto in red chalk,
studies for cornice and slaves for Julius tomb in pen and ink,
285 x 195 mm (11.2 x 7.6 inches).

With his studies in hand, he would have redrawn it in black chalk, which is easier to handle for large cartoons. To explore how this was done, I reconstructed my own preparatory cartoon for the Libyan Sibyl, about one-quarter the size, in order to copy it in fresco. After gluing the sheets of paper together, I used the small studies to redraw it (Figure 89). With the painted image on the vault as my guide, I noticed that, when he constructed the figure from the studies, Michelangelo tilted the entire figure more to the left than he had done in his drawings, increasing the bend of the torso and raising the right arm, thus giving the figure a stronger diagonal. This small adjustment from the studies to the cartoon and then the fresco demonstrates that the artistic process did not end with the studies but continued even as he was assembling them on the cartoon. He continued to refine what he had studied.

I completed my reconstruction of the entire process of the design and execution of the Libyan Sibyl by painting a copy of it in fresco. For me, the experience of seeing the power of the idea taken from sanguine studies to its execution in paint on fresh mortar was immensely satisfying. I can only imagine what Michelangelo felt.

HAMAN AND THE END OF A JOURNEY

The last cluster of three interrelated drawings for the vault are for the spandrel of the Crucified Haman, the largest and perhaps most complex nude on the entire ceiling. The format of the drawings is exactly like those for the Libyan Sibyl, but they illustrate the effort Michelangelo was willing to undertake to solve a particularly difficult figural problem. The primary drawing, and the first study to be executed, is a near-complete sanguine study in the British Museum (Figure 5). As in the other red chalk drawings, this spectacular study exhibits the same sensitive handling of sanguine in its subtle yet powerful rendering of the muscles with cross-hatched lines and blunt-point shading. The figure has the same sense of

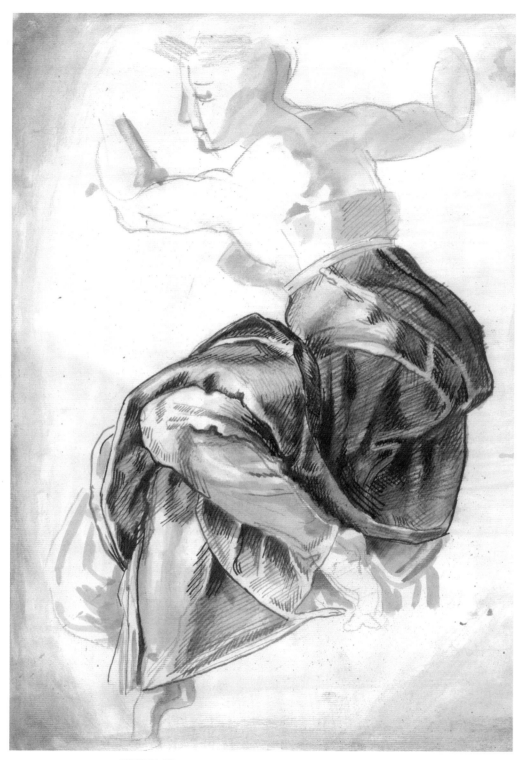

FIGURE 88: Alan Pascuzzi, reconstruction of drapery
study for Libyan Sibyl, pen and ink and ink wash,
384 x 260 mm (15.1 x 10.2 inches).

FIGURE 89: Alan Pascuzzi, reconstruction of cartoon
for Libyan Sibyl, black chalk, pricked for transfer,
85.5 x 146.5 cm (33 x 57 inches).

weight and powerful sensuality as the three studies for nudes in the Cleveland Museum of Art, the Albertina in Vienna, and the Teylers Museum in Haarlem. The dynamic pose, complex anatomy of the rectus abdominis, twisting torso, and straining muscles of the legs together create a force and vitality that are unlike in any of his previous studies.

Michelangelo's creative decision to make the pose twisting was perhaps the element that forced him to restudy the legs to the right of the figure and to seek a better solution for the head and arms, which are in near-impossible foreshortening. Since the head was completely covered by the right arm, Michelangelo had to restudy it on another sheet—perhaps the second executed—in Haarlem (Figure 90). This sheet contains the continuation of the torso with neck and head bent back. The right arm and hand did not fit on the sheet, so he restudied them to the upper right. The left arm couldn't be drawn as it would cover the face, and was only slightly indicated, but the hand was sketched in above. The last sheet to be executed is a sketch in the British Museum (Figure 91), which contains the rest of the left arm with latissimus dorsi, triceps, and muscles of the forearm drawn in foreshortening. This gives us the remaining visual information to the complex pose of the head and extended arm.

The full-figure Haman study (Figure 5) was perhaps the hardest to copy. I made several attempts at reproducing this drawing and was never satisfied with the results (Figure 6). I have seen other artists' attempts, and they too had the same problems. The contours of the figures give an almost harsh angularity to the anatomy but combine to impart that soft, fleshy solidity. I got lost in the muscles of the abdomen and ribs, which are so perfectly positioned and rendered that if one is out of place, the whole drawing looks like a bag of walnuts. Finally, that red sheen of the sanguine that creates the subtle volume on the left side of the figure and delicate highlight on the upper torso requires absolute control of the red chalk point.

After all my copies of Michelangelo's drawings over years of work, I nonetheless had reached the difficult conclusion that I was unable to copy

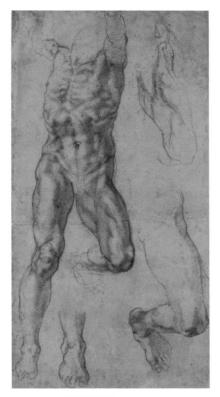

FIGURE 5: (detail)

this drawing successfully and capture Michelangelo's spirit in it. I had come close, but there was still something unattainable about Michelangelo's style that eluded me. As I sat pondering why, I realized that the elusive element was precisely what I had been looking for and trying to explain. The drawing represents the spark of inspiration—that higher level of artistic creation that goes beyond one's natural abilities and touches a perfection that the conscious mind perhaps does not even know how to recognize.

You may think I'm romanticizing Michelangelo's genius and in this following in the footsteps of Condivi and Vasari and so many others. But it's true: I had reached a limit of Michelangelo's mastery. I will never know what was on the other side of the force and beauty of the Haman drawing. That spark, that ability to put into play something that was unique to Michelangelo, will always be his—and it died with him. As his

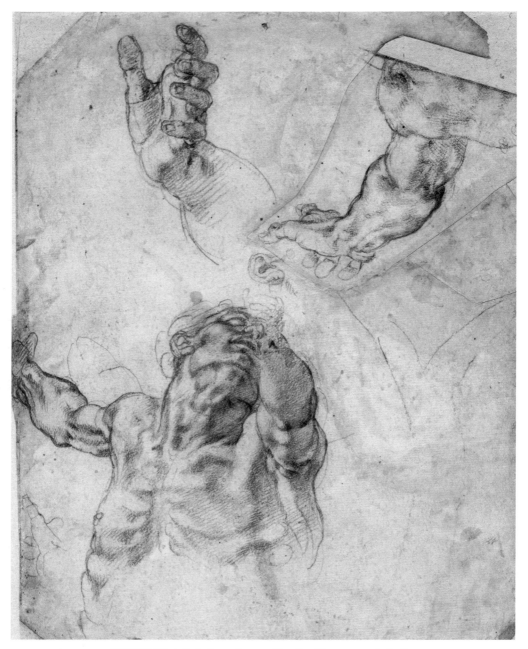

FIGURE 90: Michelangelo, studies for Haman, red chalk,
252 x 205 mm (9.9 x 8 inches).
Torso, arm, and hand are continuation of studies on large figure study for Haman (Figure 5).

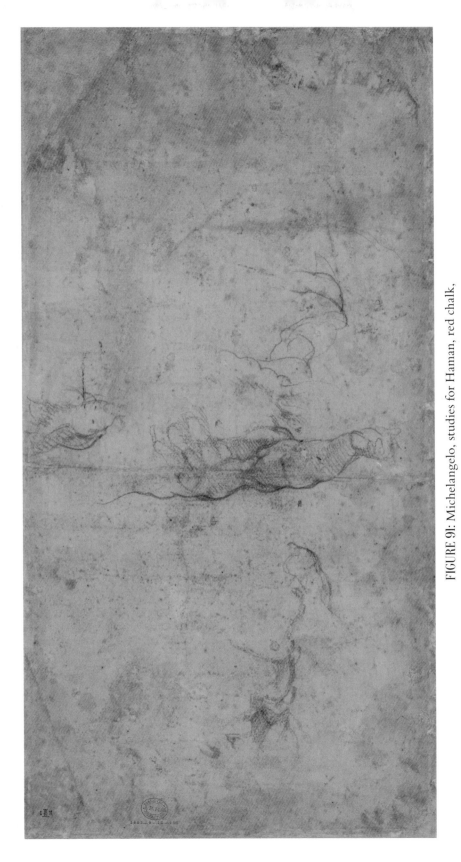

FIGURE 91: Michelangelo, studies for Haman, red chalk,
406 x 207 mm (15.9 x 8.1 inches).

The study of a foreshortened arm above is a continuation of torso study seen in Figure 90.

apprentice, I could recreate his drawings and reenact his motions, but in the end, the full and final mastery that Michelangelo achieved was his alone. It was now up to me to discover a mastery of my own and infuse my drawings with my personal spark of inspired creation. Michelangelo had taken me to the threshold, but it was time to leave him and do the rest myself.

Conclusion

MICHELANGELO'S DEVELOPMENT AS AN ARTIST from his thirteenth to his thirty-seventh year can be summarized in five of his drawings: the sheet of model book studies with his first undirected attempts at drawing when he was a true beginner **(Figure 10)**; the pen and ink copy of Masaccio in the Brancacci Chapel executed as part of his apprentice exercises under the expert guidance of his master Ghirlandaio **(Figure 17)**; his figure studies to learn and understand anatomy in order to execute the *David* **(Figure 29)**; the black chalk figure study for the *Battle of Cascina* **(Figure 47)** that displays his first drawings free of Leonardo's influence and his true desire to show forceful male anatomy; and finally the red chalk study of Haman for the Sistine ceiling **(Figure 5)**, in a style that is complex, forceful, and refined, and a true indication of his artistic maturity.

Viewed all together, these five works demonstrate the gradual evolution of his technique, knowledge of anatomy, and creative genius. They reflect the skill he acquired as an artist and craftsman in confronting and thinking through every element of each of his complicated commissions in sculpture and painting. I believe the basis of Michelangelo's genius is that he followed Cennini's precept of drawing "every day" and never stopped. Michelangelo drew and drew, perhaps more than many artists of his time—his only close competitor was Leonardo da Vinci. Drawing was

(FIGURE 10)

(FIGURE 17)

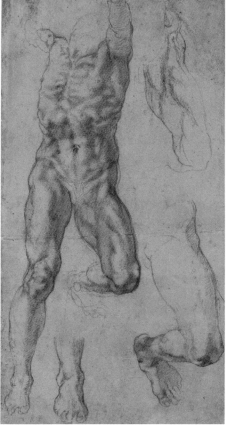

(FIGURE 5)

(FIGURE 29)

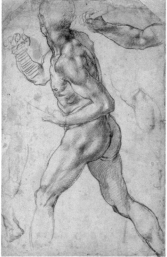

(FIGURE 47)

the basis to becoming an artist, and following a master provided the right direction. Perhaps this was the reason that, later in life, he emphatically told one of his assistants, a certain Antonio, to "draw, Antonio, draw, and don't waste time!"

At the end of every semester of my Renaissance Apprentice class, I would ask my students what they thought was the key to learning and mastering the art of drawing. Many came to the correct conclusion and answered, "Patience, diligence, and passion." Passion is what draws you to follow the apprenticeship process, but it takes patience and diligence to reach the final goal of mastery. There were perhaps hundreds more drawings by Michelangelo that might have underscored this lesson even more, and Michelangelo burned them to prevent us from seeing what I spent years to excavate: the hard work, drawing by drawing, that in the end, brought him to a level of genius.

He was not born a genius but with the capacity to become one, as perhaps we all are. His natural artistic tendencies were cultivated and allowed to grow through a rare combination of encountering favorable historical events, being recognized by influential people, and being presented with unprecedented artistic challenges. Through his young life, he nurtured his genius through practice and patience—and diligence and passion. He also knew he had something inside to express, and he didn't let anything prevent him from expressing it in his art.

After years of copying these drawings, I contemplated the results that the entire apprenticeship process to Michelangelo had on me artistically. I recalled what I had read in Cennini's *Craftsman's Handbook* that evening in Syracuse long ago, and the words now took on a wholly different meaning. Before, they were an indication of where to go; now they were a summary of where I had gone: If you follow the course of one man through constant practice, your intelligence would have to be crude indeed for you not to get some nourishment from it. Then you will find, if nature had granted you any imagination at all, that you will eventually

acquire a style individual to yourself, and it cannot help but be good—because your hand and your mind, being always accustomed to gather flowers, would ill know how to "pluck thorns."

Just as any Renaissance apprentice would have done, I had spent years following my master, I had copied and drawn, guided by Michelangelo, and in doing so had acquired something unique. My artistic view is based on the abilities gained through an old process, but is nonetheless new. I acquired a style of my own, one which was not learned from a cold, schematic academic system nor taken from abstract forms, but gleaned from closely following Michelangelo's own journey from apprentice to master. The style that I learned is not flashy or fashionable, nor superficially modern and conceptual. Instead, it consists of bones and sinew, charcoal and sanguine, passion and beauty. It is a style that I believe contains sparks from the flame of primordial creativity passed on through the centuries. This is what I had always longed for, to obtain that flame and carry it forward.

Since I began making art on my own, I've produced hundreds of original studies in black and red chalk for numerous commissions. My paintings of the Madonna have been paraded through the streets of Florence and blessed on the steps of the cathedral by the bishop. I have painted frescoes high up on scaffolding in churches in Australia and in Italy. I have hammered stone to create sculptures of saints, pietas, Christs, and Madonnas in marble. I have modeled my figures in clay and cast them in bronze. Like the masters of long ago, I have my own works in the city of Florence in tabernacles (small shrines with religious images) in the streets, in churches, and palaces. I have experienced that state when ideas are born and flow from your mind and are realized as if by magic through your hands. It is a sensation of feeling part of that ancient flame of creation that stretches from artists from even before the Renaissance and to today. I may never become rich or famous from my works, but I know that my works will survive me when I'm long gone and forgotten (this may be

artistic hubris, but it is a comfort). I have left that flame of creativity and passion in all of them.

Trying to become a master has been my life's work. As I now look back at what I have learned, and as I continue to make drawings, paintings, and sculptures in my own style based on that, nurtured by my master's guidance, I have the great satisfaction to have glimpsed and felt what it must have been like . . . becoming Michelangelo.

Acknowledgments

ON A SUNNY JANUARY AFTERNOON in 2011 in Florence, as I walked with my students past the Church of San Marco to go to Zecchi's art store on the first day of my Renaissance Apprentice class that semester, I chatted with one bright young student who began to tell me about her job at her university's press. I had always been interested in publishing my dissertation on Michelangelo's drawings, and I asked if her employers would ever consider printing it. She replied that unfortunately the press dealt mainly with textbooks. Nearly a decade later, I was contacted by the same student, now graduated and a top-notch professional editor, who still remembered my desire to publish my dissertation. She asked me if I would be interested in proposing a book, to which I replied yes. I would like to express my sincere thanks to that former student, Jenny Pierson, who was the first to believe in this book. It was her patience and dedication that allowed me to finally make it a reality. Thanks also go to Josh Boulton, a graduate student, for his razor-sharp organizational assistance, Nicole Weber for her photographic contributions, Professoressa Elena Lombardi and Professore Giudo Iodice of the Casa Buonarroti for their generous assistance in obtaining illustrations, Roberto Palermo and Cristian Ceccanti for their brilliant photographic assistance, and Jacopo Parigi, for his patient, technical help on the manuscript. I would also like to remember

my first art history professor, the late Sister Magdalen LaRow, whose advice was the foundation of this book and still guides me today. Thanks also to Professor William Wallace for his initial support in pursuing my copying Michelangelo drawings. Many thanks also go to all the museums and individuals who assisted me in obtaining rights to publish Michelangelo's original drawings—the Ashmolean in Oxford, British Museum in London, Chatsworth Museum, Windsor Castle, Holkham Hall in Norfolk, the Albertina in Vienna, the Boijmans Museum in Rotterdam, the Musée Condé in Chantilly, the Louvre in Paris, Susi Piovanelli at the Uffizi Museum, Claudia Timossi at the Church of Santa Croce, Gianpietro Burgnich, and Casa Buonarroti in Florence, Teylersmuseum in Haarlem, and Dott.ssa Antonietta De Felice of the Biblioteca Reale in Turin.

A very special acknowledgment and profound thanks also go to those who with their generosity allowed me to publish the numerous original Michelangelo drawings in this book: Blaine Trump, Steve Simon, Carolyne Roehm and Simon Pinniger, Carolyn Aaronson, Carolyn Bresee, Linda Johnston, Robert Gibbs, Pam and Bill Doyle, Robyn Smith, Mary Delmastro Breese, Rosanna Centanni, Del Staigers, Steve and Monica Pascuzzi, Hope Panara, Jennifer Hermesmeyer, Patrice Lombardi, Kevin McNamara, Brooke Tyska, Shayne Priddy, Dennis Massa, Emma Skurnick, Jenni Dougan, and Jan Elliot. I am forever thankful to them for making possible this unique collection of Michelangelo drawings in one book.

A final acknowledgment and thanks to Cal Barksdale for his patience and expert guidance in editing this book and also to Michele Rubin for her insightful suggestions and comments on the final manuscript.

Appendix

I. Additional Documents Relating to Michelangelo

A. Documents published by Karl Frey★ regarding Michelangelo's work on the fresco for the *Battle of Cascina* demonstrate that the artist began the cartoon soon after he was given the commission in 1504. The following documents show that the paper was purchased and that Michelangelo paid two helpers to paste the sheets together to make the cartoon:

i) To Bartholomeo di Sandro papermaker y VII for 14 notebooks of Bolognese royal sheets (of paper) for Michelangolo's cartoon.

ii) To Bernardo di Salvadore papermaker, y V for work in putting together Michelangolo's cartoon.

iii) To Piero d'Antonio who is gluing the paper, for work in helping and gluing (i.e., helping to paste) Michelangolo's cartoon.

B. The record of the contractual agreement for Michelangelo's painting of the Sistine Chapel ceiling★★:

★ Karl Frey, "Studien zu Michelagniolo Buonarroti und zur Kunst seiner Zeit," *Jahrbush der Koniglichen Preusischen Kunstsammlungen* (Berlin, 1909).

★★ C. Seymour, ed., *Michelangelo: The Sistine Chapel Ceiling,* (New York: W. W. Norton and Company, 1972), 102–103.

On this May 10, 1508, I, Michelangelo, sculptor, have received on account from our Holy Lord Pope Julius II five-hundred papal ducats . . . toward the painting of the ceiling of the papal Sistine Chapel, on which I am beginning to work today according to those conditions and agreements which appear in the contract written by the most reverend Monsignor of Pavia and signed by me.

2. Excerpt from Cennino Cennini's The Craftsman's Handbook⋆

In this excerpt from *The Craftsman's Handbook*, Cennini gives advice on how young apprentices should choose the right master and how studying from one master is the best way to acquire an individual style:

Now you must forge ahead again, so that you may pursue the course of this theory. You have made your tinted papers; the next thing is to draw. You should adopt this method. Having first practiced drawing for a while as I have taught you above, that is, on a little panel, take pains and pleasure in constantly copying the best things which you can find done by the hand of the great masters. And if you are in a place where many good masters have been, so much the better for you. But I give you this advice: take care to select the best one every time, and the one who has the greatest reputation. And, as you go on from day to day, it will be against nature if you do not get some grasp of his style and of his spirit. For if you undertake to copy after one master today and after another one tomorrow, you will not acquire the style of either one or the other, and you will inevitably, through enthusiasm, become capricious, because each style will be distracting your mind. You will try to work in this man's way today, and in the other's tomorrow, and

⋆ Cennino Cennini, *Craftsman's Handbook*, trans. D. Thompson (New York: Dover, 1960), 2–3.

so you will not get either of them right. If you follow the course of one man through constant practice, your intelligence would have to be crude indeed for you not to get some nourishment from it. Then you will find, if nature has granted you any imagination at all, that you will eventually acquire a style individual to yourself, and it cannot help being good; because your hand and your mind, being always accustomed to gather flowers, would ill know how to pluck thorns.

3. Excerpt from Leonardo's Writings★

In his "On the Life of the Painter in his Studio," Leonardo explains the reasons he believes it is best to draw in company:

To draw in company is much better than to do so on one's own for many reasons. The first is that you will be ashamed to be counted among draughtsmen if your work is inadequate, and this disgrace must motivate you to profitable study. Secondly a healthy envy will stimulate you to become one of those who are more praised than yourself, for the praises of others will spur you on. Another reason is that you will learn something from the drawings of those who do better than you, and if you become better than them you will have the advantage of showing your disgust at their shortcomings and the praises of others will enhance your virtue.

Leonardo on students and masters, from his "Advice to the Young Painter":

He is a poor pupil who does not surpass his master. There are many men who have a yearning desire to be able to draw, but are temperamentally unsuited to it, as may be seen from those boys who, lacking

★ M. Kemp and M. Walker, eds., *Leonardo on Painting.* (New Haven: Yale University Press, 1989), 205 and 196, respectively.

diligence, never finish their copies with shading. A youth should first learn perspective, then the proportions of all things. Next he should learn from the hand of a good master, to gain familiarity with fine limbs . . . then from work done in three dimensions along with the drawing from it, then from a good example from nature, and this you must put into practice.

Glossary

Alberti, Leon Battista (1404, Genoa–1472, Rome): Florentine architect, theorist, and humanist scholar, and the author of several important texts, such as *On Painting* (1436), which explained the use of perspective for artists, and *Ten Books on Architecture* (1452).

allievo: Italian for someone learning at school or a craft; apprentice. The plural is *allievi*.

Anonimo Magliabecchiano: Italian for "Anonymous Florentine," the title of a work of 128 pages written by an unknown author from the 1530s to 1540s that is a "gossip sheet" of the time. The author was clearly well known among artists of the period.

arti: Italian for "guild"; trade associations in medieval and Renaissance Florence.

Bargello: National Sculpture Museum in Florence that contains numerous Renaissance masterpieces in sculpture.

biacca: White substance used to highlight drawings (mainly silverpoint drawings done on tinted paper) made of powdered white lead and a binding medium, usually gum arabic.

bianc'osso: Italian for "bone-white," a powder made from burning and pulverizing chicken-wing bones; it can also be made from egg shells; chemically, a calcium carbonate or a calcium phosphate.

bistre: Transparent water-soluble brownish-yellow pigment made from the soot of burnt wood.

bottega: Italian for "workshop."

Botticelli, Alessandro di Mariano Filipepi (Sandro) (1443, Florence–1510, Florence): Painter famous for large-scale mythological works executed under Medici patronage such as the *Birth of Venus* and *Primavera*.

borghesia: Italian for "middle-class."

braccia: Unit of measure in the Renaissance, usually 26 or 27 inches, or 66 or 68 cm.

Brancacci Chapel: Chapel under control of Brancacci family, who commissioned Masaccio and Masolino to paint the fresco cycle based on Saint Peter; also, the place where Michelangelo's nose was broken when he was a young boy drawing from the frescoes.

Buon fresco: Literally, "true fresco"; "fresco" from Italian meaning "fresh," a technique that consists of painting on damp plaster with water-based pigments; when the plaster dries, the pigments become part of the matrix of the plaster.

Byzantine: Refers to the Byzantine Empire based in Constantinople; artistically, Byzantine art was characterized by flat, iconic forms.

cartoon: Full-scale preparatory drawing the exact same size as the painting; usually for frescoes.

Cascina: Town near the city of Pisa; site of a famous battle that was the subject of a famous cartoon by Michelangelo.

Cellini, Benvenuto (1500, Florence–1571, Florence): Florentine sculptor, goldsmith, and metalworker, famous for various works in Florence and also his autobiography, written 1558–62.

Cennini, Cennino (ca. 1370, Val d'Elsa–ca. 1440, Florence): Florentine painter and writer, author of the treatise *The Craftsman's Handbook*.

chiaroscuro: Italian term for "light and dark," or the deep shadows and contrasting light areas on forms created by strong lighting.

Codex Escurielensis: Model book of ancient motifs known to have been in Ghirlandaio's workshop.

Condivi, Ascanio (1525, Ripatransone–1574, Ripa): Friend and assistant of Michelangelo; in 1553 wrote a biography of his master, *Life of Michelangelo*.

contrapposto: Italian for "counterpose"; visual arts term used to describe pose of a human figure when the weight is on one foot with the line of the hips and the line of the shoulders in opposite, counterbalancing diagonals.

de Tolnay, Charles (1899, Budapest–1981, Florence): Hungarian art historian and expert on Michelangelo.

de' Medici, Lorenzo (1449, Florence–1492, Careggi): grandson of Cosimo de' Medici and son of Piero de' Medici; called Lorenzo il Magnifico (Lorenzo the Magnificent); he recognized the promise of the boy Michelangelo and took him into his home to give him humanist education and the opportunity to learn the craft of sculpting.

de' Medici, Piero (1416–1469): Son of Cosimo de' Medici and father of Lorenzo the Magnificent.

della Quercia, Jacopo (1374, Siena–1438, Siena): Sienese sculptor, one of leading sculptors of the Early Renaissance, whose work influenced later artists of the High Renaissance, such as Michelangelo.

di Bondone, Giotto (1266 or 1267, Colle–1337, Florence): Florentine painter and architect, credited for revolutionizing painting by making it more naturalistic and volumetric in contrast to old Byzantine iconic style; executed frescoes in Bardi Chapel in Basilica of Santa Croce that were copied by the boy Michelangelo.

di Giovanni, Bertoldo (1420, Poggio a Caiano–1491, Florence): Early Renaissance master of sculpture who apprenticed in workshop of the sculptor Donatello and later became head instructor of an informal academy of sculpture and painting founded by Lorenzo the Magnificent in the Medici Garden near the Church of San Marco; he was not a major sculptor, but most important Renaissance sculptors, including Michelangelo, studied under him.

di Rohan, Pierre: French marshal who entered Italy after Charles VIII and stayed in Florence in 1494; he desired a copy of Donatello's *David* in bronze, and the new government of Florence gave the commission to the young Michelangelo; when his work on the bronze was delayed, the commission was finally given to another artist to complete.

Donatello (1386, Florence–1466, Florence): Florentine sculptor, assistant to Lorenzo Ghiberti for Florentine Baptistry doors; main sculptor in Florence for early part of 1400s; worked in bronze, marble, and polychromed wood.

genii: From Latin "genius"; tutelary god; guardian deity or spirit that watches over each person from birth; also means "spirit," "incarnation," "wit," or "talent."

Ghirlandaio, Domenico (1449, Florence–1494, Florence): One of most prolific and skilled fresco painters in the late 1400s in Florence, he established a workshop with his brother Davide and created the most famous frescoes in Santa Maria Novella; he was the master painter to whom Michelangelo was apprenticed.

giornata: Italian for "day"; in fresco painting, it is the patch of plaster put on a wall that is frescoed in one day's work.

Giotto: see di Bondone

gonfaloniere: From Italian "gonfalone," a term used for the banners of communes in Italy; a "banner-bearer" who held a highly prestigious communal office of mayor for life in Renaissance Italy, particularly in Florence.

Hebborn, Eric (1934–1996): Famous British forger of drawings and paintings, author of *The Forger's Handbook*.

Julius II (Pope) (1443–1513): Born Giuliano Della Rovere, he was pope from November 1503 to his death in 1513; was a patron of the arts who initiated ambitious building projects like the new Saint Peter's Basilica that was begun under his rule, as well as Michelangelo's decoration of the Sistine Chapel.

Lippi, Filippino (1457 or 1458, Prato–1504, Florence): Florentine painter and the son of painter Filippo Lippi; finished Brancacci Chapel frescoes in 1480s and executed Strozzi Chapel frescoes in Santa Maria Novella.

Lorenzo the Magnificent: see de' Medici, Lorenzo.

Masaccio (1401, Castel San Giovanni di Val d'Arno–1428, Rome): Early Renaissance painter whose works were characterized by dramatic light and shadow and the use of perspective; among his famous works are frescoes of the Trinity in Santa Maria Novella and Brancacci Chapel in the Church of Carmine in Florence.

Masolino (1383, Panicale di Valdarno–ca. 1440, Florence): Painter who collaborated with Masaccio in the Brancacci Chapel; his paintings were characterized by delicate forms in contrast to Masaccio's.

Medicean (pro- or anti-): Pertaining to the Medici family—either in support of or against.

model book: Bound book, sometimes of parchment or skin sheets, with highly finished drawings of natural forms such as animals and plants executed in color; used in painters' workshops as a reference and source for copying and also for beginning apprentices to learn to draw.

Palazzo Medici Riccardi: Palace built by the architect Michelozzo for Cosimo de' Medici and his family; Michelangelo lived there when taken in by Lorenzo the Magnificent; later purchased by the Riccardi family.

passe–partout: Piece of paper or heavy cardboard cut to make a frame and attached to a backing; used to hold drawings.

pendante: Refers to works that are similar in size or subject that are conceived as a pair and to be placed side-by-side.

pendentive: Term for large corner spandrels, such as at the corners of the Sistine Chapel.

pentimenti: Italian for "rethinking" or changing one's mind; in relation to drawing, when an artist goes back over a previously made line with another.

Piccolomini: Wealthy Sienese family who commissioned Michelangelo to execute the Piccolimini altar in the Cathedral of Siena.

Pisanello (1395, Pisa–1455, Rome): Court painter in International Gothic style who worked for Gonzaga, Duke of Milan, Leonello d'Este in Ferrara, and the Venetian Doges; executed numerous studies in notebooks.

popolo: Italian for "common people."

popolo grasso: Italian, literally meaning "fat people" but referring to the dominant social stratum in Florentine society, which consisted of the wealthy middle class made up of merchants, powerful businessmen, and professionals.

popolo minuto: Italian, literally meaning the "little people" but referring to the lower stratum of Florentine society, made up of members of smaller or newer guilds or the hired workers who did not belong to guilds.

Quattrocento: Italian for "1400s."

Romano, Giulio (1492, Rome–1546, Mantua): Roman-born painter, assistant to the painter Raphael, who worked for Duke Federigo Gonzaga in Mantua, where he designed Palazzo del Tè and painted decorations such as room of the giants.

sanguine (sanguigna): Red stone, haematite or red oxide, that can be cut into points and used for drawing.

Santa Maria Novella: Dominican church in Florence where Domenico Ghirlandaio executed his frescoes in the high altar.

Sassetti: Wealthy Florentine family allied with the Medici through business ties; Francesco Sassetti commissioned Domenico Ghirlandaio to paint the Sassetti Chapel in the Church of Santa Trinita in Florence.

Savonarola, Girolamo (1452, Ferrara–1498, Florence): Dominican monk, prior of Convent of Saint Mark in Florence, politician, and preacher; after banishing of the Medici from Florence in 1494, Savonarola established a puritanical government there and preached against the corruption of the papacy; he was excommunicated, eventually arrested, and executed by the Florentines.

Schongauer, Martin (1445, Colmar–1491, Breisach): Northern artist and engraver who was the most important and prolific printmaker before Albrecht Durer; his print of the Temptation of St. Anthony was copied and colored by the young Michelangelo.

silverpoint: Stylus made of silver used to draw on prepared paper treated with crushed bird bone and tint and highlighted with white.

Soderini, Piero (1450, Florence –1522, Rome): First gonfaloniere, or mayor for life, of the newly formed Florentine Republic after the banishing of the Medici and Savonarola.

spandrel: On the Sistine Chapel ceiling, a concave triangular space over the windows.

tempera grassa: Italian for painting medium consisting of the yolk of an egg and oil.

Tornabuoni, Giovanni (1428, Florence–1497): Head of Tornabuoni, a wealthy Florentine family with close ties to the Medici; the head of the Medici Roman bank and treasurer in Rome to Pope Sixtus IV; the brother of Lucrezia Tornabuoni, who was wife of Piero de' Medici, and uncle of Lorenzo the Magnificent; commissioned Ghirlandaio to paint frescoes in the high altar of Santa Maria Novella.

Tornabuoni, Lucrezia (1427, Florence–1482, Florence): Wife of Piero de' Medici and mother of Lorenzo the Magnificent; an established poet and patron of the arts.

Tornabuoni: Wealthy Florentine family closely connected by marriage and business ties with the Medici family.

Torrigiani, Pietro (1472, Florence–1528, Seville): Florentine sculptor who studied with Bertoldo di Giovanni and frequented the court of Lorenzo the Magnificent; a competent sculptor but is remembered mainly for breaking Michelangelo's nose while both were drawing in Brancacci Chapel.

Vasari, Giorgio (1511, Arezzo–1574, Florence): Italian painter, architect, and artists' biographer who was a friend and associate of Michelangelo; most

famous for his *Lives of the Most Eminent Painters, Sculptors, and Architects*, first published in 1550 and reprinted in 1568.

vault: Structure based on the arch; in reference to Sistine Chapel, the barrel vault or continuous rounded vault intersected with transverse ribs that formed the ceiling area painted by Michelangelo.

Via dell'Anguillara: Street near the Basilica of Santa Croce in Florence; literally "eel street," so named because of its twisting course.

Via dei Bentaccordi: Street near the Basilica of Santa Croce in Florence where Michelangelo's family and the family of his friend Francesco Granacci lived.

Wilde, Johannes (1891, Budapest–1970, Dulwich, England): Hungarian art historian who was a noted expert on the drawings of Michelangelo.

Illustration Credits

Figure 1: © The Trustees of the British Museum.

Figure 2: © Alan Pascuzzi.

Figure 3: WA1846.38, Image © Ashmolean Museum, University of Oxford.

Figure 4: © Alan Pascuzzi.

Figure 5: © The Trustees of the British Museum.

Figure 6: © Alan Pascuzzi.

Figure 7: Photo Nicole Weber.

Figure 8: Permission for image thanks to Italian Ministry of Internal Affairs, Department for Civil Liberties and Immigration, Central Direction for the Administration of Religious Monuments (amministrato dal Ministero dell'Interno, Dipartimento per le Libertà civili e l'Immigrazione, Direzione Centrale per l'Amministrazione del Fondo Edifici di Culto). Foto D'Arte Firenze, Cristian Ceccanti.

Figure 9: Permission for image thanks to Italian Ministry of Internal Affairs, Department for Civil Liberties and Immigration, Central Direction for the Administration of Religious Monuments (amministrato dal Ministero dell'Interno, Dipartimento per le Libertà civili e l'Immigrazione, Direzione Centrale per l'Amministrazione del Fondo Edifici di Culto). Foto D'Arte Firenze, Cristian Ceccanti.

Figure 10: The Albertina Museum, Vienna.

Figure 11: Roberto Palermo, Gabinetto Fotografico delle Gallerie degli Uffizi.

Figure 12: Roberto Palermo, Gabinetto Fotografico delle Gallerie degli Uffizi.

Figure 13: © Devonshire Collection, Chatsworth. Reproduced by permission of Chatsworth Settlement Trustees.

Figure 14: Photo: Roberto Palermo.

Figure 15: Paris, Musée du Louvre, D.A.G. Photo © RMN–Grand Palais (Musée du Louvre) / Thierry Le Mage.

Figure 16: Permission for image thanks to Italian Ministry of Internal Affairs, Department for Civil Liberties and Immigration, Central Direction for the Administration of Religious Monuments (amministrato dal Ministero dell'Interno, Dipartimento per le Libertà civili e l'Immigrazione, Direzione Centrale per l'Amministrazione del Fondo Edifici di Culto).

Figure 17: © Staatliche Graphische Sammlung München.

Figure 18: Permission for image thanks to Italian Ministry of Internal Affairs, Department for Civil Liberties and Immigration, Central Direction for the Administration of Religious Monuments (amministrato dal Ministero dell'Interno, Dipartimento per le Libertà civili e l'Immigrazione, Direzione Centrale per l'Amministrazione del Fondo Edifici di Culto). © Foto Scala Firenze.

Figure 19: Photo: Roberto Palermo.

Figure 20: Roberto Palermo, Gabinetto Fotografico delle Gallerie degli Uffizi, Florence.

Figure 21: Roberto Palermo, Gabinetto Fotografico delle Gallerie degli Uffizi, Florence.

Figure 22: © Alan Pascuzzi.

Figure 23: Casa Buonarroti, Florence, © Associazione MetaMorfosi, Roma.

Figure 24: © The Trustees of the British Museum.

Figure 25: © Alan Pascuzzi.

Figure 26: National Gallery London, UK/Bridgeman Images.

Figure 27: Paris, Musée du Louvre, D.A.G. Photo © RMN–Grand Palais (Musée du Louvre) / Thierry Le Mage.

Figure 28: Paris, Musée du Louvre, D.A.G. Photo © RMN–Grand Palais (Musée du Louvre) / Thierry Le Mage.

Figure 29: Paris, Musée du Louvre, D.A.G. Photo © Musée du Louvre, Dist. RMN–Grand Palais / Suzanne Nagy.

Figure 30: The Albertina Museum, Vienna.

Figure 31: © Alan Pascuzzi. (Original in Louvre.)

Figure 32: Paris, Musée du Louvre, D.A.G. Photo © RMN–Grand Palais (Musée du Louvre) / Thierry Le Mage.

Figure 33: © The Trustees of the British Museum.

Figure 34: Berlin, Kupferstichkabinett, Staatliche Museen zu Berlin, 287 x 209 mm (11.2 x 8.2 inches). Numero di inventario: KDZ 1363 © 2017. Foto Scala, Firenze/bpk, Bildagentur für Kunst, Kultur und Geschichte, Berlin.

Figure 35: © Alan Pascuzzi.

Figure 36: Paris, Musée du Louvre, D.A.G. Photo © RMN-Grand Palais (Musée du Louvre) / Michel Urtado.

Figure 37: Published by kind permission of Lord Leicester and the Trustees of Holkham Estate, Norfolk/Bridgeman Images.

Figure 38: © The Trustees of the British Museum.

Figure 39: Royal Collection Trust/© Her Majesty Queen Elizabeth II 2018.

Figure 40: Royal Collection Trust/© Her Majesty Queen Elizabeth II 2018.

Figure 41: WA1846.39. Image © Ashmolean Museum, University of Oxford.

Figure 42: Roberto Palermo, Gabinetto Fotografico delle Gallerie degli Uffizi.

Figure 43: © The Trustees of the British Museum.

Figure 44: Paris, Musée du Louvre, D.A.G. Photo © RMN-Grand Palais (Musée du Louvre) / Michèle Bellot.

Figure 45: The Albertina Museum, Vienna.

Figure 46: Teylers Museum, Haarlem, The Netherlands.

Figure 47: Teylers Museum, Haarlem, The Netherlands.

Figure 48: © Alan Pascuzzi.

Figure 49: © Alan Pascuzzi.

Figure 50: Photo: Roberto Palermo.

Figure 51: The Albertina Museum, Vienna.

Figure 52: © Alan Pascuzzi.

Figure 53: © The Trustees of the British Museum.

Figure 54: Roberto Palermo, Gabinetto Fotografico delle Gallerie degli Uffizi.

Figure 55: Roberto Palermo, Gabinetto Fotografico delle Gallerie degli Uffizi.

Figure 56: © The Trustees of the British Museum.

Figure 57: Musée Condé, Chantilly, Photo © RMN-Grand Palais (domaine de Chantilly). Michel Urtado.

Figure 58: © The Trustees of the British Museum.

Figure 59: Foto © Musei Vaticani.

Figure 60: Roberto Palermo, Gabinetto Fotografico delle Gallerie degli Uffizi.

Figure 61: Roberto Palermo, Gabinetto Fotografico delle Gallerie degli Uffizi.

Figure 62: Roberto Palermo, Gabinetto Fotografico delle Gallerie degli Uffizi.

Figure 63: Casa Buonarroti, Florence, © Associazione MetaMorfosi, Roma.

Figure 64: © The Trustees of the British Museum.

Figure 65: Paris, Musée du Louvre, D.A.G. Photo © RMN-Grand Palais (Musée du Louvre) / Thierry Le Mage.

Figure 66: Roberto Palermo, Gabinetto Fotografico delle Gallerie degli Uffizi.

Figure 67: © The Trustees of the British Museum.

Figure 68: Casa Buonarroti, Florence, © Associazione MetaMorfosi, Roma.